D1257494

The Motherhood of Art

The Motherhood of Art

MARISSA HUBER & HEATHER KIRTLAND

FOREWORD BY DANIELLE KRYSA

SCHIFFER PUBLISHING

Other Schiffer Books on Related Subjects:

50 Contemporary Women Artists, John Gosslee & Heather Zises, ISBN 978-0-7643-5653-7

I Shock Myself, Beatrice Wood, ISBN 978-0-7643-5595-0

Master Your Craft, Tien Chiu, ISBN 978-0-7643-5145-7

Copyright © 2020 by Marissa Huber and Heather Kirtland

Library of Congress Control Number: 2019946894

All rights reserved. No part of this work may be reproduced or used in any form or by any means—graphic, electronic, or mechanical, including photocopying or information storage and retrieval systems—without written permission from the publisher.

The scanning, uploading, and distribution of this book or any part thereof via the Internet or any other means without the permission of the publisher is illegal and punishable by law. Please purchase only authorized editions and do not participate in or encourage the electronic piracy of copyrighted materials.

"Schiffer," "Schiffer Publishing, Ltd.," and the pen and inkwell logo are registered trademarks of Schiffer Publishing, Ltd.

Designed by Ashley Millhouse
Type set in Agenda
Front cover photographs by Kimberly Michelle Gibson, Alycia Jiskra, Steven Cotton, Jay McLaughlin, Julia Stotz, Erika Leitch, Amy Tangerine, and courtesy of Sonia Brittain, Karina Bania, and Meredith C. Bullock.
Back cover photographs by Little Cuddlebug Photography, Zoë Suelen, and courtesy of Karina Bania.
Endsheets: *Jungle*, digital illustration by Marissa Huber.
ISBN: 978-0-7643-5918-7
Printed in China

Published by Schiffer Publishing, Ltd.
4880 Lower Valley Road
Atglen, PA 19310
Phone: (610) 593-1777; Fax: (610) 593-2002
E-mail: Info@schifferbooks.com
Web: www.schifferbooks.com

For our complete selection of fine books on this and related subjects, please visit our website at www.schifferbooks.com. You may also write for a free catalog.

Schiffer Publishing's titles are available at special discounts for bulk purchases for sales promotions or premiums. Special editions, including personalized covers, corporate imprints, and excerpts, can be created in large quantities for special needs. For more information, contact the publisher.

We are always looking for people to write books on new and related subjects. If you have an idea for a book, please contact us at proposals@schifferbooks.com.

To Don, Violet, and Jack, who inspire me every day. To the strong women in my life: Mom, Sally, Carrie, and Peggy, whose examples give me something to live up to and whose support helps me maintain my studio practice. To Andy, with whom I share a love of art. To my dad, who always believed in me and never wanted me to stop creating.

—HK

To the loves of my life, Henry and Sloane; being your mama is my greatest joy. To Mike, who loves and accepts me just as I am. To my mom, who encouraged our creativity and believed in us always. To my dad, who passed down a love of writing, and the moxie to question everything. To my brother Andrew, who is always in my heart and makes me braver.

—MH

To our creative community at Carve Out Time for Art: the generous, talented, and encouraging group of artists without whom this book wouldn't be possible.

Contents

Foreword
BY DANIELLE KRYSA

Mothers cannot be artists. Your family will need all of your time and energy. You'll be much too busy for creativity. It's selfish to focus on your artwork. Nobody will take you seriously.

We've all heard various forms of this nonsense. Movies, nosy relatives, and the occasional very poorly researched magazine article have been saying these things for years. None of it's true, by the way, but unfortunately there are a lot of people who believe you can't have a life that combines both motherhood and art. Well, as the title suggests, each page of this book contains cold, hard proof of the opposite.

When I found out I was pregnant in the fall of 2005, I was thrilled. I threw myself into the joys of motherhood before my son, Charlie, even arrived. I decorated his room, wandered through every trendy baby shop I could find, and wore clothes that were sure to show off my growing bump.

Somewhere during this obsessive almost ten months—yes, he was very late—my mother pulled me aside. She is a painter and actually supported our little family when I was a newborn and my father was finishing his PhD. Anyway, she wisely advised, "Once the baby comes, you need to make an effort to have something in your life that is solely for you. You need something that is still very much 'Danielle'; otherwise you can

easily slip into being only 'Charlie's Mom.'" In that moment, I didn't understand what she meant. All I wanted was to be "Charlie's Mom." However, skip ahead six months after my bundle of joy arrived, and I realized what a brilliant mother I have. I did need something, and, for me, that something is and always has been art.

I took this challenge down two different avenues—writing about other artists through my blog, The Jealous Curator, and focusing on my own artwork. I began making small mixed-media pieces while my baby napped. I did several daily practice series (usually on tiny 4-inch canvases because they were easy to get out and tuck away) that documented my day with Charlie. Sometimes those pieces were about insane meltdowns on the way home from the park, while others captured his daily discoveries—the magical wonders of crawling on grass, for example! I was literally combining my experiences as a new mother with my artwork. Did I expect any of these works to be acquired by MoMA? No, but I was successfully holding on to "Danielle" while also being "Charlie's Mom."

As I just mentioned, I also started my contemporary art blog during these years. It was early 2009, and Charlie was not quite three. I needed a way to feel connected to other artists—not just the usual crew at our many Mom 'n' Tot groups. Very quickly, I found that the majority of my posts were about female artists, not consciously, but because I was so inspired by their subject matter, materials, color choices, and, most importantly, the effort they were clearly putting into their careers. I wanted to be them when I grew up! Wait, I was a grown-up. Time to dig a little deeper. I don't suppose these talented artists, whom I desperately wanted to emulate, were also mothers? Yes, so many of them were! And guess what? Not only were they making work, they were also showing in galleries, selling, and living a life as an artist. Hold on—had those movies, nosy relatives, and badly researched articles been wrong? Yep.

Here we are today, and my tiny baby is now a teenager who's taller than I am. Not only is it time to take him pants shopping—again—it's also high time we get rid of these ridiculous myths: Mothers cannot be artists. Your family will need all of your time and energy. You'll be much too busy for creativity. It's selfish to focus on your artwork. Nobody will take you seriously. Ugh. In hindsight, I wish I hadn't allowed any of those false statements into my head even for one second. Well, thanks to authors such as Marissa Huber and Heather Kirtland, there is now a book in the world that is changing the narrative. *The Motherhood of Art* shares the stories of artists who have made the decision to live a creative life, and to be a mother.

Is it easy to be a mother and an artist? Of course not. Is it worth it? Absolutely. (Just ask my mom.)

Introduction

Heather: "Jack is watching a movie in the car, so I can't listen to you on Bluetooth."

Marissa: "If you put your phone in your bra, it works if you forgot your headset. I do it all the time."

H: "Ah, you're a genius!"

M: "What did you get done in the studio today?"

H: "Well, I did manage maybe three fifteen-minute increments of painting between, fixing an unlimited amount of snacks, refereeing two fights, and cleaning a spilled box of cereal. The final fifteen minutes I think I just stared at the canvas. How was your day?"

M: "I feel like my brain is all over the place. Work was intense, traffic was bad, and I just need to lock myself in the studio to finish that commission—but I haven't seen my kids all day and feel guilty. I think I'll try not to fall asleep putting Henry to bed, and I can get to it then."

Can you relate? Then you're in the right place. **We know you love your family, but it's okay if you need something more.**

In 2009, Heather, desperate to find examples of artist mothers, googled "Artist Mothers.". The only thing she could find was stuff about famous artists' *actual mothers*. She was so frustrated.

Even before Marissa had her child, people were always saying, "Just you wait! You won't be able to _____ once he gets here!" Once she did become a mother, she was so stressed with full-time work, primary caregiving, and art commissions to help pay the bills, that she ended up passing out at work (scaring the crap out of everyone) and thinking maybe it wasn't possible.

Too often the everyday tasks of motherhood take over. I mean, we love these little people and want to do all the things for them, but then what's left for us? We feel like this all-too-familiar situation is compounded when you're a creative. As you nurture tiny humans, you feel like you have nothing left for your own artistic practice. When you're killing it in the studio, you're serving cereal for dinner and no one has clean underwear. All the while you're being told to find a balance (and now make time for self-care)!!! We don't know about you, but we're lucky if we can balance two things, let alone the literal laundry list of expectations that are put upon us.

We can dream all day about a white studio of solitude with a lock on the door, but really we just need a bit of time at the kitchen table to create.

We need space in our heads for the next great idea instead of scrambling to prep for whatever theme day it is at school *all* of next week. (Why?!)

And you know what? We are not alone. This book is full of examples of creative mothers making it work, their way. We want to show you it's possible, and give you permission to create a space for you.

In these interviews, these women share the most-vulnerable parts of their lives. These women have felt great joys, sorrows, frustration, failures, and everything in between. Some of these women stopped creating, and for some, the birth of their child led to the birth of their creative practice. You're going to laugh and maybe cry during some parts. If you're like us, there are some parts where you are going to raise your fist in the air and scream, "Yes!" Most importantly, we want you to see yourself in these remarkable women. Because we are ALL remarkable in our own unique way.

This book can be read front to back, five minutes at time while hiding from your family, or when you need to know that you are a part of a community. Every mom is an individual, and we hope that you can relate to at least one of these artists' unique experiences. These women are honest and candid. Most importantly, we don't want you to get lost in the trap of comparison but to find possibility within these pages.

We met in 2015, when Marissa interviewed Heather for a blog series *Carve Out Time for Art* to find out how artist mothers were finding ways

When you're killing it in the studio, you're serving cereal for dinner and no one has clean underwear.

to make time for their art. We connected because Heather confided that one of her dreams was to create a book like this. Marissa hadn't told anyone, but that was her dream too. After speaking on the phone for two minutes, we both knew that we were meant to do this together. We had a common passion to create a book that would be a comfort and resource to artist mothers.

Motivated by our conversation, we started a website (www.carveouttimeforart.com) and Instagram account (@Carveouttimeforart) to share these interviews. We could not have dreamed of what a phenomenal community it would become. We found our people, and this lit us up even more to keep going to help them. It was the constant encouragement of our followers and the many people we connected with that spurred us along to bring *The Motherhood of Art* to fruition.

We asked the questions that Marissa was hoping to put out into the world, and that Heather desperately needed to hear the answer to as a new mother. We want you to feel less alone in the messiness of this artistic life. We want to raise you up. We want our children to see what is possible.

We are here to tell you you're not alone. There is a motherhood of artists out there that you belong to.

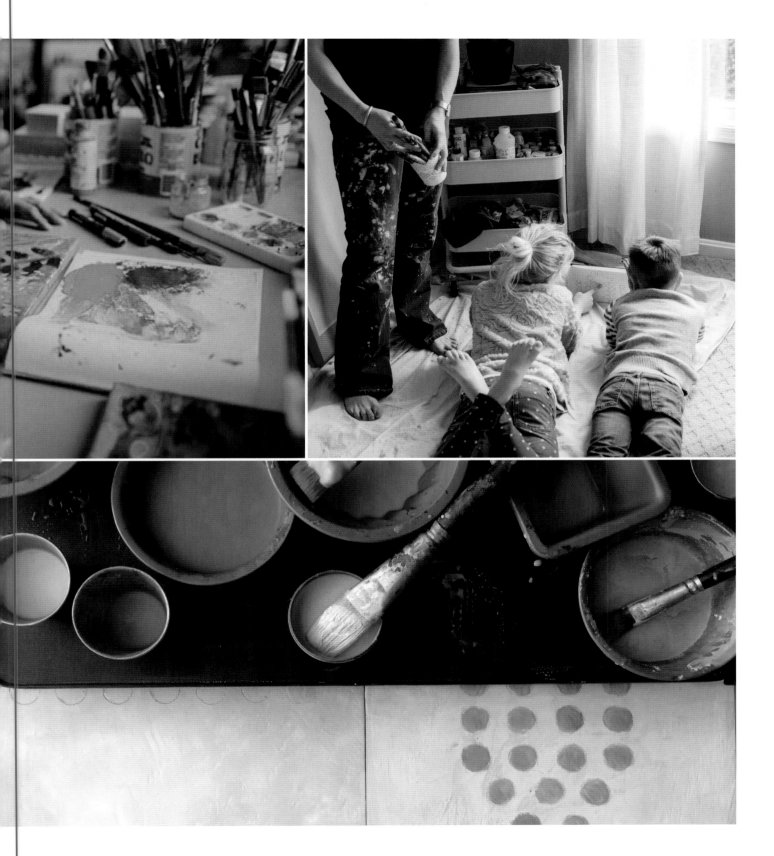

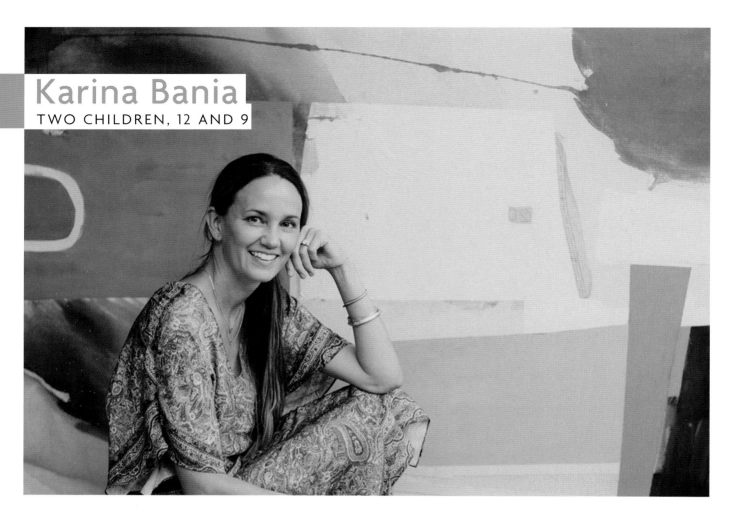

Karina Bania
TWO CHILDREN, 12 AND 9

Photograph by
Jamie Street

Why is it essential for you to create? What happens if you cannot have this time?

I've always had an intrinsic drive to create. I love bringing things to life—ideas, the aesthetics of a space, a piece of writing, a painting. As a child, I used to have long talks with my father about life and the theories of science. He was in awe of the innate creativity that exists in the universe. I was so struck by the thought that, from nothing, comes something. This line of thinking still fascinates me: clear mind ➔ idea ➔ execution ➔ formation ➔ creation. I believe that the evolutionary force of creation exists within us all; we just need to tap into it.

Although painting has always been my first love, there hasn't been a day when I am not creating in some form. I think that we tend to get stuck thinking that creativity has to look a certain way. If we expand our definition of what it means to create, then it will help us relax when time doesn't allow for creating in the way that we would like to. If we can see our whole life as a form of creative expression, we will feel fulfilled living every day.

What does creative exploration mean to you?

As I think about the process of creative exploration, it has two parts. The first part takes place in the world. It is the looking, thinking, and making connections between things that I'm drawn to. It's the unique way I see and translate images and ideas. For example, the lines of a mountain, the slant of light that hits the floor, the lingering feeling

after a good conversation, a few lines of poetry, or an unusual color combination can all spark a series of paintings. For me, these moments and noticing all translate into art. Back in the studio, creative exploration becomes "the space to meet myself." The studio is where the ideas and images that I absorbed mingle with possibility and are translated into something new. This is the space where there is an equal effort of thought and letting go in order for creating to happen.

What ideas or themes do you explore in your work?

I've always seen another world in things. When I look at something, I'm able to see it simply as shapes, movement, and color. My eyes can read a person or an image as a landscape. I ground the things I see and they become heavy in contrast to the energy that moves around them. Each painting begins as a field of space from which an environment will be created. As I begin to paint, a conversation ensues between emptiness and fullness, stillness and movement.

My work centers on the visible and invisible landscapes of place and connection. When I look around, the air in front of me appears empty, but it actually holds things we don't see—unspoken words, the energy from a conversation, glances exchanged between people, feelings unexpressed. The things that linger and are felt. In my paintings, I try to capture this unspoken world that lives in the spaces between us. Echoes of past conversations live between the lines of the mountains; imperfections drift with the movements of the sea. I pay close attention to objects in life but also represent the spaces from which they come.

> I've always believed that the objects in our homes become part of our family.

When did you learn your craft? Do you have a strong memory about this?

I grew up in a house filled with art. My parents collected paintings and sculptures from the places they lived around the world. Some of my first memories were standing in front of huge paintings trying to see forms in the abstraction. I began painting very young. Each week I went to an art class at a studio where I was the only child surrounded by adults. I remember so well the smell of linseed oil, the slanted afternoon light, and the hum of adult conversations; I loved it.

I continued painting on and off throughout my adolescence and, after college, began traveling and living abroad for many years. I studied art on the road, in small studios, and from people I met throughout Europe, India, Sri Lanka, and Asia. When I returned home, I worked in a number of creative jobs, while painting on the side. More and more, I began by selling my work through art shows, local shops, and galleries, and online, giving me the wonderful painting career that I have today.

Both of my parents have now passed, but their collection of art, curated and infused with their spirit, lives on. I've always believed that the objects in our homes become part of our family. The legacy my parents gave me through their collection and by encouraging me to follow my passion for art is one that I hope I can give to others through my work.

What does your process look like?

My artistic process involves a mix of intuition, discipline, inspiration, and structure. When I begin a painting, I try to clear my mind. Ideas come to the surface when my mind is free with space to settle. I usually begin by making marks on the canvas, sometimes following an idea or just being free. With every mark, I move my way further into

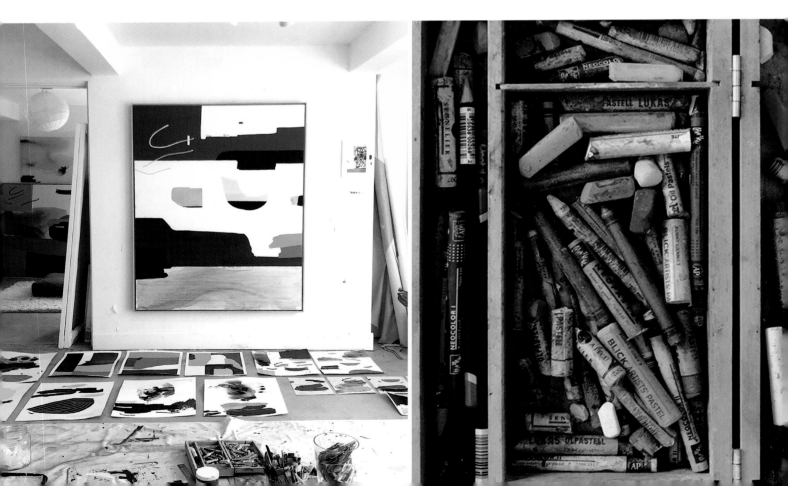

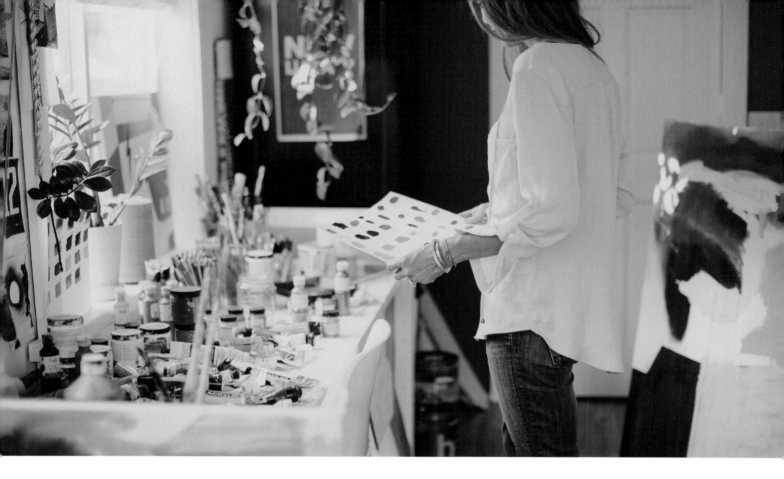

the painting, wandering its landscape and developing a sense of connection with it. Working from intuition, response, and presence, the painting begins to take shape. I am following a thread of movements that lead me to the next one. Sometimes a painting doesn't feel complete until one small mark is added. Often it is something that no one necessarily notices, but for me it brings a sense of balance and completion.

I usually work on two to three pieces at a time. I create in series, meaning that there is usually a unifying idea or feeling that is connecting a body of work. I have inspiration boards around my studio, which I curate with each changing collection. The images, words, and groupings serve as color and mood inspiration. I always have playlists of music that I work to. I listen to the same music over and over so it serves as a familiar backdrop to the unfamiliar place that I am going with a painting. It becomes grounding and meditative.

Paintings are always hanging around the studio in various states of completeness. I can't rush things that need to ruminate. Paintings need time to settle into themselves, and I need time to coax things out of them. Returning to paintings after a few days usually brings new inspiration that really deepens the work.

One of the most interesting things about the artistic process is the amount of not-making-art time that goes into art making. As an artist, I need to spend time looking, staring, squinting, blurring my eyes, standing back, and walking in to help me visualize and see what I'm creating. This contemplative time is essential to the process.

What does self-care look like to you?
A few years ago I came across this quote by Annie Dillard that says, "How we spend our days is, of course, how we spend our lives." Time passes so quickly, so I try to take time every day to slow

> One of the things that I do is to stay focused on my own improvement by comparing myself to myself.

down, be present, and do something I love. This "something" is nothing grand, just daily moments to myself outside work, family, and obligations. Reading, walking, thinking, talking, and looking. Or in other words, absorbing, engaging, reigniting, replenishing, and being. A few moments, every day, eventually fills a life.

How do you keep from comparing yourself to others?

Everyday I'm flooded with hundreds of images and opportunities to get lost in comparison. One of the things that I do is to stay focused on my own improvement by comparing myself to myself. "How am I doing today? Am I spending time on the things I feel passionate about? Am I moving in the direction I want to go?" Over the years I've learned that we all have our own pace and process.

When we compare ourselves to others, we get lost in our image of their idealized lives, which takes us out of our own life. So I've learned to seek connection, not comparison. I develop friendships and have meaningful conversations. Instead of comparing, I try to look for what it's inspiring me to do. I use it as a tool to better know myself. We're a collective. When one rises, we all rise. Believe this and comparison will fall away.

Do you compartmentalize your life and roles?

As L. P. Jacks said in *Education through Recreation*, "A master in the art of living draws no sharp distinction between his work and his play; his labor and his leisure; his mind and his body; his education and his recreation. He hardly knows which is which. He simply pursues his vision of excellence through whatever he is doing, and leaves others to determine whether he is working or playing. To himself, he always appears to be doing both."

Whether I'm in the studio making art, parenting and running my home, or out in the world, everything I do is connected. There is an intangible

quality of life that I'm always seeking to express. I have an unending desire to infuse life with creativity and beauty. I want to relax and be real in the things that I do and the people and places with whom I spend my time. I feel like if we expand our idea of what constitutes creative expression, we can see that creativity is what ties all of life together. Everything we do can express our inner nature. When I'm able to see life in this way, roles blur, duties lighten, and moving through life becomes art.

What do you want to pass on to another mother?

About a year ago my mother passed away, and a few years before that, I lost my father. Being with them in their last days, I learned how clearly simple moments and time spent with family are what we remember and hold on to in the end. These experiences with my parents put my life and priorities into perspective. I try to spend a lot of time unplugged and engaged with my children and friends and in my life. I don't always get as much work done as I might like, but I have learned to become very selective and choose projects that are meaningful.

I also value being alone and doing things just for me. Giving to myself makes me better able to give to others. Life is so precious, and it's so easy to get swept up with things that don't really matter in the end. I live what I can live; I do what I can do. I remember and I forget. I move forward and I stand incredibly still. Sometimes living feels like nothing more than just being present. Which in a life, I guess, means everything.

What do your kids teach you about life and yourself?

Becoming a parent put me in touch with the feeling of living for something greater than myself. It gave me the opportunity to determine the person I want to be in their eyes and the legacy I want to leave.

Raising children is like holding a mirror up to the best and worst parts of yourself. Every moment reflects the areas where I need to grow. Some of my favorites are learning to gracefully admit when I'm wrong, the need for laughter every day, not worrying about what people think, being authentic, maintaining curiosity, and being present. Parents are always so focused on teaching our children, but honestly, they are our greatest teachers.

What do you want to teach to your children?

My hope is to raise passionate, curious, independent, creative beings that pursue the things they love. I want to teach my children to ask questions, to wonder, to never stop learning. I want them to dig into life, to fall, to fail, and to get up again. If they learn that life is punctuated by messy, joyful moments, with spontaneous singing, stories, laughter, and love, then I feel like I've really done my job.

How does being an artist influence you as a mother?

Art making and life making aren't about the finished product. They're about creating and living, which are active practices. Much like art, life and parenting are a string of moments full of change, movement, indecision, and revision. As an artist and a mother, I work a lot through intuition. I feel my way into situations and decisions. Creative thinking fuels both. My creativity soared after having children, and they have given me the focus and motivation that has driven my career.

How have your studio practice and art changed over time? Especially before and after children.

I'd been painting consistently for a few years before having my first daughter. After she was born, I felt a surge of inspiration and creativity. I became much

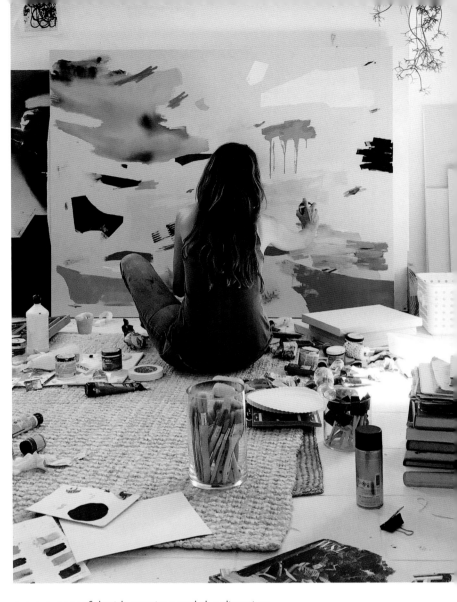

more purposeful with my time and the direction of my art. I knew that raising the girls was going to be my primary focus, so I needed to find a way to fit my passion and career into that.

One of the biggest changes since having children has been the limited hours to create. I'll be in the middle of a piece, inspired and in the zone, and I'll have to walk away to focus on family life. I think that as mothers, we are always adjusting to the changing daily demands and needs of our children. Creativity doesn't always fall into schedule, and yet, raising children requires one. Learning and accepting the contrast between structure and fluidity has helped me both in parenting and in creating art.

As an artist and a mother, I work a lot through intuition. I feel my way into situations and decisions.

What has one of your biggest struggles been as an artist? As a mother?

One of the greatest challenges for me both as an artist and a mother has been the loss of personal time for reflection. Life is so busy, and time in the studio to sit and stare or time alone to think is limited. Many times, I just have to keep going. But on the flip side, one of the greatest benefits has been the loss of time for perfectionism. Not everything is a masterpiece. My parenting grows through missteps and lessons learned along the way. Work gets completed, the kids grow and thrive, and I reflect when I can.

How do you deal with periods of no time to create or make things?

There are always going to be times when my priorities shift and I am not creating. Since becoming a mother I have learned to be content with small steps, knowing that great distances are made from them.

When I'm not in the studio painting, I work a lot in my mind. I mentally sketch out shapes and colors and store stacks of imagined ideas. For me, half the work of a painting takes place when the brush is not touching the canvas. So in this void, my imagination stores ideas that I will later create on the canvas. Another thing that I try not to do is compare myself to others. Everyone has their own trajectory. Mine might be slower because I have children and different things that are important to me, but if I continue moving forward and living the life I want, I will accomplish the things I dream of.

What helps you through creative slumps or times when life is full?

Life moves unevenly. We ebb and flow with changes. There are periods of creative abundance and times when I experience creative slumps or periods of dormancy. In my art practice, I don't paint every day. Sometimes my family takes priority or I need to express myself in different ways. Like nature, I feel that there are cycles in creativity. Periods when things are abundant and times when dormancy lays the foundation for new growth to come. For me, understanding this cycle helps me relax when I'm feeling creatively empty.

When I need inspiration, I often go somewhere new. Experiencing new places, images, or ideas jump-starts my mind. Nature and solitude are also very important. When my mind is singularly focused in the moment, ideas come to the surface and the cycle of creating begins again.

Describe what the feeling of flow is to you. What does it mean to you?

There are moments in life when everything aligns. Time falls away and I'm engulfed in the flow of the moment. This usually occurs when my inner and outer worlds are in harmony. When I look around and see beauty, ease, and inspiration, I'm able to feel that within and then live or create from that place. That same energy, in the form of paintings, words, or actions, then flows back out into the world again. To me, this is being in the flow.

How do you find your artistic voice?

My voice as an artist is shaped simultaneously on the canvas and off. There are things that I notice in life, things that I'm drawn to, and ideas I'm curious about. Over time, my mind creates a blending of these inspirations and influences, which develop into my unique perspective and expression.

When I paint, I'm taking these experiences and communicating them visually. The more time I spend painting, new connections develop, understanding deepens, and patterns emerge. It's exciting to uncover meaning in my work. Over the years I create a visual language that grows and deepens into the voice I speak today. ▪

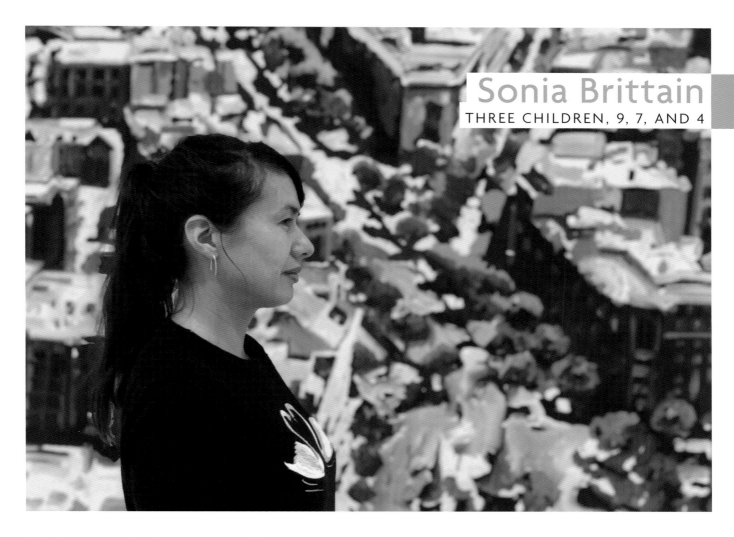

Sonia Brittain

THREE CHILDREN, 9, 7, AND 4

Why is it essential for you to create? What happens if you can't have this time?

Looking back, I can see I have always had a desire to create. I spent hours of my childhood drawing and painting; it probably helped I was an only child for nine years, so I had a lot of time by myself to fill. Even when I decided to enter medical school, I still put a lot of time into making the prettiest and most-colorful study notes I could, and tried to occasionally make time for drawing classes and art gallery visits.

As I've gotten older, and with having a family, I have become more honest with myself about how important being creative is. In the past I thought I should allow myself to do it only when I had done all the other tasks, the jobs on my list. However, now I know I am a happier, more mentally stable person if I make time to draw for me, even just five minutes a day. I view it like meditation, because when I'm drawing and painting I totally get into a flow state, and even if the piece doesn't go as I had envisioned, I get something out of the process. I have had days when stuff happens (e.g., the kids get sick), and you really don't have time to draw or paint, but I remind myself I can pick it up again when I have time, and even a bit of doodling/ marking in bed or at the breakfast table can help me relax. Just like if I don't exercise I can get grumpy or more irritable, if I don't draw or paint for a bit I can end up feeling a little out of sorts.

Oddly enough, becoming a mother has made me much more productive artwise than I have ever been before.

So what I have
found is that
it is okay to
change.
Who I was at
eighteen is
not who I
am now.

**Did you think you would need to stop
making work once you became a mother?**
Oddly enough, becoming a mother has made me
much more productive artwise than I have ever
been before. After childhood and before having
a family, I believed you were either a professional
artist or you did it as a hobby. As a doctor in
London, that meant it fell to the wayside.

In my late twenties I started rethinking how I
could make art again, especially as I was experi-
encing fertility issues and thinking how I wanted
my life to be if I didn't have children. Stress was
obviously a factor, as after taking a sabbatical I
got pregnant quickly and had two boys with only
eighteen months between them. With such a
close age gap between them, I was pretty con-
sumed in adapting and coping with motherhood.
Again I put art on the back burner. Thus I really
do understand how, for some mums, having chil-
dren may mean a temporary hiatus in their creative

work. I did sketch a little when they were small,
but it was just quick sketches of them napping.
Yet, it was more drawing than I had done when I
was a doctor revising for postgrad exams!

I also think no one should make a judgment
on another mother's ability to carry on with
creative pursuits, because everyone's circum-
stances/environments/children are so different.
My oldest child was pretty spirited and full of
energy, and then having another child so close
in age, and living in London, meant that period
of motherhood was intense, and I was out running
them about to parks and going to stay-and-play
groups as much as possible. Yet, it was so different
with my third child. We had moved to Switzerland,
through my husband's work; the older boys were
at school, and my third baby was pretty easygoing.
Being more socially isolated and having a regular
nap schedule meant I suddenly had time to make

art, and I made the most of it.

I started a drawing-a-day project in 2014, when my youngest was about nine months old, and after completing the year I have continued, essentially, to make art every day—so in this phase of motherhood I have actually made more art than I ever have before.

Do you come from a creative family? Was there support in your endeavors?

I think at some point we have to take responsibility for allowing ourselves to do the things we want to do. In some ways my family is creative. My grandma was hugely creative; she painted, knitted, baked, had many hobbies. My dad was a design and technology teacher, and I think he is a great draftsman. However, while it was acceptable for me to draw and paint in childhood, I began to realize a career in art was viewed as particularly risky, and I felt it wasn't strongly encouraged even though I "was good at art."

At my school, academics were prized, and in hindsight I wanted security. I really appreciate all that my family has done for me, and they have given me so much support in many areas of my life. However, I realized that it is okay that they don't share my interest in the sort of drawing and painting I do.

It was freeing creating art primarily for myself and sharing it on Instagram with a community of others with the same interests. None of my family or friends were on there, so I didn't worry about being judged or feeling that "they are thinking I am wasting my time and I should be doing something more useful or getting a proper job." Honestly, they probably wouldn't be thinking that, but our internal voices can be pretty harsh at times. So what I have found is that it is okay to change. Who I was at eighteen is not who I am now. Having a creative family would be great, but also having family who have their own hobbies and interests, and aren't that into art, is pretty fantastic too.

How do you know when to share something and when to keep it private?

It seems funny how I've gone from keeping my art much to myself, to now sharing it unashamedly on the internet. Knowing when to share something is a personal response and looks different to everybody. I admire people who are able to share without worrying too much, because I think honesty and vulnerability are good. It helps connect people who are going through similar things.

I try to share all parts of my art making, including the sketchbooks, paintings, and progress videos. I hope to connect and inspire similar people who have a drive to create art and want to see how far they can take it. In many ways I am fairly introverted and like to keep some thoughts to myself. When it comes to personal matters, it naturally affects my art. I often don't feel comfortable sharing things that are too personal, especially related to the kids. One day, how they want to share their lives will be up to them. While I'm happy to talk about it and joke about common issues in family life, I'm not going to go into serious issues online (and we do have our share of challenges). I also don't have a problem going offline, hibernating a bit, and I understand why others need time-out also.

Do you have moments of resentment or longing for freedom?

Truthfully, yes. I think there is a general conception that if you are a perfect mother, you won't feel resentment and will want to keep your children near you as long as possible. And I do get that some people may not be able to have children, and it can look bad to not appear grateful for them, but motherhood is really hard. Not for everyone; I get that some people may sail through it. Not everyone is going to relate to those who have feelings of resentment. However, I had times when I was so worn down caring for young babies or when the kids were playing up that I did long to escape for

It seems funny how I've gone from keeping my art much to myself, to now sharing it unashamedly on the internet.

a while and felt like I was losing myself.

Living in Switzerland with no family or friends near and my husband traveling a lot was hard initially. In hindsight I may have been slightly depressed at times. I knew in a lot of ways we were lucky, but I definitely had that overtired zombie feeling. I think that is why I started a drawing project, because it was a form of escape, or a feeling of control that arose from being able to draw something how I wanted to. It didn't move or get dirtied and thrown around for you to tidy or pick up! Things have really changed in that respect, as the kids are older and sleep better and therefore I sleep better! I do get where mums of babies and toddlers are coming from, and can empathize with the feeling of being trapped, as it may just be you responsible for your kids 24/7. When I was a doctor in the first few years of this century, the longest on call I did was twenty-four hours straight, but then I'd get the next day off. There is often no next day "off" in motherhood.

Why do you think so many mothers express that they're not good enough? How can we support each other and shift this?

While we are lucky to live in the times we do in many ways (medical care, sanitation, education, etc.), it is also a time of so much knowledge and information that there do seem to be more expectations placed on parents. Parenting is now a complex matter with so many different schools of thought on how to raise children (often contradictory). Everyone has their opinion on how to bring up children, from food choices to screen time to eduction styles. If your child has mental health problems, there are opinions on medicating or not medicating, and it can feel impossible to get anything right. So it is no wonder, even if we are not aiming for perfection, that just being good enough can seem a distant goal.

I think the reality is every mother is trying her best. Maybe if it's all falling apart that is because she or her family are facing struggles and challenges, not because it's her aim to be a bad mother. Life isn't black and white. There are so many differences in family circumstances, personalities, and issues. I think it is important to remember we are all doing the best we can while being open and understanding of how difficult it can be to parent in this modern age.

Do you experience guilt as a mother?

For sure, from time to time. I think it is easy to get wrapped up in "shoulds." I should be doing this or that, because that is what other mums who seem to have it sussed are doing. When your kids are having problems, it is easy to take it to heart and feel responsible for sorting everything out. To get a sense of perspective, to let your children separate and be their own people, can be hard.

Truthfully, mothering has not turned out to be how I thought it would be. In some ways it has been so much more challenging, but in some ways it has been really good for me, having to let go of control at times. Dealing with the tricky times has made me appreciate the golden family times more and celebrate when everyone is contented. We have had to deal with some family issues recently, and it is hard not to feel really guilty, or let it get you down. Deep down I know that come what may, I have tried my best. This is what I tell my boys to do, so I should not be so hard on myself for doing just that.

How do you handle people in your life who criticize or diminish your creative pursuits?

When I was younger I was a bit of a people pleaser. I worried that people would belittle my art, so I kept a lot of it to myself. The great thing about getting older is I really don't give a ____ (insert your favorite curse word) on certain matters. Life

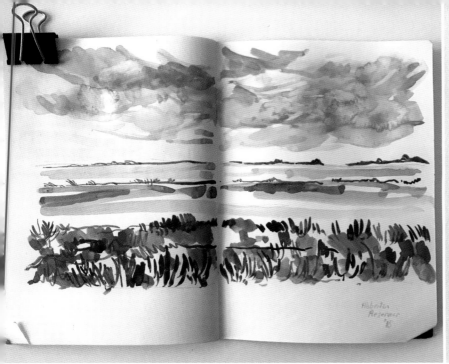

is too short to let people bring you down over something that brings many people hope and joy.

It is sad if people feel the need to criticize someone for making art. My husband wisely says it is easy to criticize rather than look for the good and be constructive. I do get that someone may be trying to be helpful, but I don't expect everyone to like or care about what I do. I am at the stage where if you want to talk to me about my work, then do. But I don't need to justify what I am doing with my time anymore. I know my priority is my family with the kids still young. But I also want to do things just for me.

I know now to take care with whom I share my dreams and passions with. I assume all the people included in this book or reading it are going to be on the same wavelength, and in many aspects it is lovely to know I am not alone.

What has your role as a mother taught you about yourself?

I would say that thanks to being a mother to three boys, I am pretty optimistic. I've had to be more relaxed about tree climbing and other hijinks. When I'm exasperated, I ask myself frequently,"Will

they still be doing this when they are thirty?" Being a mother has taught me that I am not as patient as I thought I was, and why was it so much easier to keep my cool at work? Yet, my kids know how to press my buttons. I do hope it has made me more understanding and forgiving, though.

What do your kids teach you about life and yourself?

Not to make judgments about people, that just because I found school easy and breezed my way through, school is not always the best experience for everyone. Different aspects of life are challenging for different people, and it has made me even more of a supporter for the misfits and underdogs. It has taught me to rebel a bit, to make the most of the good times, that sometimes things are just what they are, and to try to accept them as best I can.

I love how young children can get pleasure from the here and now, how they laugh so freely. With three boys I have learnt how to be patient about toilet training; one day they will surely master peeing with the seat up. I love how creative they are, and happy to give things a go.

Has becoming a mother changed what you want to do with your work?

It has made me aware of what I can or cannot do as a mother. I can love them unconditionally, but I can't and shouldn't control them. I don't want to end up living life through them or putting pressure on them to do things I wanted. I want to show them it is important to commit to what you are passionate about, and give it your best go so you don't regret it. At some level, you have to not give a f**k and create. The process and joy of making marks on paper give you a sense of who you are, and nobody can take that away from you.

I now want to see where I can take my work. I like to push myself and recently started drawing couples' portraits. This has helped me develop a style in pen and watercolor. I also love painting florals and would like to look at creating patterns. Another change that has come about through having children and drawing them so much over the years is that while I still love drawing realistically, I feel more able to experiment and be freer in my interpretation of a subject. Maybe being pressed for time means I have to work more quickly and loosen up.

Describe how you find ways to make work and keep at it through changing seasons of life.

Committing to daily drawing in 2014 helped me get into the habit of allowing myself to do a bit of art everyday. It showed me how even in five minutes, I could fill a sketchbook page, and it kept me motivated. By drawing every day, I could improve and visualize this as the sketchbooks built up and I became quicker. Prior to this, my art making was pushed to the sidelines for studying or prioritizing reading and socializing as my hobbies outside work.

Being at home as a mother helped because I really appreciate my free time so want to make it count. However, it is important to go easy on yourself. There is no way I could have committed to a drawing project when my first two were toddlers, as it was too frenetic. I also appreciate there will be times when you decide not to make art that day, and that's okay.

Share your tips on finding time to create when you have children.

Creating art in naptimes was key when my third child was a baby. I tried to be organized and do chores during the first sleep, then kept the longer lunchtime nap for making art. When he outgrew naps and was still home with me full time, that was more challenging, plus we were also staying temporarily with my parents between moving from Switzerland to the USA. Then I had to get up early, do a quick painting in the morning, or sketch in the garden if they were all playing. At night in bed when they were all asleep was also a good time to play around in my sketchbook, and often I might draw the children or doodle.

Now things have changed again as my youngest has started preschool three mornings a week, so during term time this is bliss, as once I have done chores and errands I am really strict about making sure I get time to make art. It has been great to make another artist mum friend and sometimes draw together over coffee. I am also exploring selling my art, as I finally have the time and space to work on finished pieces and have started getting out of just working in a sketchbook. Holiday time I just accept it will be chaotic at times, but I can generally find a small window in the day to either do a quick sketch when we are out and about, or paint alongside them. Sometimes I sketch at the kitchen table while cooking, which does maybe lead to slight overcooking, or a late tea!

What helps you through creative slumps or times when life is full?

I think getting back to basics helps during creative slumps. Often just the act of starting with a sketch even when I don't feel like it helps me see other possibilities. I might allow myself to paint the things I know make me happy—florals, patterns, abstracts, the type of art where I can loosen up and don't have to focus too much. Sometimes the best sketches come from what I thought was going to be rubbish, and had no great expectations other than doing a sketch. Other times, life may be so full that I learnt to ease up and do something totally different or make time for my hobbies like running, reading, and looking through cookbooks.

Getting exercise and running is super important for me, as it definitely helps my mood and gives me the energy to cope and run around with the kids. Plus, a lot of my creative ideas or desire to draw and paint will come to me while out on a run, or while reading a good book. I experienced burnout in my previous career as a psychiatrist, and it was not fun. I think it is important to realize you have limits and to allow yourself to switch off, and rest up when you can.

What is something in your life that you never thought you'd accomplish but did?

Okay, so not art, but coming in third woman in one of the 5 km park runs in my home town in Colchester Essex last year was a highlight for me, as I was so not sporty at school. Especially when compared to my dad and brother, who were good at rugby and running, and I think it slightly surprised them. I also completed a half marathon in a pretty decent time for me last year. I think it has shown me it is never too late to have a go at something, and while I'm never going to be the fastest runner, I really enjoy running. It has helped me make new friends through joining a local community running group.

It is a similar ethos with the art. I wasn't sure I would make it through a year of drawing every

day and sharing my art on Instagram, but I did. Through it, I have a nice little online art community and friends, have been asked to write about my art, and recently have opened online shops and made a few sales through my portrait project. It is a really nice feeling to know that my artwork could be bringing pleasure to someone in their home. I have so many ideas and things I would like to explore with my art; I probably need to be a bit more focused as I can jump from idea to idea and get distracted. ■

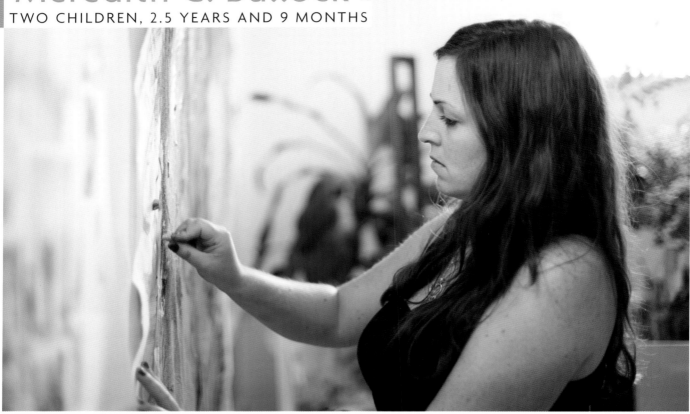

Meredith C. Bullock

TWO CHILDREN, 2.5 YEARS AND 9 MONTHS

Photographs by
Amy Hobbs

What does creative exploration mean to you? What does it look like to you?
Creativity is an expression that is fluid for me. Sometimes it comes out as paintings, other times it comes out through storytelling/writing, and other times through how I arrange my home. I never feel the need to be loyal to a specific medium, because I feel creativity itself isn't tangible or predictable. The more I allow creativity to move through me and into each thing I do, the more I feel I'm utilizing its potential.

What ideas or themes do you explore in your work?
The past few years my work has been heavily influenced by becoming a mother and losing my mother. I tend to work through unresolved issues, questions, and pain when I paint. It's as if I need answers and the only way I'm going to get them is through painting.

What was the first thing you remember making after having your first child?
One of the first paintings I approached after having my first son was a large white canvas with black ink. I had my son wrapped onto me while I expressed my frustrations of becoming a mother. I recall rapidly applying black ink markings on a large white canvas while wondering how long it would be before he wasn't content.

This painting ended up being a pivot point for me because it proved to me that even five

minutes of painting was enough to start something bigger. I wanted to be reminded of this simple truth, so when I finished the piece I kept it and I display it in my kitchen. It's titled *Balance*.

How do you know when it's time to switch it up?

I like to think of everything (life, parenting, creating, our home) in systems. So when I implement a system into my creative routine and begin to see positive effects, I keep it. When that same system no longer serves me, I adjust. A really great system that has been working for me with painting is premixing paints and then storing them in airtight containers. This helps make the painting process quicker and easier to jump into. The fewer obstacles to get painting, the better. Before I start a project or a body of work, I'll identify the colors and mix them in their own separate jars.

Were you self-taught? What did that look like?

I'm self-taught. But I owe a lot of creative encouragement, and the seeds to pursue a love for making art, to my high school art teacher. He was a fantastic teacher, had us paint while listening to a band I never heard of until then (Cake), and would always give objective critiques that pushed our/my skill. I liked how free I could be in art class, and ended up trading all of my study halls for art classes. I spent most of my free time in his classroom. Even though it took many years after graduating high school to pursue my creative passions, it was his influence (and a brief semester in a community college) that solidified I could do what I loved without a degree.

What do you want to tell to future generations of women?

It doesn't matter how many followers you have, how nice your website is, what your artwork looks like, or what materials you use to create it. What matters

is what the creative process does for you. Does it help you uncover buried feelings? Does it help you have conversation with your community? Does it help you beautify spaces? Does it help bring you closer to God? Does it help you feel peaceful?

What does self-care look like to you?

To be honest, I had no idea what self-care really meant to and for me until a few months ago, when I chose to pause my art business to focus primarily on caring for my two children. I can now say that self-care, for me, is much, much more than a pedicure and a face mask. It's knowing what your body needs and making it a priority. It's asking for

The fewer obstacles to get painting, the better.

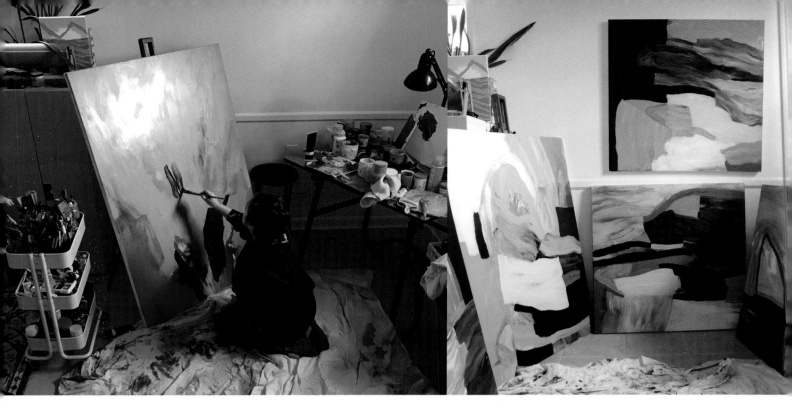

Before, I would paint for hours with less pressure and, honestly, less intention.

help when you need it. It's saying no to commitments when I already have way too much on my plate. It's creating boundaries between work, family, and friends. It's creating anchors that ground me and give me stability when I feel like I'm in survival mode. It's building in rituals of self-care that make me feel good, allow me to reflect, provide solitude, and encourage self-growth and peace. Which, ultimately, helps me and everyone around me.

Was there a time when you couldn't see a way to make things work?

Through many moments of distress and self-pity, I've found that challenging myself to meet very specific goals always helps me overcome slumps or that feeling that things weren't working. The concept of the 100-day challenge taught me to create (and share it) even if I wasn't feeling it. A self-created challenge of running for twenty-one days taught me I could. A yoga studio taught me that I couldn't attend a yoga class more than three times per week for an entire month (but at least I tried). A self-created challenge of painting and

posting my art for sale on Instagram taught me that pricing my art and selling it on Instagram wasn't as scary as I made it up in my head to be. A fourteen-week challenge to exercise three times per week held me accountable and allowed me to achieve my goal.

Why do you think so many mothers express that they're not good enough? How can we support each other and shift this?

I believe mothers say this because they don't truly know if they are [good enough]. Believing in ourselves and knowing we are worthy of success, beauty, goodness, love—fill in the blank—is something we must first cultivate within. To do that we must believe there is something bigger than us. For me, surrendering to God allows me to lean in to what His plan is.

If I know I'm living the life I'm called to, then self-doubt can't survive. When it does—when self-doubt is very present—then I know my judgment is off. When that happens, I pull back and make time for meditation, prayer, writing,

and reflection. Then, when I feel aligned with God's love, I begin again. I've coached many artists through the years and found that the artists who felt the most supported, worthy, and good enough were the ones that had support and encouragement from loved ones.

If you do have an issue with a loved one not believing in you or your work, let them know how valuable their support and encouragement are to you. Help them understand what your art and the process of creating mean to you. If you don't have family or ones that support you, or if you just want all of the support you can get, online communities (Facebook groups, Instagram— like COTFA) and coaches are great for that! I want you to know that no matter what art you create, how you create, or why, you are good enough, you are worthy, and I believe in you.

What has your role as a mother taught you about yourself?

Being a mother has taught me so many things! To name a few: how much impact I can have. For example, if I'm in a snippy mood, unfortunately, I unintentionally influence my kids to be in one too. Another lesson is how much better my life feels and functions when a solid routine is in place. I learned about creating a routine several years ago (before kids), when I became self-employed. But I never had it down to systems and rituals. Now, each day unfolds with predictable anchors, so that when things are unpredictable (like they often are as a mother) it doesn't throw off our day. We're always adjusting as the kids grow and we learn what works and what doesn't.

Did you experience a sense of loss or grief for the life you had before you became a mother?

YES! I was overly positive that life would remain the same and that the only thing different would be a kid in tow. I knew there would be naps and adjustments, and I would be tired. But I never predicted I would feel like a zombie for almost a

Another lesson is how much better my life feels and functions when a solid routine is in place.

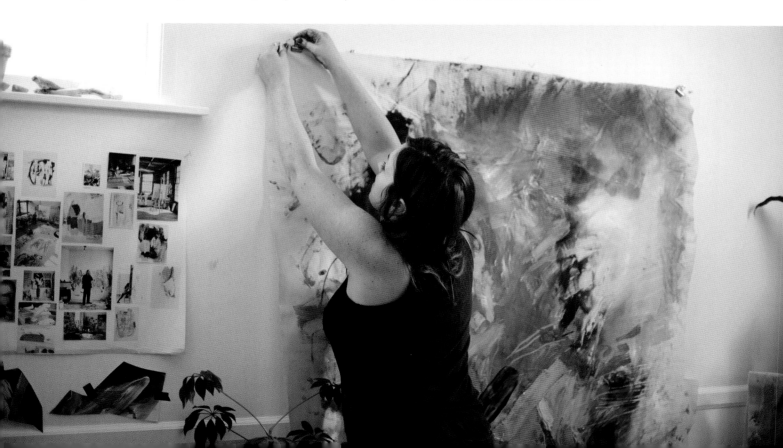

mother—and, second, the time frames in which I paint. Because I have limited time (naptimes, a few nanny hours here or there, or after the kids are sleeping), my process is more condensed and intentional. Before, I would paint for hours with less pressure and, honestly, less intention. Now, I plan things out much more in advance. I identify the color palette, poems or words, images, and overall mood and vision of the painting before I step foot in the studio. Then I mix paint in airtight jars and begin painting.

How have your studio practice and art changed over time? Especially before and after children.

When I first started to paint, I painted in my apartment kitchen and had to break out my supplies each time. Because of that, I believe, I painted much smaller. At my next apartment, I had a designated room that I would use as my studio, and that changed everything! I was painting bigger and no longer had to put things away or feel the need to clean up each time. Today, I have a large studio in our home that I've painted my largest paintings in, to date. I absolutely believe there is no coincidence there. Larger studio = larger paintings.

When was a time you felt like giving up? How did you get through this?

I actually did give up several years ago. I was unsure of how to make money creating art, and desperate to find a way to quit my day job as a hairstylist. The amount of money I made with my art only supported and couldn't replace my salon job. I found a few other creative business endeavors that did allow me to quit my job. It took several years and a moment of clarity (I was pregnant with my son Noah) to eventually find my way back to art. ■

> I say this lovingly now, but after my firstborn I grieved my old life.

year postbaby or that we would have to sacrifice so much in order to create the life we want with and for our kids.

I say this lovingly now, but after my firstborn I grieved my old life. There were several months that I internally blamed my son, my husband, and the circumstances for why I wasn't painting anymore or able to sleep or to get out of the house kid-free. But when I stopped fighting it and leaned into the life of motherhood, with the help from God, I was able to enjoy each day, with its sacrifices and lack of sleep, more fully.

Have there been shifts in your work related to your role as a mother?

Yes, definitely. My art is an abstract reflection and expression of my life. So becoming a mother completely changed me and my life. It was only natural for my art to change as well. Two ways it has shifted are, first, in the subject matter—I paint a lot about the struggles of becoming a

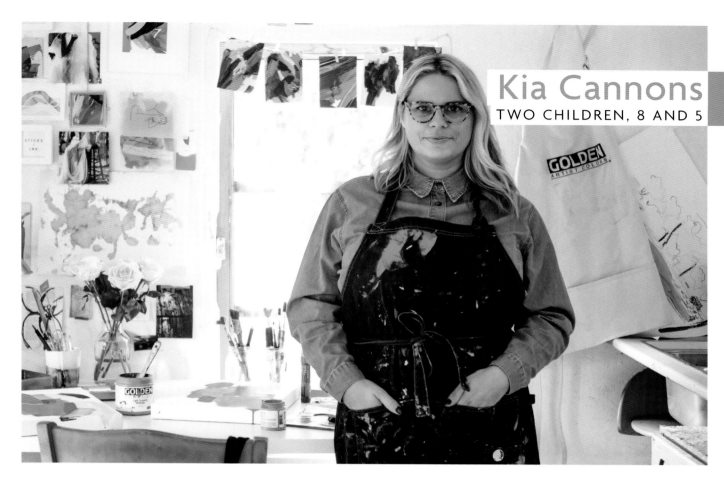

Kia Cannons
TWO CHILDREN, 8 AND 5

Was there a time when you thought you were not meant to make work?

Oh yes. When I was about twelve years old, we had to pick our exam subjects at school. I wanted to choose art, but the art teacher told me I wasn't allowed, as I couldn't draw. I absolutely believed I couldn't do anything arty until I was in my late thirties, when thankfully I realized I could give myself permission.

What are you not working on that you wish you were?

I would love to paint bigger. My studio is too small, but superlarge canvases are what I feel I'm meant to paint!

Were you self-taught?

I attended a weekly messy drawing class for a little while and picked up my love for hot-wax batik there, but I've not been taught painting in any capacity. Once I realized it was painting I was drawn to, I simply bought the art materials I was drawn to—I would figure out how to use them later. I then just played with them in pockets throughout the week when my oldest was at school and my youngest was napping.

The first year felt endlessly frustrating; I was desperate for someone to tell me how to paint, but so many fellow artists would tell me they envied my free approach—and they believed it was partly because I had no teacher's voice in my head telling me I was breaking the rules or doing it wrong. Being self-taught is a satisfying experience in the end, just super challenging to begin with.

Photographs by
Jay McLaughlin

Being self-taught is a satisfying experience in the end, just super challenging to begin with.

33

What do you want to tell to future generations of women?

Listen to your instinct. Do what you love. Ask for people's experience if that helps, but overall follow your gut and do what feels right to you. Life is short; live your life the exact way you want to.

Do you have moments of resentment or longing for freedom?

Not very often anymore. I did have to work through a few feelings of frustration, as my business suddenly began to take off and I couldn't say yes to all of the opportunities I wanted to, because my husband commutes to work so basically isn't around Monday through Friday, so it's down to me to do all the school runs and looking after our boys.

However, I have always seen motherhood as freedom, so it only took looking at what I have and what my priorities are (spending high-quality time with my children) to see that I wasn't really missing out. Being able to wake up and decide what I do with my day is my version of freedom. I felt that the moment I became a mum, and still do.

> You will get your sense of self back. However, it's likely no one will give you permission or help.

How do you keep from comparing yourself to others?

By reminding myself that comparison is the thief of joy, and by being grateful for the gifts I've been given. When you accept who you are and learn to love yourself, learn that your journey is your journey alone, then there's not much that can make you feel inferior to others.

Do you compartmentalize your life and roles?

Totally. When my first baby was five months old I started a cupcake-decorating business. At first it was easy; he napped a ton and I could work whilst he napped. However, when he grew out of his naps, I found I was working whilst looking after him. I wanted to do both things well but felt I wasn't doing either brilliantly. So I stopped, and when I started my painting business I decided I would try my best to totally separate work and motherhood. I didn't want to do either in a distracted state. So that meant the two things needed to be separate if I could help it.

I decided I could work when the children were at school, at clubs, or asleep, but once they are around I go back to being Mummy. With both boys at school now, my work simply has to fit inside the confines of 9:30 a.m. and 2:30 p.m. during the working week. To do this, I take on only what I can manage, and accept that I will miss opportunities and income. There will be a time in the not-too-distant future when I can take on much more. Whilst my children still want to spend time with Mummy I will do my best to be fully available to them.

What do you want to pass on to another mother?

I would want to say that you matter. Your feelings, desires, wants, and needs are important. You are worthy of following your passions and having time out for yourself and your interests. Motherhood

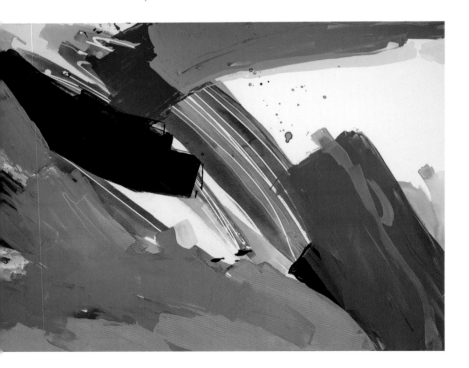

is exhausting, but it will get easier, your babies will grow, and you will get your sense of self back. However, it's likely no one will give you permission or help. You have to stand up for yourself and your needs, because you count. What you do for your family every day is work. You are most probably working in some capacity all of the time with next to no one recognizing this. You have to be your own advocate. Your needs matter.

What do you wish you could tell yourself as a new mother?
You are a brilliant mother. Block out everyone else's opinion and listen to your gut; you are a natural.

What is something you needed to hear when you were in the early stages of motherhood?
I needed to hear a bit louder that my hopes and dreams mattered and I didn't need to listen to any-one's opinion about how I should raise my babies.

How do you handle people in your life who criticize or diminish your creative pursuits?
It was so hard in the first two years of being a mum, before I started having obvious success. My well-meaning friends would constantly say things like "you're so lucky to be a full-time mum; I mean, I know you do your art thing, but . . ." This was heartbreaking and could have been a real catalyst for imposter syndrome to creep in. I'd been working on my art career most evenings for a couple of years, juggling my children and their sleepless nights, painting in a tiny space, and managing it all with a husband commuting to work and not around all week. Having friends not get my "art thing" made taking me taking my work seriously a chal-lenge at times.

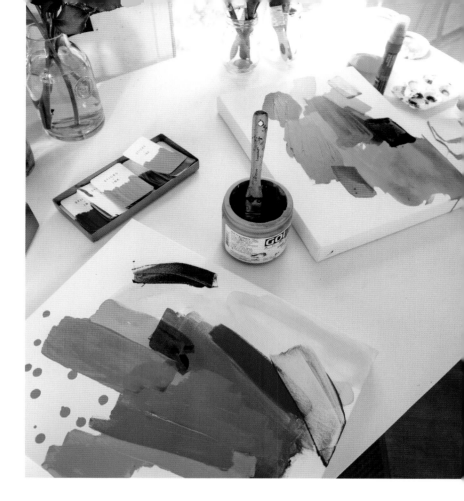

How does being an artist / creative person influence you as a mother?
It has meant that I don't worry when my children's teachers tell me that my children are daydreamers and would prefer to be outside running around or designing things than learning what's on the curriculum. I was exactly the same at school, and the compulsion to be outside and [having] curiosity to design and daydream are critical parts that have made me the artist and mother I am today. I don't want to squash that. So, we practice our spelling, work together on math homework, and read endlessly to one another, but the rest? Well I'm pretty laid back about it. As long as I see them work hard at the subjects that interest them and the basic building blocks (math and literacy), I'm satisfied. This is all because I've recognized who I am and how accommodating my natural tendencies have led to my career/life success.

Having friends not get my "art thing" made taking me taking my work seriously a challenge at times.

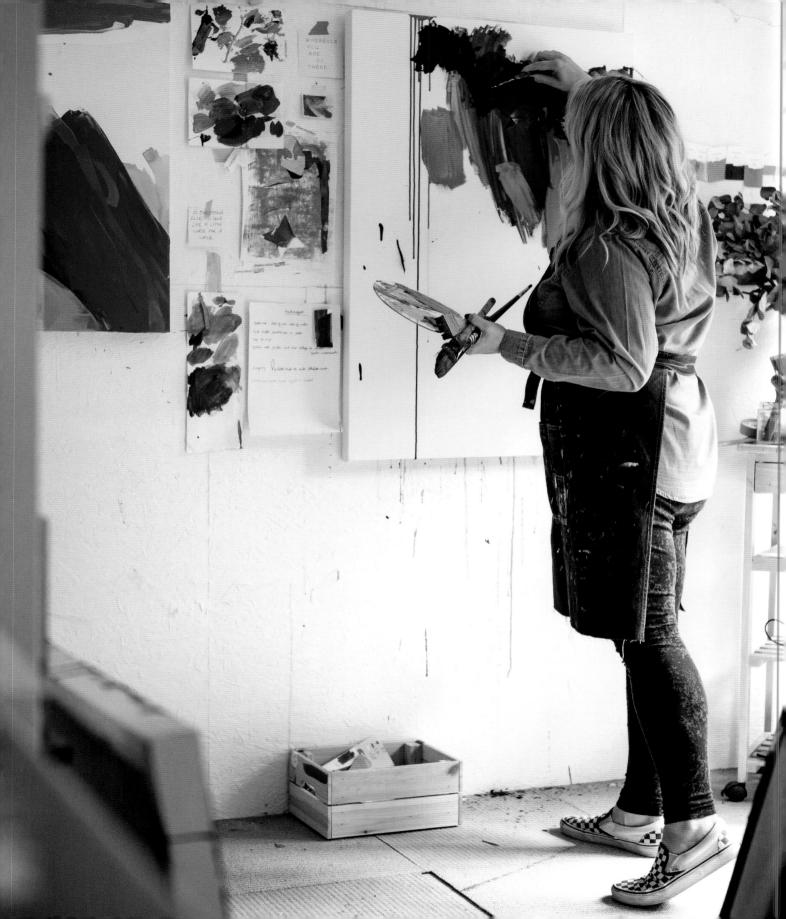

What has one of your biggest struggles been as a mother artist?

One of my biggest struggles has been matching my priorities with my expectations. My priority is spending high-quality time with my children and being there for them, but I also want to put everything into my business, as this is something that I enjoy. However, it has been a real journey trying to get my expectations for my business to match with my priorities. I've had to accept that I can't do everything without burning out, so I have had to recognize that choosing my priority was important, and accept there will be more time to work more when they are older.

Share your tips on finding time to create when you have children.

Busy boxes are my main hack. From the moment I became a mum I started looking forward to the school breaks, when my boys and I could hang out, not get dressed for days, and enjoy each other's company. Turns out, day after day of hanging out led to me feeling pretty burnt out mentally from the constant chatter. I've come to recognize that I am a bit sensitive to an overstimulating environment. I need every day to have some alone time, or at least time to retreat into some quiet. So, I started busy boxes during the school breaks.

Every day that we have a day at home, after lunch we have busy-box hour. My two boys have a room each to themselves, and so do I. I put one hour on the oven clock, and the rule is we all stay in our rooms until we hear the beeper. For that hour I do something for me: I read in bed, watch trashy TV, take a lie down, paint, have a bath, etc.

I change the contents of their busy boxes every time, so it's always exciting for them to find out what's inside. There are tons of ideas on Pinterest. It's my best secret to staying sane and totally enjoying spending every day with my children for seven weeks each summer. I can tell they really enjoy the opportunity for some quiet alone time too.

Does seeing the world through your child's point of view inspire you in your work?

Absolutely. When they create something, they are so self-confident and proud of their work that it reminds me to allow myself to feel that way too if I want to.

What has been the best advice you've ever received?

The best advice I have received is the notion that life is not a rehearsal, and also to not care what other people think. Once I grasped the attitude that we get one crack at this thing called life and I'm not going to care about other people's opinions of me, I had the tools to fully enjoy my life just as I pleased. ▨

Rachael Cole

ONE CHILD, 7

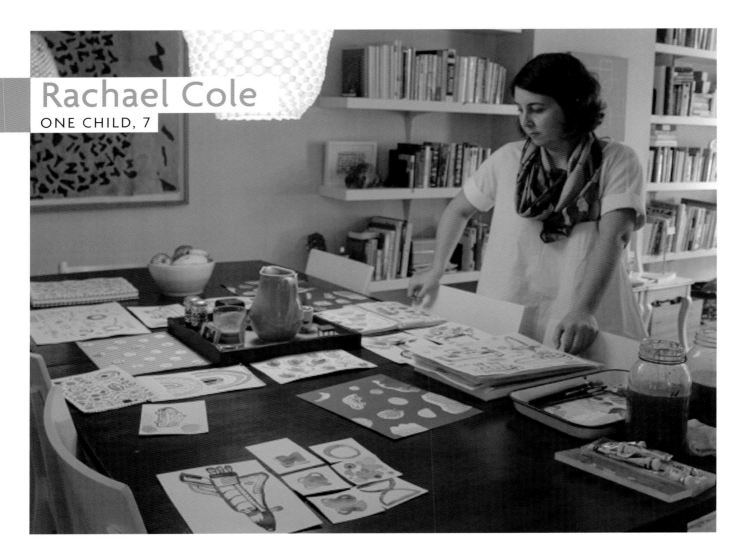

> I am much less precious with what I make. I work more quickly and think less about it.

Why is it essential for you to create? What happens if you can't have this time?

Creating connects me to myself, and to the world. It feeds on itself and makes me feel alive and see the world better. It gives me reason to connect with life. When I don't have the time, I start feeling bitter and depressed, to be honest!

Tell us about your work.

I write children's books, and I'm an illustrator and art director. These three creative worlds often intersect, but I have thus far kept each discipline rather separate in terms of my finished projects—surprising even myself. As an illustrator, I use ink, sumi ink, and watercolor.

What are you not working on that you wish you were?

Every darn thing. I am in that frustrating place of having many ideas and not being sure which one will take off. And I'm also coming out of a time period where my family required more attention and I had no energy left at the end of the day. I'm still in recovery mode creatively, and it's tough to have to ramp back up, but I'm not beating myself up about it. That doesn't work anyway, and, of course, my family comes before all else. My hope is that the time I needed to take will inform my next project, as it often does.

What does self-care look like to you?

For me it's simple things, like getting a haircut, making a lunch date, or walking to a museum at lunchtime by myself. It can also be an organizing and purging session at home, which feels so good and gives me balance and focus afterward.

Do you have moments of resentment or longing for freedom?

All the time. But life has constraints, and the puzzle is to figure out how to have the constraints work in your favor, or at least how to work around them. The more you can break apart tasks into microtasks that are involved in getting projects done, the easier it gets to move forward in tiny moments, like making a three-minute study for a larger drawing while you are in a meeting or on the subway, or pulling together a Pinterest board of visual research, for example.

What do you wish you could tell yourself as a new mother?

That it is okay to spend a lot of money on a wet nurse so that you can avoid being completely sleep deprived.

What is the best advice on motherhood you received?

That to be close to your kids, make sure you are interested in whatever they are interested in. Don't push them to love what you love.

Why do you think so many mothers express that they're not good enough? How can we support each other and shift this?

That mode of thinking is pushed on us from the high above—dare I call it the corporate state, here in the USA? My husband is Dutch, and moms (and kids) are much more relaxed there. Most of them don't work full time while they have young children, because they don't have to. There is concrete, in-home support for new mothers, subsidized daycare while they do work, and much more flex and vacation time codified into law. Not to mention that they don't have to worry about going bankrupt if they lose their health insurance. It all creates a much less neurotic atmosphere. No one is asking them to "do it all." It's understood that no one person can. We don't think we are good enough because we are asked to do too much without any real societal support. I don't play that game with myself, and I've stopped drinking that Kool-Aid. I do the best that I can within the system we have here, and I work to change it when I have time.

No one is asking them to "do it all." It's understood that no one person can.

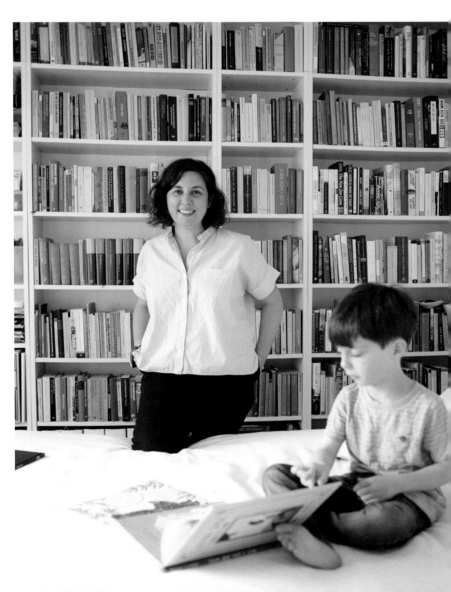

What's the hardest thing about being a mother? The easiest? The funniest?
The hardest thing about being a mother for me is that I'm always making the calculation about how much time I should be spending with my son. The answer is usually to be around as much as possible, and especially don't miss bedtime. Which is what I know to be true for my son, but tough, as it's isolating to be away from other adults so often. The easiest thing is that you know how to prioritize. It's easier to say no. It's easy to love that adorable, small, warm, funny human.

How does being an artist influence you as a mother and vice versa?
Both my kids' books were written in direct response to things that inspired me about my son's reaction to the world.

How have your studio practice and art changed over time? Especially before and after children.
I am much less precious with what I make. I work more quickly and think less about it.

What has one of your biggest struggles been as an artist? As a mother?
Being multidisciplinary is tough as an artist. It can be hard to decide where to focus.

What is something in your life (or creative pursuits / art) that you never thought you'd accomplish but did?
Having three published books, all after becoming a mother. ■

The Motherhood of Art

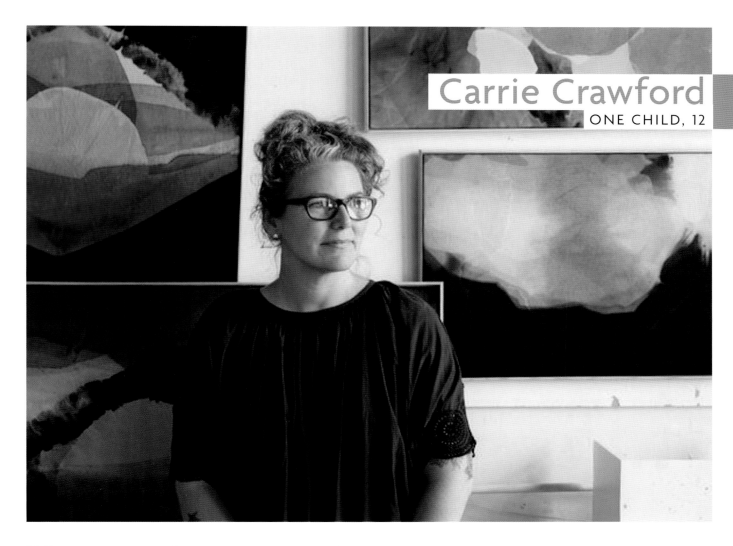

Tell us about your work.

Right now I work with natural dye. I have a daily practice with indigo currently. I am interested in doing painterly things with dye and fabric, honoring our earth in my use of materials, exploring themes of joy and survival. I am drawn to process. Earth elements and plant dyes all take a good deal of work and care to coax the color to emerge. I love the texture of linen, visible weave construction, and the way dye sinks into the fiber and becomes part of the cloth. Working with indigo has been transformative. . . . it's a true partnership. The vats have different compositions and require daily attention; they are beings in my life, and I love them like family. Indigo is notorious for being difficult.

Unlike other plants that yield dye, there are several specific steps to creating a functional indigo vat.

I am not a chemist or very precise person, so the trial and error has been a huge journey. Many folks love the science that makes the dye come alive, I appreciate that and consult their books and methods but truly prefer the magic. . . . I don't feel a need to totally understand or become any sort of master; I am just glad we are together, and I truly appreciate the luminous blue.

Would you share your journey with motherhood and art?

Early motherhood was honestly very stressful and full of grief. Having experienced infant death with

Photographs by
Sarah Deragon

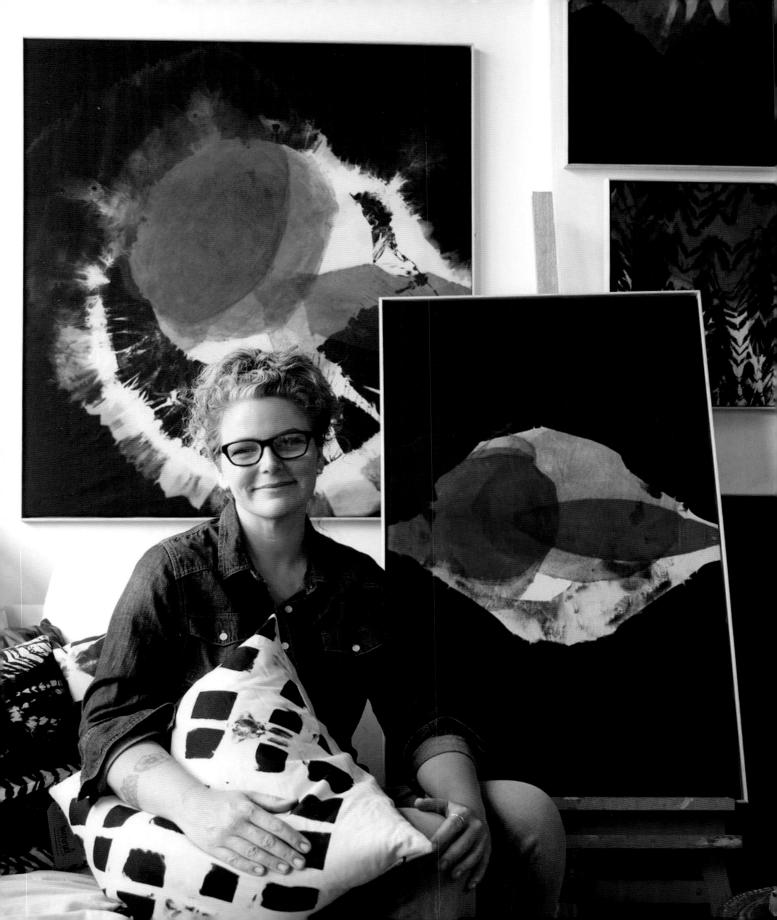

my first son, I came into some very deep feelings when my second son was born. With family far away, I leaned heavily on my partner, dear friends, and a few cherished professionals to support me. I started making art again when my son was about one. I paid a babysitter to come over while I painted in the next room. I had this big installation idea, and I chipped away at creating the pieces and parts with the help of that babysitter. I began to appreciate what being patient felt like, what this new life was asking me to cultivate. Seeing creativity as a lifelong pursuit and having faith that I could follow through on an idea, the key being a loose grip on the timeline and showing up.

Eventually I rented a U-Haul truck and created an immersive gallery inside it. Up the ramp and literally squeezing through a small portal, into an interior zone of sculpture and paintings, all reflecting inner states . . . some monsters . . . some guts. . . . It was sweet and playful and serious and ultimately some processing of what the heck I just went through having a baby and becoming a mother. I parked it in the alley next to my house and had a party. It was a very meaningful night; I remember giving my son a bath in the middle of the evening—some explosive diaper situation no doubt. Mostly I cherish this time in my life for its beautiful difficulty. It was important for me to make the idea real and share it with my community. To embrace my new life as a mother.

About a year later, when my son was about three, we moved to care for my dying mother. I did a one-year certificate program for surface design, my only real art education, and upon entering the field, I hated it. I worked a job and maintained a studio practice that amounted to me sitting in a room with no ideas—totally burned out, totally sad.

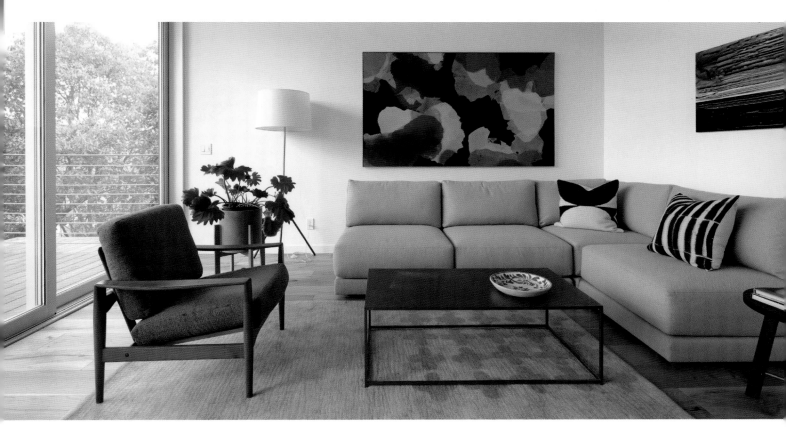

After a few cross-country moves, it took me a few years to come into some creative flow again. When my son was six, I befriended another mom and we shared a studio. We eventually went our separate ways, but the time we spent working together was a mutually affirming/supportive creative zone . . . it was amazing. I realized then that I really must be working with my hands and following my creative ideas for real, every day. I didn't know what I was doing; I just knew I needed to do it. My son is twelve now, and the last four years I have been working under the name Mineral Workshop. It's an ongoing journey . . . rooted in my wish for busy hands and a practice of showing up every day. I still need quiet chunks of time, though my art making has become more flexible and integrated into who I am.

What do you wish someone had told you?
To be patient and fearless, both.

Describe how you find ways to make work and keep at it through changing seasons of life.
I have come to understand that when I feel overwhelmed, it is usually because I am afraid. Meeting this fearfulness with some compassion has been really helpful. I try to think of it as if my child was fearful, and what my response would be; with that in my heart, what to do gets clear. Slowing down a bit and extend some softness, and the details tend to sort themselves out.

Have there been shifts in your work related to your role as a mother?
Creative slumps are hard . . . mostly I try to remember that I am an artist for my whole life, and if it's a dry season right now, not to despair; the flow will return. I try to remember the things that connect me to myself. . . . I have a specific journal practice that I rekindle when times are dry . . . I transcribe poems that I really like, noting what I am grateful for or what is catching my eye. I create endless wish lists. The journal becomes a written record of daily curiosity, something physical. It is proof to myself that I am still here, and fleshing out that creativity is curiosity, and within me always. But mostly I just try to relax into the anxiety and urgency that comes when I am slumpy, remember to move my body and laugh a bit, and see the creativity in the mundane aspects of my day. I do a little something, anything, to remind myself that the time will come again. ■

Elise Blaha Cripe
TWO CHILDREN, 4.5 AND 2

Did you think you would need to stop making work once you became a mother?
No, I didn't, and that was actually why my entry into new motherhood was so difficult. In those early days it felt very hard to do anything except care for this new life, and I couldn't see the future. I couldn't imagine a time where my brain was not filled with diapers and nursing and sleep sacks and tears. I wish I had given myself more grace those first few months as my life changed and my family transitioned from two to three. Eventually things leveled out and I had time to create, but it took awhile.

Tell us about your work.
I don't have one medium but consider myself a "generally crafty" person. Over the years that has meant paper crafting, photography, letterpress printing, painting, DIY decor, quilting, pottery, weaving, etc. Right now I am doing a lot of garment sewing and knitting, but just for myself, not for sale.

What was the first thing you remember making after having your first child? What was that like?
When Ellerie was about two months old I made some quilted floor pillows, and they reenergized me in the most amazing way. I had a few more quilted project ideas and decided to do them all and write a quilt e-course. It was a great project to pull me back into work, and I sewed the projects and wrote the lessons during naptime. It reminded me that I could still be myself in this new motherhood life.

Photograph by
Tara Whitney

45

Photographs courtesy
of Elise Blaha Cripe

What things do you do to continually learn, improve, and grow as an artist?
I take a class in a new medium about once a year, solely on the basis of what seems fun. In 2016 I took pottery and learned to throw (we now eat our dinners off plates I made, and drink our coffee out of my hand-thrown mugs). I took a screen-printing class this winter because I know very little about the medium but want to be able to pull my own prints.

I also set creative challenges to try to push myself and dive deeper into new things. The 100-day practice by artist Elle Luna is a great way to do this. In 2016 I wrote 100 pep talks and published a book of them. In 2017 I experimented with different ways to get plants on fabric and create a quilt. This year I have challenged myself not to buy any clothing and instead make all my clothing.

How do you know when to share something and when to keep it private?
This has gotten easier as I have spent more time online and as my girls have gotten older. Basically my default is just to keep it all private. Then I make an active decision to share instead of making an active decision to keep it to myself.

Do you have moments of resentment or longing for freedom?
Of course! Thankfully they are fleeting. These days I have moments of joy and contentment with more frequency.

How do you keep from comparing yourself to others?
I can't do this completely; it's normal to compare. But I think where it gets unhealthy is when the comparison keeps us from focusing on what's in

front of us. I do not struggle much with "social media jealousy" because I have been sharing my own life online for so long. I know that I post the "good" photos. I know that behind the scenes there is more to the story. I know that if you looked at my feed you might think my house is always clean or that my kids never watch TV—but of course my house is often messy and my kids watch TV. Since this is true for me, I don't assume that what fits into someone else's highlight reel is the complete picture. We all have flaws and insecurities and we all make mistakes. I can't compare without having the full picture, and *even if I did*, where would that get me?

What do you wish you could tell yourself as a new mother?
It gets so much easier. You'll be back to *you*, a better you eventually. You'll read books and take trips and watch full episodes of *Game of Thrones* without interruption and make stuff again. You'll have time for everything that matters and more.

Was there specific advice or commentary about becoming a mother that made you angry?
Yes. I hated being told "just you wait . . ." and then something negative. "Just you wait until they are crawling, and then you're really in for it." "Oh, you think this is hard, just you wait until they are teething." "Just wait until they have opinions about what they are wearing/eating/doing." UGH. How unhelpful. These comments—which hit us in the rare moments where we are feeling good, and are warning about the potential tough times to come—are the opposite of what we should be doing to support each other.

Do you experience guilt as a mother? What are your thoughts on this?
I don't. And I actually have guilt about that fact because mom guilt is so often discussed. Here's

the deal: my job as a mother is to love and support my daughters. And I do that. We read books *and* watch TV. We play outside *and* on the iPad. We eat asparagus *and* ice cream. I am not perfect in my motherhood, but that doesn't make me feel guilty or less than. No one is perfect. The point is that we keep showing up and working hard and showing love every day.

Photograph courtesy of Elise Blaha Cripe

Did you experience postpartum depression or "baby blues"? How did you find the support you needed?

I did with my first daughter but did not with my second daughter. I think more than anything I had "life change anxiety" when my family went from two to three. I really struggled. I cried every day for the better part of a year.

I didn't seek outside support, and I regret that very much. I talked to my husband and my mom a lot about it, but I think (in retrospect) they were too close to the situation. I should have spoken with a therapist or doctor from the very beginning. I don't think I would have felt as alone or been so sad for so long. I got better around when my daughter started going to daycare two days a week at fifteen months. I started to have some time to myself, and that helped me feel like me again. When I had my second daughter I was prepared for the panic and the sadness, but it never occurred. Instead I spent much of that first year blissed out as a mother.

Has becoming a mother changed what you want to do with your work?

The biggest shift in my work since becoming a mother is it has simplified. I am not trying to balance five different projects and income streams. I want to do more-meaningful work in just a few areas instead of half-assing multiple projects at once. I hate to be pulled in too many directions at once, and adjusting to motherhood made this crystal clear for me.

What are you most proud of as a mother?

I work hard to show my girls what it means to experiment and be creative, and even at two and four [years old] I can tell things are clicking for them. I try to never say "no" to art time, and we make things throughout the day. sequins, of that. They have full access to their art supplies and get to go through as much paint, glue, pipe cleaners, and paper as they want. They think daily creativity is "normal," and I am proud.

Share your tips on finding time to create when you have children.

My biggest tip is just to *do the art* in front of the child. Let them see you with all the supplies. Let them see you painting or cutting or knitting or whatever you're doing. If they grow up with it and around it, they don't know any different. It's not fast or the easiest to create side by side with your kiddos, but it's part of how you keep it normal and stay active.

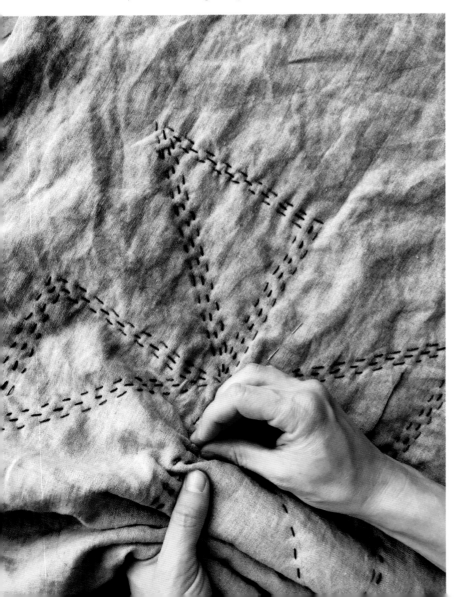

Photograph courtesy of Elise Blaha Cripe

Photographs courtesy
of Elise Blaha Cripe

How have you overcome struggles or times of feeling overwhelmed?

I think the most helpful thing I do is remind myself of all the other times I felt overwhelmed and how I always got through those moments (or weeks or months). The reminder that the circumstances are temporary and will pass helps me remain calm and just focus on doing one thing at a time.

What do the easy times feel like?

The easy times feel like perfection. I accomplished my work for the day. We just ate dinner. The girls are playing together outside (it's summer, so it's still light out and warm). I'm barefoot, sitting on the outdoor couch with my husband, and I feel relaxed and at peace. Those moments are so special to me. I can close my eyes (right now on a Monday afternoon in February while I stand at my computer) and I can be right in those moments. I try to never let them pass uncelebrated. ▦

I hated being told "just you wait . . ." and then something negative.

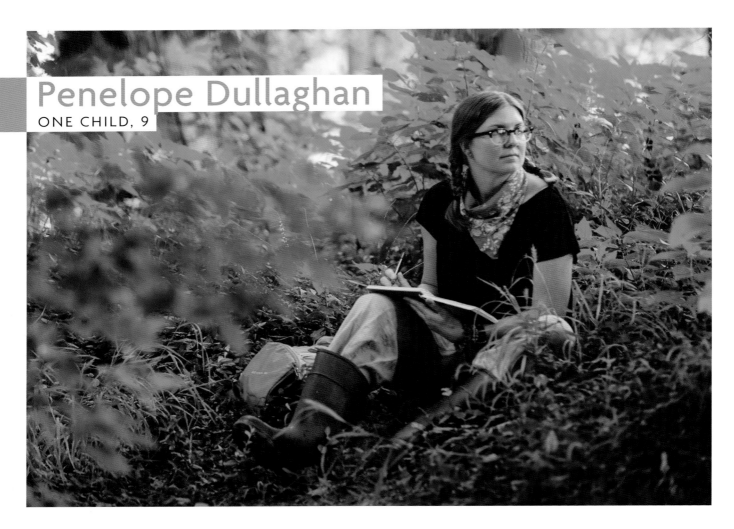

Penelope Dullaghan
ONE CHILD, 9

Photographs by
Michelle Craig

Did you think you would need to stop making work once you became a mother? Explain, please.

Most artists I've talked to experienced a surge of creativity when they were pregnant—they were just teeming with ideas and the desire to create art. But, for me, that wasn't the case at all. When I was pregnant, my creativity dried up completely. For the first time in my life, my need and compulsion to make art just . . . wasn't there. No more ideas were bubbling up in me, not like they'd always seemed to. Ever since I could pick up a crayon, I could count on that happening, but now my creativity was completely absent.

I panicked, of course. My thoughts ran wild. "What if it never comes back?" "How am I going

to find another path?" I thought maybe motherhood would be replacing my creativity, which was a little comforting, but also a little sad. And I was sad about being sad about it.

After my daughter was born, I started yoga-teacher training. In truth I never thought I'd actually teach it, but I really wanted to learn what it had to teach me. And that ended up being the best thing that could've happened. I learned to quiet the panicky thoughts and come back to my breath. I learned the philosophy of nonattachment and of breathing through discomfort until something softens.

And, in time, I brought what I learned from yoga into my parenting. I learned that things constantly change—including those sleepless

newborn nights. I learned that discomfort can be held and experienced without being permanent—just like a two-year-old's tantrum.

Looking back now, I can say that losing my creativity was the best thing I didn't know I needed. And, eventually, it came back. Even more robust than before. It came as I watched my daughter experience pure joy with her finger paints. As I saw her fearlessly tackle a blank piece of white paper with the brightest crayons. All these discoveries I got to witness firsthand. And as I did, lo and behold, I felt my own artistic joy start to come awake too. Veda and I explored art together. We still do.

Tell us about your work.

I am an illustrator and work on a huge variety of projects, from magazine work to advertising campaigns to animation and pattern surface design. I really love it all. I usually use acrylic and digital to make my work, but it varies with the assignment.

I started my career as an art director at an advertising agency. I loved getting illustrator promos (postcards, stickers, posters, etc.) across my desk and sometimes hired illustrators for appropriate projects. That was an eye-opener for me, and at some point I realized I'd rather be making the art than directing it. So I moonlighted as an illustrator for a year. I'd put in a full day at the agency and then go home and work on illustrations to build my portfolio. After a year of that, with the support of my partner, I decided to make the leap to freelance illustration full time. I haven't looked back since.

What does self-care look like to you?

Self-care for me means saying no to a lot of opportunities with my work. I wish I could take on all the work I want to do, and I've tried doing just that. Now I know that it doesn't lead to a very centered and happy me. When I say yes too much,

it's a recipe for me being overbooked and overwhelmed. And when that happens, I'm less patient with my family and with myself. I'm stressed and don't sleep and stop practicing mindfulness. So I have to be careful and say yes only to things I really want to do. For me, saying no is the keystone to all the other forms of self-care.

Was there a moment or time when you could not see how you could make things work?

When my daughter first started school, she loved it. She was so excited about what she was learning

SOMETIMES I NEED ONLY TO STAND WHEREVER I AM TO BE BLESSED
~MARY OLIVER

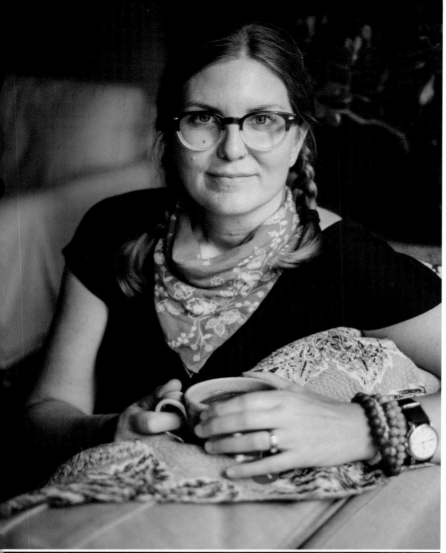

and the friends she was making. She came home filled up and told me all about it. And then, little by little, it wasn't like that anymore. With each grade came more structure and less freedom, and she would come home from school tired and worn out. Her bright, creative light started to dim. And we started toying with the idea of homeschool. We went back and forth talking about it for a year and a half before deciding to just try it. We could always change our minds. My main hang-up was that I just didn't see how I could make homeschooling work with my current schedule as a full-time artist. I used every minute (and then some) she was in school to do my work, and I felt I needed that time to be creative. So I fully expected my work to suffer as we started homeschooling. But I was willing to make that sacrifice.

As it turns out, though, it hasn't been a sacrifice at all. I've always been pretty good about squeezing work into small windows of time—a little before breakfast, a little during nap, a little more while she's playing. Well, now that's even more the case. She has a lot of free time in our homeschool schedule, and I use that time to work.

Now we've been homeschooling for just a little while, and I don't feel my work has suffered. In fact, I am happier because I am more connected to my kid. We laugh more together. And we get outside a whole lot, which didn't happen as much when I was nose down in my work.

What do you wish you could tell yourself as a new mother?

I wish I could tell myself to relax and enjoy it. To soak it all in and not be so fretful or worried. To just let things unfold in their own time and in their natural way. Each phase that you think is there permanently . . . isn't. It all goes by so quickly.

I also wish I could tell myself to empathize more. I have talked with many inspired parents and also read a few books that credit empathizing

as a key to connection, and I've found this to be true. It changed my parenting when I started practicing more intentional empathizing. I wish I'd found those resources earlier. Really, when you think about it, it's just not an easy thing to be a human who is two, or three, or eight years old. There are all these challenges, and one pretty constant one is knowing that much of your world is not in your control. Having your parent understand this and be able to help you through these big and brand-new emotions—and not judge you for it—makes for easier going.

Why do you think so many mothers express that they're not good enough? How can we support each other and shift this?

I think lots of mothers express that they're not good enough because they compare their whole life to tiny glimpses into other mothers' lives. It's easy to peek in on social media and see the fun, picture-perfect mom taking her pack of kids to

the park. You see the smiles sparkling and the sun shining and the perfect picnic. But what you might not see is the epic fit thrown about socks not fitting right. Or the DVD playing in the car to keep the kids from fighting. Or the gum stuck in the hair. I think we all know social media gives us an unfair view.

The way to shift this, I think, is with real conversation. For me, getting together with other moms and telling our stories is always an eye-opener. You can talk about the difficulties and challenges and not just gloss over them. You can ask for advice and hear what works for other real parents who are deep in the trenches with you and who aren't afraid to share their experiences.

What has your role as a mother taught you about yourself?

My role as a mother has almost been like a giant spotlight highlighting where I need work. And the spotlight appeared because I realized that the

> I'm a drop in the ocean, but without each drop there is no ocean.

easiest way for my kid to learn was to watch and mimic. So I saw my impatience in her. I saw the mirror of frustration and of anger and of not making good choices with big emotions. And I resolved to work on those less-than-stellar aspects of myself in order to help her learn a better way. Motherhood has also taught me that I'm damned resilient. I can let my livelihood ebb and flow easily, knowing that my role as a mother is more important. I can take the big emotions of another person and walk through it with grace. I can make mistakes and get up again and do better. Motherhood has been a crash course in personal development.

What do you want to teach to your children?

I would like to teach my kid to be kind. To live with her heart wide open. To know the world can be awful, to carry that knowledge with her, and yet still make an effort to improve things. I want her to know also that the world can be beyond beautiful, and often is, but even when that happens, you still need to keep putting one foot in front of the other. I want her to be able to show up with kindness for all beings, including herself.

How does being an artist influence you as a mother and vice versa?

Being a mother has influenced the kind of projects I take on. Since having Veda I've shifted my focus to work on projects that I feel are making the world a better place. I don't want to support consumerism for its own sake. I don't want to take on a project that I know doesn't add good to the world. I am more responsible in my actions, now, because I know she's watching and because I want

to show her that one can make a difference—even if it's small. I'm a drop in the ocean, but without each drop there is no ocean.

Has becoming a mother changed what you want to do with your work?

Before having a child, I never wanted to work on children's books. I have always loved children's books, but I didn't think it was something I wanted to take on myself. I remember telling people, when they asked what I did, that I was an illustrator who works on all kinds of projects—except for kids' books. And now that has changed. Now I see how influential and important children's books are. How they offer insight and open up questions and bring magic into kids' lives. And now I see what a privilege it would be to offer my skills to that task.

Share your tips on finding time to create when you have children.

I think my best tip on finding time to create is to open up your studio or workspace to your kids. Since Veda could hold a crayon, she's been working with me, side by side, in my studio. I have all my art supplies out and accessible to her. She doesn't need to ask to use them.

I think this open-studio policy has helped me have more time to create because I've blurred the lines between work and parenting. I can work beside her, and we can talk. She can come in when I'm working and play beside me. That's made it easier to find time.

Does seeing the world through your child's point of view inspire you in your work?

My goodness, yes. I love how honest Veda is about my work. How I can show her something I'm working on and she can either love it or not, and if she doesn't she usually has a good reason. It usually echoes something I already know about it, too, but was just being too lazy or too tired to address. She asks questions and makes suggestions, and I love considering her point of view.

How have you overcome struggles or times of feeling overwhelmed?

Times of being overwhelmed are hard to deal with. But I think there's only one way to the other side of it, and that's straight through. Put one foot in front of the other. Just do the next best thing. Whether that's staying up late to finish a job or setting the agenda aside because a little person really needs some one-on-one time.

Asking for extra help is also a good strategy. Reaching out and admitting you are struggling and asking for your partner to help with specific things. Or asking a friend to schedule a playdate for the kids (at their house) so you can get your head on straight. I just keep in mind that it's give and take—so when I'm feeling more on top of things, I can return the favor.

And last, it really helps to prioritize. Letting go of things that don't matter so much and just doing the top few that really matter. I've learned that even if you let a few things go, somehow the world keeps spinning.

Describe what the feeling of flow is to you. What does it mean to you?

For me, flow feels like being held. Like floating in a lake—lying back and trusting in the water to hold you up. Feeling the warm sun on your face. Your heart expands. There is no fear. It happens when I'm fully connected to my family, when I know I'm being an engaged parent and partner. When my work feels easy and is a part of my life but isn't taking it over. ▨

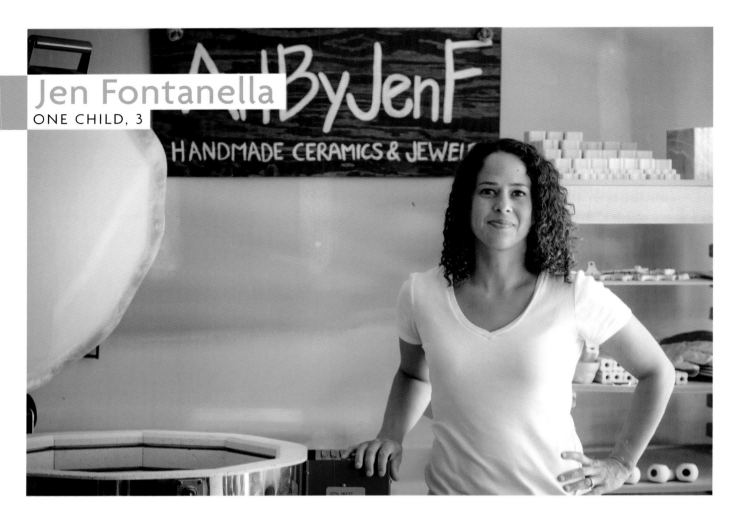

Photographs by
Alycia Jiskra

Why is it essential for you to create? What happens if you can't have this time?
From the first moment I touched clay, I found that it fed my soul. There was a moment of peace and clarity whenever I would manipulate the material. I took a long break from the craft, when I focused on a corporate career, but there was always a longing and the feeling of something missing. When I returned to clay—the smell, the feel, the touch, everything—I felt whole again. This is why it's essential for me to create; without it I am incomplete.

Did you think you would need to stop making work once you became a mother?
I didn't know what to expect after I had a baby. Of course, for your first pregnancy you imagine a perfect little world of how you and the baby would coexist in the life that you have already created and become accustomed to. Seasoned parents around me made sure to tell me, once I had my baby, that I would have to stop creating. They told me there's no room for being both a stay-at-home mom and an artist; it would be time to give up my "hobby." I never let that get under my skin. Plenty of mothers have full-time jobs and raise a child; you just have to figure out how you can make it work for everyone involved.

What does your process look like?
Right now my process is focused more on production work. I make a line of products that I retail and wholesale. Usually in one 1.5-hour session I can throw about fifteen to twenty pieces. My

sculptural pieces, however, can take anywhere from a week to a couple of months to make out of wet clay. My work always starts as a sketch, but I like to allow an organic process and let the clay speak as I make.

Clay itself has a process before you can have a completed piece—there are at least six steps, sometimes more. It's a delicate dance managing the natural environment along with the state of the clay. If it is too wet, it's hard to build onto it and it gets muddy; if it is too dry, you cannot work with it anymore—you recycle it and start over. If it cracks in the kiln, explodes, or has a flaw, or the glaze didn't work how you envisioned it, you have to start over. Adding a kid into the mix makes the managing of clay so much harder!

I will say, the process that comes with clay is very humbling. It teaches you not to put too much emotional value on a piece and to be more receptive when the unexpected happens. We also pray a lot to the Kiln Gods.

Were you self-taught?

I am mostly self-taught. I took some classes in high school, some in college, and I attended a ten-month baccalaureate program in Italy, where I learned the basics. Once I decided to start my own business, it was a lot of trial and error. I can never be afraid to ask a question, because without the answer my business may not be able to function. A lot of times, the fact that I am self-taught makes me super insecure, especially when I compare myself to other established potters, but I cannot let my ignorance hold me back. There's so much to learn, and I'm ready to learn it.

What do you want to tell to future generations of women?

You're enough. There are so many people out there that will tell you what to do or how to do it, or that you're not doing it well enough. Just find your inner peace and your inner focus and go for it. Love yourself, find your happiness, and don't let the naysayers affect you in any way.

What keeps you going during tough times?

The best lesson my son has ever taught me was when he was six months old. He was in his Pack 'n Play, and he was trying to pull himself up to stand. I watched him stand up and face-plant over and over again all day for many days. He kept trying until he succeeded, and when he succeeded he moved onto the next challenge and so on.

It made me wonder: At what point did we stop this genuine perseverance and allow ourselves to give up? At what point does insecurity and fear of failure outweigh our passion and goals?

I had big dreams that I'd bring my son into my studio and we'd live this happy little life working together, but the reality is, my son's nickname is the destructor, and it's best he stays out.

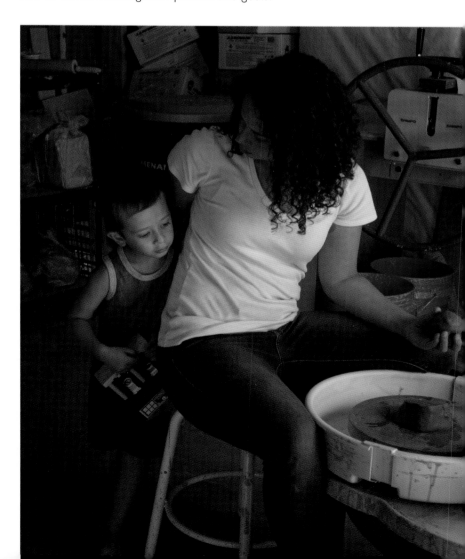

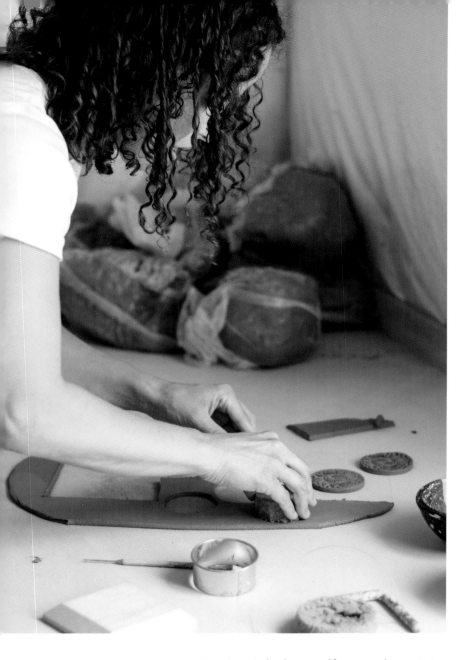

and it's always important to see how your brand stacks up against the rest: how are you similar, how are you different, what did they do to grow, what are they doing right, what are they doing wrong— all are important observations. But if you look at other brands and use the information negatively, causing you to look down on yourself and your work and avoid your own growth because of what others are doing, that is bad.

You need to remember that everyone starts somewhere. Some have to work harder than others, some people are lucky, some people are in the right place at the right time or know the right people; whatever it is, we all have our own journey and we all have to keep moving forward. Sometimes I'll read how big brands started their business, and I'll be reminded that success doesn't happen overnight; they had to work hard too.

Do you compartmentalize your life and roles?

My life roles are supercompartmentalized right now. I had big dreams that I'd bring my son into my studio and we'd live this happy little life working together, but the reality is, my son's nickname is the destructor, and it's best he stays out. I'm also way more productive when I don't have to keep tabs on him. I think I was surprised at how much brain energy he takes from me, how hard it is to concentrate on things when he's around. So I set my business up around his sleep schedule. While I obviously prioritize parenting him, I do have tasks I can do while he's awake, like Etsy, social media, or emails, and while he's asleep I work on the making side of the business.

Anytime I doubt myself or ponder quitting (because let's be real, this is hard!), I remember his constant determination for life, and it reminds me to keep going.

How do you keep from comparing yourself to others?

How can you not?! Here's my thing: as long as you compare yourself to others for business growth, it's okay. I come from an advertising background,

What is something you needed to hear when you were in the early stages of motherhood?

It's going to be hard; it's going to be worth it; you just have to find your tune. Don't let anyone tell you it cannot be done. Of course it can.

Why do you think so many mothers express that they're not good enough? How can we support each other and shift this?

I really think it's the lack of the village. Me personally, I don't live near any family, and my husband and I are trying to conquer this new world of parenthood on our own. Parenting used to be a group-wide effort, with different people chipping in with different roles. Now it seems like the mother is expected to fulfill all those roles, and it gets overwhelming. You can't be the best mom and the best business owner, the best worker, and the best wife at once—you can't be the best everything. Something has to give. You have to find the balance and allow for flexibility as it evolves when your children grow.

How do you handle people in your life who criticize or diminish your creative pursuits? Do you feel the need to defend it—how do you do this?

In one ear and out the other, of course, after spending a decent amount of time venting about it to my husband. In the beginning years, I let it get to me, I listened to it, and I allowed it to affect the outcome. I tried to start my business three times, the third being the final attempt. Everyone has an opinion shaped by the experiences of their life and possibly their own insecurities or anxiety; you can't let that dictate your vision for yours. You know what you want, you know what you're capable of, and you have the power to make it happen.

What has your role as a mother taught you about yourself?

Motherhood has taught me that I am resilient. After becoming responsible for keeping a human alive, it diminishes every other petty worry that I had before. If I can be a mom, I can do anything.

What do you want to teach to your children?

I want to teach my children that life is what you make it. I want to teach them to find happiness and to find peace, whatever it may be. Not to shortchange themselves. To be confident and humble. To be fearless. That they are extraordinary, and to find their strengths and pursue their passions. That everything has beauty, and to be the ones that see it.

Describe how you find ways to make work and keep at it through changing seasons of life.

First, communication. My husband has been awesome at listening to my needs in my studio. He'll take our son on Daddy-Son dates on the weekends so I can give my work a few hours of undivided attention. This is especially helpful when I have deadlines approaching.

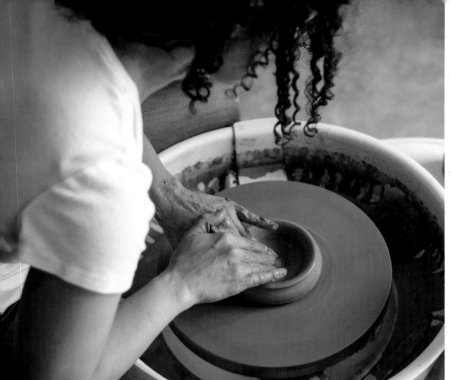

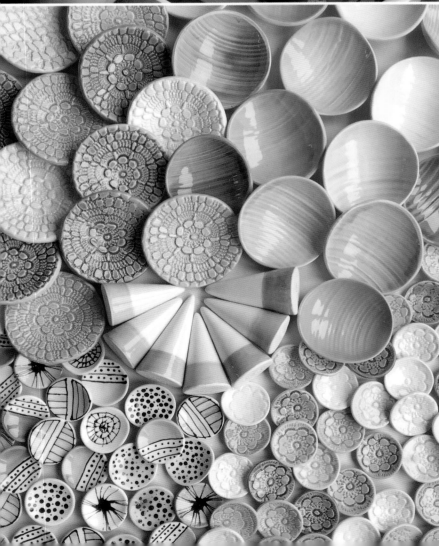

Second, I think it helped to make my business flexible with what life gives me. Being production based has made it easy for me to scale my business larger or smaller depending what's happening in my life.

Third, remembering it's okay to say no. I feel as an artist, it's ingrained that you should never reject work, because you don't know when another interested party will come again. But for the sake of mental health and the family, I often remind myself it's okay to say no.

I have a vision of what my business and I can be, but I have to understand that right now it's not feasible with life's demands. It's definitely an act of patience.

How have your studio practice and art changed over time? Especially before and after children.

Ha! Before children I could do whatever whenever. Stay up late, work long hours, never take a break, focus, explore the medium, take my time, etc. My thoughts were clear, my time was available, and my focus was on point. It was exactly how art should be, organic and passionate in every way possible.

After having a child? It's been a rollercoaster. I can work only when he's asleep. So right now I run every aspect of my business within four hours every day, separated in two two-hour increments. My tasks are planned out weeks in advanced so I can meet deadlines appropriately. If he's sick or has a snow day, I cannot work, and I have to rejigger my tasks accordingly. As his sleep schedule changes, so does my studio schedule and responsibilities. I changed my business model to be more product based because that take less brain space to make and manage. And I worked hard to simplify my process and flow so I can complete more items in less amount of time. It's all about being as organized as possible, even though it's rooted in chaos. It's definitely a different world than it was before.

The Motherhood of Art

What has one of your biggest struggles been as an artist? As a mother?

I think one of the biggest struggles, as an artist, was becoming a mother. Is that bad to say? For my art, it produced a slew of new limitations. My priority is, of course, my son, but I get antsy when I want to be in my studio and can't be. I had to relearn my business and relearn what I can/cannot do because of my circumstances. And I have to be open as it evolves over time. Sometimes at the end of the day, when I finally can be in my studio uninterrupted because my husband is home and can attend to our son, I'm just so exhausted from the day or the week, and it feels so forced and unwanted to be in there. It's like a cruel mind trick, where I was so eager to be in my studio to work, but once allowed the time, I cannot function because I'm drained.

Share your tips on finding time to create when you have children.

During infancy, I wore my son in the studio. We hung out lots because he slept lots. Once he became mobile, it was impossible to bring him in. He also wasn't one that wanted to chill in a controlled, closed-off space. This is where communicating with my husband on my business needs helped. Scheduling time has helped. Keeping a sketchbook around so I can jot down ideas or write to-do lists helped. Or a drawing app so I can draw things quickly as they come around. Never be afraid to ask for help from others. I live somewhere without a family network, but I have amazing neighbors and I can ask them to play with my son when I *need* to get something done. I know one day I'll return to the more organic nature of art, but for the time being it's all about organizing time while being mindful of everyone's needs.

What is something that you never thought you'd accomplish but did?

Starting a functioning business is something I thought I could never do, but I am doing it. Sometimes I still don't believe it, but then I stop and look and think holy crap—it's happening. I seriously never thought I was smart enough, confident enough, or capable enough for such an endeavor. I'm glad I stopped listening to those thoughts, took the plunge, and just kept putting one foot in front of the other. Start small and keep going.

When was a time you felt like giving up? How did you get through this?

When things really ramp up, whether there's a lot going on with my son, or my business, I have strong feelings to just give up. The feeling mostly creeps up when I've stretched myself too thin on work projects. I don't get through this very eloquently. I usually do a social media hiatus and avoid my studio for a decent amount of time. Most recently I started prioritizing self-love and started yoga and some other things to ground myself and remind myself not to lose sight of me. Thankfully, I have a very encouraging and supportive partner. I suggest everyone find a cheerleader to help you during the insecure times. ■

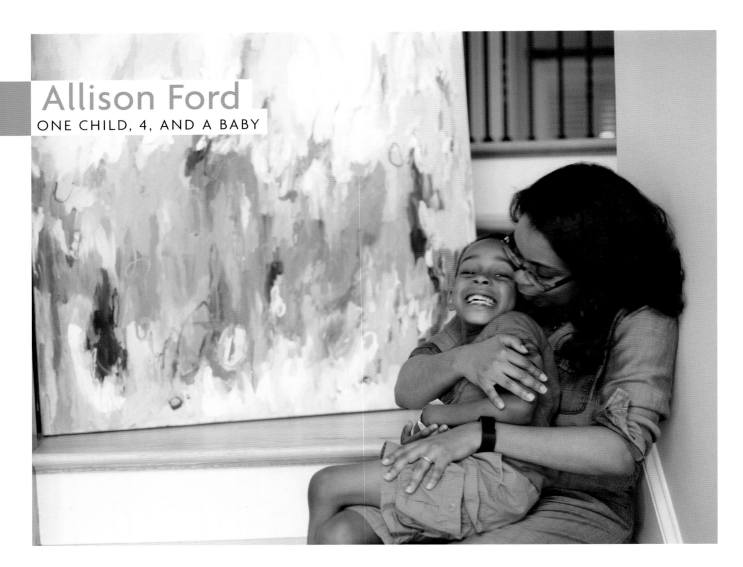

Allison Ford

ONE CHILD, 4, AND A BABY

Photographs by
Kimberly Michelle
Gibson

Why is it essential for you to create? What happens if you can't have this time?

Creating gives me peace and joy. I literally crave my painting time. I think having the quiet time alone to express myself and translate my feelings into something tangible makes me a more pleasant me.

When did you first learn your craft/ medium? Do you have a strong memory about this?

I have an early memory of art making as a child. I made necklaces with beads and semiprecious stones in elementary school as a hobby. I went to a creative-arts elementary school and grew up in a town where arts were abounding. I had an opportunity as a young person to participate in a unique summer arts program doing "real" art with professional artists. I spent a few weeks learning how to make stained-glass pieces, cutting glass and soldering. An early memory I have is working with world-renowned artist Mary Edna Fraser, who does the most beautiful batik work, and exploring the wax and dyes. I think those early opportunities stuck with me and helped me appreciate being a creative person.

How do you know when it's time to switch it up?

When I get stuck, I just try something else for my painting. I often paint with my four-year-old, so when I need some fresh eyes, I let him have a stab at the process and see what he comes up with. Children are brilliant artists. I may be the same way at parenting. I'll try different methods to getting my message across. I'm a big proponent of encouraging him to "take a step back" and try to see the whole picture; this goes for painting and life.

Were you self-taught?

This is an interesting question. I don't think anyone is really self-taught. Did I go to college to learn how to paint, no. But part of me wanted to. I had a roommate in college who was a studio art major. She was always so encouraging to me. I knew I wanted to take some studio art classes but I was afraid of painting. I had no idea what I was doing, and the thought of it was intimidating to me, especially with her being around and being so knowledgeable. I took sculpture as a "pass / fail" course in college just in case I were to make a bad grade. The instructor was baffled as to why I would discount my abilities in that way, and told me I would have made an A. Again, it was that fear there of thinking I wouldn't be successful. But I do believe in instruction. I am a big proponent of taking a class here and there, and learning as much as you can from others. Even if it's not in your medium, I find that you can pick up techniques, approaches, or just different ways of looking at the world.

What keeps you going during tough times?

My family and my faith. I am blessed with a wonderful support network. I usually allow myself a good cry, some time for reflection and processing of feelings, and then it is time to move on—cheer up, buttercup.

I start to think about positive things, read some scripture, pray and have quiet time, paint.

Do you have moments where you have so many ideas you could fill an entire sketchbook?

Yes! So many ideas. I walk around with paintings in my head that I want to paint. I also am a writer, so I am always dreaming of blogging or writing a book or something like that. That's actually the thing I like about being a lawyer—the persuasive writing aspect of it. I am perfectly content writing a brief or doing some persuasive writing. For me it is about time. I have really had to focus my attention on one thing (the best I can) and try to cultivate that the best I can.

> I often paint with my four-year-old, so when I need some fresh eyes, I let him have a stab at the process and see what he comes up with.

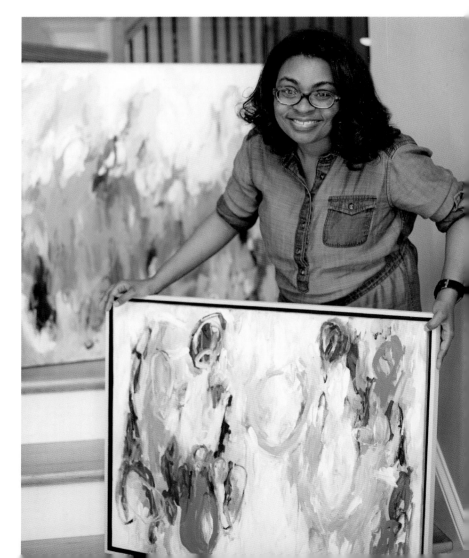

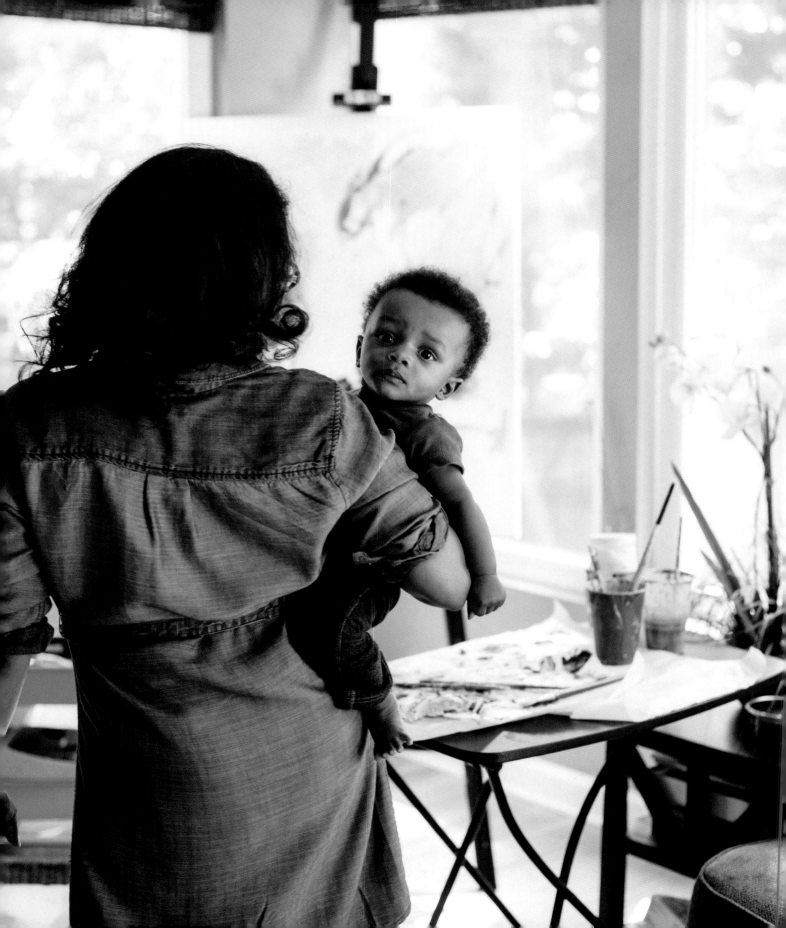

How do you keep from comparing yourself to others?

This is hard, especially in the world of social media. It is easy to look at someone else's following or successes and say, What about me? Why not me? What I do when I feel myself wanting to make comparisons is think back on my successes, whether they be for my art business, for my legal career, or in parenthood. I try to think about the opportunities I have and the progress I have made. When I look at my list of blessings in that way, it usually reassures me that I am on the right track, I am where I am for a reason, and that I am doing a good job.

What do you wish you could tell yourself as a new mother?

Not to be so hard on myself. And don't buy all the things. All you need is diapers. Meals are taken care of—as mamas we are blessed with the only free buffet in the world. All you can drink! Better than Golden Corral.

Why do you think so many mothers express that they're not good enough? How can we support each other and shift this?

I think we just need to let each other know, "Hey! You are doing a good job!" It's okay if you have three piles of unfolded laundry. Girl, so do I. Everyone is alive and well in your house. Everyone is fed. That's what matters. Things don't have to be perfect as long as you tried. And don't mom-judge. Everyone moms differently. It's okay to work outside the home; it is okay to be a stay-at-home mom. It is okay to drive a car; it's okay to drive a minivan. Give everyone the space they need to make the mom(ing) decisions they need do. And cheer them on for showing up and doing a good job regardless!

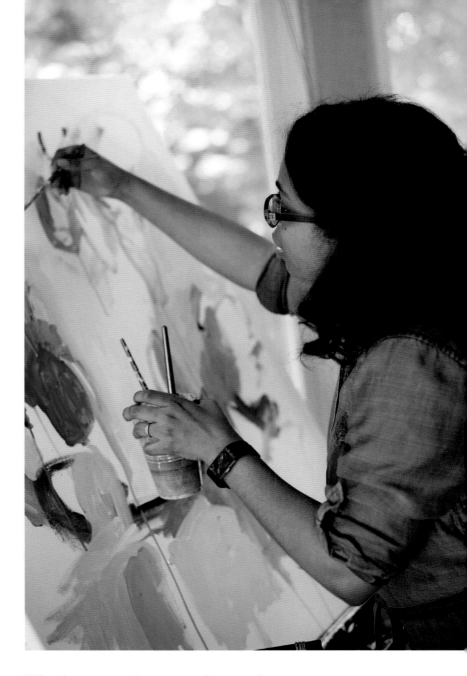

What has your role as a mother taught you about yourself?

This is what I was meant to do. It is a great honor and pleasure to be a mother. Being a mother has taught me about love in real and tangible ways. Life is about giving.

Did you experience postpartum depression or "baby blues"?

I did not in the traditional sense, but I did have some significant mom guilt (this goes back to an earlier question). I am just now able to talk about it substantively. My guilt came from my birthing progress. My labor process went faster than we all (including our doula) expected, and we did not make it to the hospital in time. I ended up delivering my own baby in the car while we were en route. It sounds very superwomany, but for us it was traumatic.

I was disappointed that things didn't happen just as I planned. I felt guilt because I was constantly thinking about what could have happened to my baby instead of just being grateful that he was alive, well, and thriving. It took me a while to make peace, forgive myself, and move on.

Has becoming a mother changed what you want to do with your work?

I don't want to give up. Someone is looking up to me. And watching me keep plugging along with little accomplishments here and there along the way.

Describe how you find ways to make work and keep at it through changing seasons of life.

I started painting with my son as a way to spend time with him and also give myself some studio time. Allowing him into my process has been incredibly special. He brings a fresh perspective and innocence. The thing about painting is that the more layers, the more interest you can generate. So I try not to be afraid of painting over something that just doesn't work. But painting with him was my way to embrace a new view of our time together. Now we can create work of which we are both proud.

How have your studio practice and art changed over time? Especially before and after children.

Definitely it has changed. We moved to a new house and I had my own room as my studio space. When my second son was born, we converted that room to a nursery. I felt a sense of loss in giving up my space. I'll admit I cried. Things work out now; I paint in our guest room, but it is certainly different. Also, I recognize I don't have as much time to just paint anymore, and that's okay. I commit now to taking a few moments here and there to create. That is why the concept of carving

out time for art is so important to me. I don't usually get long stretches of time to paint. I do what I can in an hour or two and then give myself permission to walk away.

What has one of your biggest struggles been as an artist? As a mother?
Finding cohesiveness. Everyone always says, "Have a collection," "try to have a uniform body of work," things like that. Because of the way I paint and everything else that is going on with life, work, and home, sometimes it is not that simple for me. I have struggled with the push and pull of doing what feels right in the heart, and trying to define myself through cohesiveness. Doing what feels right is winning.

How have you overcome struggles or times of feeling overwhelmed?
Prayer and asking for help. When I can't get it all done or need help, my support network usually senses it and comes through. And when I get down or feel overwhelmed, I try to regroup and then take life one minute at a time.

What helps you through creative slumps or times when life is full?
If things are not clicking and I am on the verge of frustration because of a slump, I turn my attention elsewhere. Coming back with a fresh perspective usually helps. It also helps to remember everyone has those times. Whether they admit it or not. Something fresh and new usually comes out of a slump, so I try to remember that too! ■

It's okay if you have three piles of un-folded laun-dry. Girl, so do I. Everyone is alive and well in your house. Everyone is fed. That's what matters.

Monika Forsberg
TWO CHILDREN, 16 AND 6

Photographs by
Monika Forsberg

Why is it essential for you to create? What happens if you can't have this time?

I go stir crazy if I don't do something creative with my hands. Also I find it keeps my mind happy. If I don't draw (I spent a few years not doing any drawing), I dabble with crocheting woodwork and all sorts of different things.

What does creative exploration mean to you? What does it look like to you?

I like creating and exploring—it quiets my brain, and the less I think, the better; more interesting things happen. It's like my brain gives a few prompts and directions and then things happen.

Did you think you would need to stop making work once you became a mother?

I didn't "work" for the first two to three years of my kids' lives but was always creating. I don't really know how to not do things. My brain gets so full up if I don't empty it (in the form of making something new) at least every two days. Kids always come first, though, and being with them is creative. But I do really like the selfishness of creating. It is for me. My little thing.

Tell us about your work.

I draw, paint, and scribble. It's possible in the space where we live. It's practical and doable. I work with

marker pens a lot because it reminds me of drawing as a child. I feel safe and free in my creating.

What ideas or themes do you explore in your work?
I do 80 percent commission work, so it really depends. When I draw for me, I like to draw ducks. Not very profound, but at least I'm honest.

Do you come from a creative family? Was there support in your endeavors?
My parents weren't in a position to study, so they always said study for as long as you can. I think they probably worried about my choice of career at times.

When did you first learn your craft/ medium? Do you have a strong memory about this?
I remember drawing as a very young person and how it was easier to draw how I felt than say it with words.

Was there a time when you thought you were not meant to make work?
I don't think so. I know that there were times when I didn't know what I was meant to work on. I made things complicated. I thought it needed to be profound and have context rather than just happy doodles.

What was the first thing you remember making after having your first child?
I drew Danet. I sketched him in pencil as he slept in my arms. After I had Reggie, I sketched houses.

What are you not working on that you wish you were?
I wish I was making a big, fat, colorful book! Not for kids. But a book of inspiration.

What does your process look like?
I don't sketch. I draw lots 'n' lots of bits together. Sometimes if I have several jobs on at same time I draw for both simultaneously.

My brain gets so full up if I don't empty it (in the form of making something new) at least every two days.

What things do you do to continually learn, improve, and grow as an artist?

I try reminding myself of what I find fun and what I dream of and what I felt as a kid. And to stay curious.

How do you know when to walk away versus overwork a piece of art or project?

I used to be very good at stopping in time. But lately I have learned that it's good to spend a bit of extra time rather than stop too early. I sort of go "Okay, done." Usually I share what I'm working on with some friends when I'm nearly finished, and then I can see it through their eyes and know what I need to change.

What keeps you going during tough times?

Crying! And laughing. And catastrophizing.

What does self-care look like to you?

Swimming, walking, laughing, boyfriend, and friends. Human contact.

Do you have moments of resentment or longing for freedom?

Oh yes. But I always long for my lovelies when I'm away.

Was there a moment or time when you could not see how you could make things work? How did you get through that?

I felt more secure working with sequential work rather than doing the one piece. I felt I wasn't good enough to make art. If I drew lots and lots of pictures (good ones) it moved beautifully if I put it together in an animated sequence. So hiding amongst many rather than be seen through just the one. But my friend and I have pep talks every week. We have our "OMG, this is terrible!" days, but we always mostly say, "We can do this! We are on fire!" and other simple but encouraging quips.

Do you have moments where you have so many ideas you could fill an entire sketchbook?

Yeah! But what's in my head never translates onto the paper. I see amazing things in my head. Nothing like what I draw.

What was a big goal or dream that you accomplished? How did you make that happen? What did that feel like?

To make a living from my art. To be honest, I never really had a proper job but can live within my means. I would rather make some sacrifices than have a "boring" job.

How do you keep from comparing yourself to others?

I do all the time. And then I think, well, if they can be successful, why couldn't I? And it's nice when people do amazing things.

How do the many roles you have connect and influence how you handle things?

I think it's good. The more things happening at the same time, the easier to think clearly and concentrate. When I wrote a book I was listening to an audiobook at the same time.

Tell us about a time when you created something that was important to you. What made you proud of this accomplishment?

I locked myself in our guest bedroom, where my mum kept the sewing things. Aged five. And sewed a doll. All by myself. The pride I felt when finished was the *best ever*.

What do you want to pass on to another mother?

Hug your kids a lot. Be kind. Share. Take the time. Sleep.

What do you wish you could tell yourself as a new mother?

Trust yourself. Chill.

What is something you needed to hear when you were in the early stages of motherhood?

You are okay.

Why do you think so many mothers express that they're not good enough? How can we support each other and shift this?

I think we need more communities. Motherhood really thrives on having a group of especially females in your life. To share, to talk and help each other out.

Do you experience guilt as a mother? What are your thoughts on this?

Guilt isn't productive. I have done lots wrong and made mistakes, but I always try to take note to not repeat those things. No one is faultless, but we can all learn from our mistakes.

What joy does being a mother bring to your life? What hardships?

It has made me a better person. It has made me happier. And it has made me feel better. And more fun. And made me less self-absorbed. And more able to gaze outside my own belly button.

What has your role as a mother taught you about yourself?

That I am what I am.

Did you experience postpartum depression or "baby blues"? How did you find the support you needed?
With my first son, yes. I tried to talk to doctors but no one listened. It took me years to work things out. By myself.

What do you want to teach to your children?
To be kind and generous and stand up for themselves.

Tell us about a role model or supportive person in your journey.
A woman called Elin helped me immensely when my oldest son was little. She was like a big sister to me.

Did you experience a sense of loss or grief for the life you had before you became a mother?
Never. I miss cycling out on adventures with my boyfriend, just me and him. But . . . we have fun!

How does being an artist influence you as a mother and vice versa?
Motherhood has slowed me down in some ways, but I learned to not procrastinate.

Has becoming a mother changed what you want to do with your work? How?
I know now that it's okay to draw ducks. There is no bigger picture. At the end of the day, it's only drawing. But I love it.

What are you most proud of as a mother?
Our family.

How do you find ways to make work and keep at it through changing seasons of life?
I work when the kids are at school. I never do housework when the kids are at school.

How have your studio practice and art changed over time?
I am about to build a studio in the middle of the house, but for now I work in our tiny bedroom. On top of our bed. It's messy; it's crowded and unpractical.

What has one of your biggest struggles been as an artist? As a mother?
There are never enough hours.

Share your tips on finding time to create when you have children.
Do it when they sleep. And if they sleep in a sling or right next to you, they will sleep longer, so you'll have longer time to draw.

How have you overcome struggles or times of feeling overwhelmed?
By crying, drawing, laughing, and loving. And forgiving.

What helps you through creative slumps or times when life is full?
I have learned that it'll pass. So . . . patience.

Describe what the feeling of flow is to you. What does it mean to you?
It's like floating downstream.

When was a time you felt like giving up? How did you get through this?
When I was in a really dark place. I made changes to my life, then was patient and healed, and then started slowly to rebuild my life.

What question do you wish we had asked?
I wish you'd asked me to draw you some ducks. ■

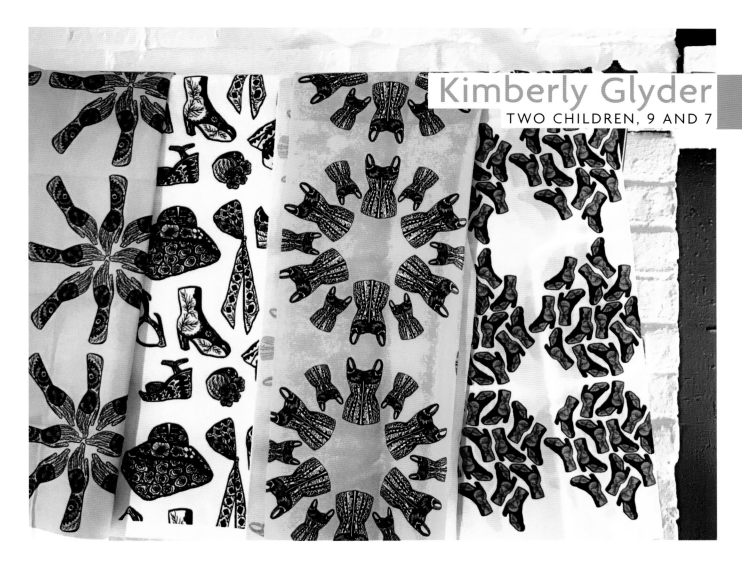

Do you come from a creative family? Was there support in your endeavors?

My mom is an artist and has always been very supportive. She began her art career later in life, while I was in middle school, then went on to own an art gallery and was recognized with multiple awards. Beyond just having talent, she taught me that a successful career meant working hard, entering competitions, putting yourself out there, and facing rejection.

Was there a time when you thought you were not meant to make work?

I went to an art magnet program in high school, where most kids went on to art colleges with scholarships. I had been drawing and painting ever since I was very young, and though I was strong academically in school, I had never really entertained the thought of doing anything other than being a fine artist.

Once I was at art college, in my first drawing class I remember having a teacher telling me I was drawing wrong. That statement really shook me. Had I been drawing wrong all my life and now had to unlearn everything I thought I did well? It was one factor, among many at the time, in why I left art school. I decided it might be best to pursue my interest in English literature and

Photographs by
Kimberly Glyder

Taking that "break" and pursuing other interests just made me realize how important art is in my life.

73

transferred to a liberal arts college. It took me about a year to realize that I missed creating too much. I even missed the smell of my paints.

I transferred back to art school (RISD). Returning to an artistic field of study, and eventually a career in art and design where I get to be creative every day, is one of the smartest decisions I have ever made. Taking that "break" and pursuing other interests just made me realize how important art is in my life.

What are you not working on that you wish you were?

I really pine for more dedicated free time to explore. So often I work on pieces and know that I want to push the concepts/methods/styles further but lack the time. I would love to go larger scale, but the limitations of time and space hold me back.

How do you know when to walk away versus overwork a piece of art or project?

I can usually sense early on when a piece is just not coming together. Some of my favorite finished paintings were when I realized the original idea wasn't working and I had to let go. I tend to want to salvage the parts I do like and go from there . . . literally at times cutting them up and reconfiguring them. As a mom, the "free time" I have for personal pieces is typically something I've worked hard to carve out, and it's tough to walk away if the art isn't coming together.

What keeps you going during tough times?

I attended intensive art classes in high school. My teacher pushed us hard by holding regular critiques. I learned pretty early on that sometimes the work you do is not always good, but it's part of the overall process toward improving. I'm very much driven by my failures. When I create work that I

don't like, I know I can do better because I've come up against failure before.

In the end, there is always *more* I want to create and accomplish, and that carries me through times of self-doubt. Having friends who are also fellow creatives to vent to helps immensely!

How do you keep from comparing yourself to others?

Social media plays a big part in our day-to-day lives now, so we're exposed to a daily onslaught of self-inflicted comparisons. I try to look at the work I view as inspiration, not competition. Often I'll put away my phone so as not to dwell on what other people are doing because I don't want it to influence me too much.

What do you want to pass on to another mother?

Every child is completely different. We set up a lot of standards for how we should react/behave/discipline/teach our kids, but it really comes down to the fact that you know your child best, and every kid develops and behaves in a completely unique way. Certainly read the books, check out the Facebook groups, talk to other moms, even just for the encouragement and opportunity to vent, but don't judge yourself by those books or those other voices in your head on what is the "right" way to raise your kid.

What do you wish you could tell yourself as a new mother?

Slow down, enjoy more. I've always had so many deadlines, and the stress consumed me much of the time. I look back to when my kids were smaller, when their problems seemed less overwhelming, and wish I had taken in more. Teaching myself to live in the moment is one of my greatest challenges in life.

> Often I'll put away my phone so as not to dwell on what other people are doing

Sometimes
letting go and
focusing on
just getting
through the
hour or that
very day is the
only thing that
helps.

Do you experience guilt as a mother? What are your thoughts on this?

I'm in a little bit of limbo with my kids. I'm not a stay-at-home mom per se, but I am there to take them to school and pick them up because I work from home. I never *really* ever stop working either. Sometimes they are frustrated I can't play with them because I'm still occasionally fielding emails or finishing up deadlines during the couple of hours right after they get home, so I feel guilty about that. They don't think my job is really "work" because I don't commute into an office like other parents they know. They also don't see me up late at night working to make up for the time I spend with them. Although they may not appreciate it now, the trade off for not having a "traditional" job is that I am able to show up for most every school event and pick them up from the bus each day. We all do our best to make the schedules work.

What do you want to teach to your children?

I always tell my kids I want them to pursue a career they love, because they'll have to work at it every single day. So choose wisely! It's important for me to model respect and kindness in the interactions we have with people while I'm with them. Just as important, I want my kids to know they need to work hard at whatever they do.

Did you experience a sense of loss or grief for the life you had before you became a mother?

I do have moments of grief for the luxury of time before kids. The time to explore and to mess up . . . or even to do nothing! My mom, who is an artist, has always said you'll have that again one day. I don't want to rush my kids' childhoods at all, but the occasional pang for more free time does hit me.

Have there been shifts in your work related to your role as a mother? How so?

I've recently worked on more client projects that are geared toward younger kids. I have consciously taken on these projects when I might not have before kids, not wanting to skew my work in one direction. Now, that's not an issue, but a benefit. I like the idea of my own kids relating to books I've designed and illustrated. Recently, I illustrated and designed a new package set for *A Wrinkle in Time*. My kids are eager to read the books, but I'm asking for them to hold off until my new designs come out. I like the idea of them holding the books while they are reading and relating to the covers, knowing I had a hand in their creation.

How have your studio practice and art changed over time?

Now that I have children, my days are broken up in chunks of work time, whereas before my children I worked from morning until whenever I finished

at night. Now, I very much have to stick to a schedule based on the kids' hours, then resume working when they go to bed. I'm up so much later, even though I'm older and need more sleep!

Share your tips on finding time to create when you have children.
Naps were a great way to get in extra creative time. After the kids go to sleep is really the best time to work and feel uninhibited by interruptions.

How do you deal with periods of no time to create or make things?
I find my stress level goes up if don't get in time for personal work. Often, I'll create mental notes of ideas I want to pursue, maybe even write a couple things down so I don't forget a concept.

Who is an artist mother you look up to? Why?
There are a few Philadelphia moms who constantly inspire me with their beautiful work. I know how hard it is to be creative on days that can feel so overwhelming, but they consistently produce pieces, client work and personal, that I admire: Gina Triplett, Kimberly Ellen Hall, and Georgena Senior.

Does seeing the world through your child's point of view inspire you in your work?
Often I'll ask my daughter and son about colors or concepts I'm working on. They are typically wonderful in that they love everything I do, but they will tell me which parts aren't working if I press them by asking questions. I think it's important to show my kids I value their opinions. I also want to encourage them to have confidence in what they are saying by really taking the time to analyze art and design work. It's always interesting to hear what they find inherently beautiful and engaging, and I do believe it influences how I create my art.

What helps you through creative slumps or times when life is full?
Every week when I plan out my work schedule, I figure which days would allow me to have time for personal work. I love painting and drawing and designing for my clients, but personal work allows me to deal with stress and anxiety in an entirely different way. Organizing my time helps focus me even on tough days.

When was a time you felt like giving up? How did you get through this?
The days where the schedule is thrown up in the air by sick days, or snow days off, or unexpected revisions to projects, etc.; those are the days where being completely overwhelmed can derail me. For me, returning to my calendar and trying to do some last-minute organization helps immensely. Also, the mantra that everything usually works out plays on repeat in my brain. The kids come first, and sometimes letting go and focusing on just getting through the hour or that very day is the only thing that helps. ◼

The time to explore and to mess up . . . or even to do nothing! My mom, who is an artist, has always said you'll have that again one day.

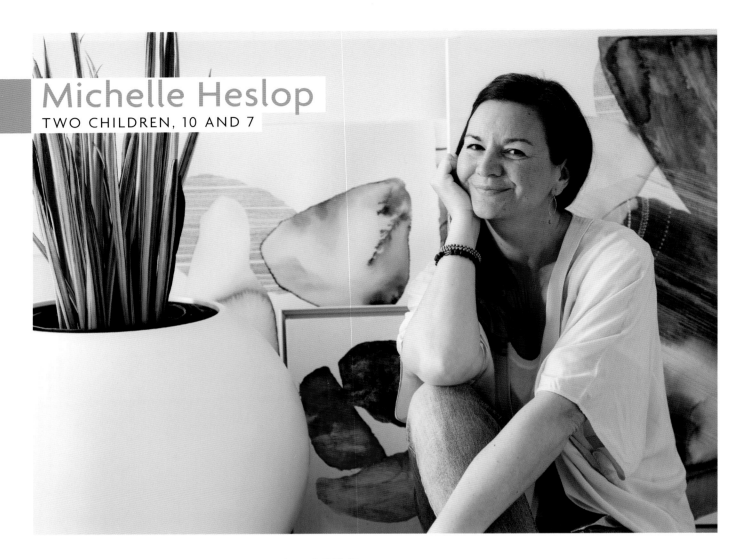

Michelle Heslop
TWO CHILDREN, 10 AND 7

If I couldn't find time to do basic life stuff, how was I going to carve out time for a studio practice?

Were you a creative child? Do you come from a creative family?

I was a creative kid, always pursuing the next craft or experiment from my creative mother of six. My mom is an accomplished painter and always encouraged my creative exploration as a child. But somewhere between preschool and adulthood, I lost the connection to my creative curiosity. I became interested in sport and friends more than anything else.

After my undergrad degree, I moved to the West Coast of Canada and traveled to tropical destinations, surfing and exploring. I dabbled in creative pursuits throughout my twenties and eventually thought my creative calling might come

in the form of a graphic design diploma. But when this didn't satisfy my artistic longing, I realized that making was stored so deep that somehow it was locked in the depths of my consciousness. In retrospect, it was perfectionism that kept creativity at bay. All this dabbling had become a "perfection or nothing" approach to making. And you know what Elizabeth Gilbert says about perfectionism, right? "Perfectionism is just fear in fancy shoes and a mink coat, pretending to be elegant when actually it's just terrified."

When did you first learn your craft/ medium? Do you have a strong memory about this?

When I had children, something magical happened. I gave birth to a boy in my mid-thirties, and two years later we were fortunate enough to have a baby girl. Up until I had children, I wasn't terribly existential. I was enjoying traveling and adored hearing others' stories, but I hadn't yet questioned what my story was. As soon as my first was born, I wondered: What is my story? What will my children say about me? How can I embrace and leverage all the things that make me unique?

After their births, perfectionism and fear diminished and in its place came an insatiable craving for making and creating. Maybe it was the primal need to be my best, most authentic self for my children, but miraculously my childhood curiosity and creativity were unlocked. Perhaps it was the endless hours of self-reflection while breastfeeding for five consecutive years, but as I stared into my babies' eyes, I rewrote fairy tales through a feminist lens, I envisioned pouring paint onto large canvases, and I started doodling on every bit of paper like I did as a teenager.

In 2012, I ditched the perfection-or-nothing approach and started to take small steps toward my creative journey. I took a few painting classes, but it was the commitment required for Elle Luna's 100-Day Project in 2015 that really kick-started my art practice and business.

Photographs by Jody Beck Photography

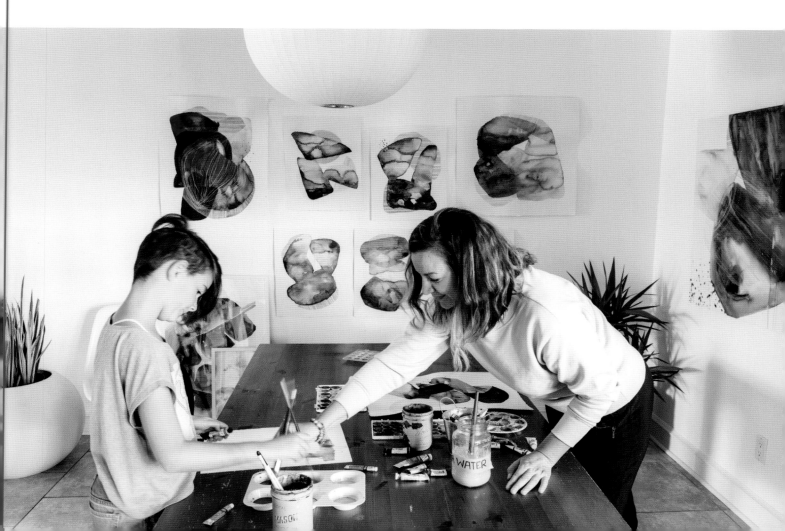

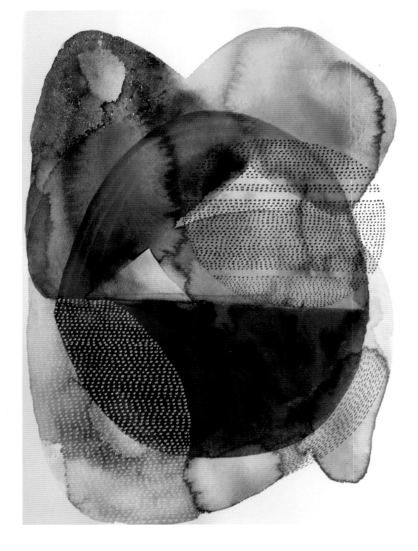

and took hours and hours, not to mention the major hand cramps. Needless to say, now I am focusing on how to evolve my style without losing the feel of the dots.

Why is it essential for you to create? What happens if you can't have this time?

Mothering is a continual act of giving, patience, and love, and let's face it, we can't pour from an empty cup. Painting is the act of self-love I need to fill the well; it energizes me and makes me feel connected and alive. It offers quiet reflection and builds my inner strength. When people say, "You should meditate," I think "I do, I paint." If I can't make time to paint, I become frustrated and very unfocused and distracted. As Brené Brown puts it: "We are creative beings. We are by nature creative. Unused creativity is not benign. It metastasizes. It turns into grief, rage, judgment, sorrow, shame."

What do you do to continually learn, improve, and grow as an artist?

I've been a working artist for only a few short years and feel like I could write a novel about what I've learned. I think we are in the midst of a paradigm shift that is reshaping the art world, how we share our work and use our creative voices. What has been most apparent in my learning is that artists are entrepreneurs. The act of putting paint to canvas is only about 20 percent of being an artist. The remaining 80 percent is defining your style, understanding your audience, accessing this audience, the role of photography, recording your work, bookkeeping, customer service, social media, website maintenance, and the joyous topic for artists, pricing! Unfortunately, painting hours are often overshadowed by entrepreneurial tasks, so I've relied on some strong mentors and my online art community to help guide me. As for growing as an artist, I just keep painting. Discipline and habit keep my work unique and evolving.

Tell us about your work.

I started the 100-day project using mostly acrylics on watercolor paper and, over time, added acrylic inks and watercolors to my mediums. I live a couple of blocks from the sea, which I visit almost daily, so I think I'm attracted to the use of water in my work. I've even used Pacific seawater in my pieces—the salt makes a lovely sediment. I'm attracted to the uncontrolled intuitive process of letting the colors move in the water, blend and fuse. But I felt like I wanted to make the forms connect somehow, so I started experimenting with mark making. Stitching the shapes together with dots and lines allowed the pieces to become whole. However, once I started getting commissions for large pieces, all those dots and lines became very labor intensive

Was there a moment or time when you could not see how you could make things work?

There are a lot of moments and weeks when I don't think I can do it all (I also have a business with my partner, https://victoria.modernhomemag.ca). I start to feel deflated and burnt out from the hustle and can't continue to make art, have a career, raise kids, drive them to activities, exercise, and take care of their socio-emotional needs and growth, household duties, friends, and family. It was a bit easier when they were small and didn't have lives of their own. Most days I feel like a crazed clown juggling too many balls. But the pull to art is strong, and my fear of time and its ticking clock is stronger. I turn to others when I feel like this, because at this stage in my life, I know I'm not alone.

Art mentors have been invaluable, good friends who cheerlead and help me brainstorm, and my incredibly creative and business-savvy husband is always there with answers. I am so fortunate to live with someone who lives and breathes creative living and embraces the unknown. He just doesn't have the same fear or see the obstacles like I do. Often when I feel burnt out, I just scale back the business side of art and keep painting. Reverse the percentages to 80 percent painting / 20 percent business, and life is good. I often remind myself that I don't have to make a living from my art and that it is there to fill my well, not drain me.

Do you have moments where you have so many ideas you could fill an entire sketchbook?

Idea surges and waves of creativity happen often. They hit more like tsunamis and want to flow out in binge painting sessions. It can take over my waking and sleeping life until I get to put the brush to paper. Once I hit my flow, I could paint all day and night. Sometimes it causes angst knowing I have to stop. Ironically, painting can cause me equal amounts of anxiety as joy.

Transitioning from creative to practical life is a challenge for me. As a mom, painting comes in shorter periods of time, the in-between moments. I don't think I've ever had the privilege of painting for seven or eight hours straight. #goals. But I feel so fortunate to have this part of my brain stimulated and curious—ideas are constantly surfacing, whether I'm at the beach with the kids collecting rocks or driving them to piano; ideas are always popping in to say hi.

What do you wish you could tell yourself as a new mother?

We do motherhood very differently today than even twenty years ago, and I felt this internal struggle when I had babies. This new way of parenting can be problematic for having a life, especially a maker's life, outside parenthood. Motherhood looks different for everyone. But I wish I could go back and tell myself that motherhood is enough. Stop beating yourself up about what you're NOT doing and start finding strength and real power in the small underwhelming moments of life. By 8 a.m. you've snuggled and loved hard, refereed fights, found lost books, cleaned spilled milk, cooked eggs, made pigtails, packed lunches, and brushed your teeth. Winning! There is a lot of power and confidence in the messy moments of motherhood. Connect with that confidence. Laugh in those moments and know that this is true grit and tenacity. And please remember that creative pursuits do not have to be in conflict with parenting. Bring out your paints and paint with one hand while you're breastfeeding or while kids nap (the dishes and folding can wait). There really are moments when being an artist and mother can seamlessly coalesce.

What do you want to teach your children?

I believe one of the greatest gifts I can give my kids is how to access pleasure and joy in life. In a day or in a moment, accessing your own personal joy and laughter is the most important thing. I've never been one to follow a recipe or the status quo, for that matter. When my friends were doing their MAs, getting married, and buying homes, I was happily surfing in New Zealand and working kiwi farms to get to Indonesia. I want my children to learn how to make something from nothing. It's important to me to create a home that honors activities that light you up and places health and happiness at the top of the to-do list. This is success to us.

You need time and boredom in order to explore what truly creates that fire in your belly. Passive screen time is moving in quickly to disconnect kids from themselves. Downtime in our house isn't screen time but wandering around until you figure out what to do. We want our kids to be motivated and resilient, so we work hard at providing unscheduled time to daydream and make something from nothing. We may not be the most popular house to be at, but that's okay for now. As cliché as it sounds, money will follow if you are doing something that lights you up. I feel strongly about all the different paths to success and prosperity and want to give our children permission to make space for it.

I am beyond grateful for our home and family. But I still dream about alternate realities.

How does being an artist influence you as a mother? How does being a mother influence you as an artist?

Awesome question. Having children transformed me. I'm not even sure I'd be painting if it wasn't for them. I might still be collecting cameras and books on photography. ;-) Let's be honest, there is a tremendous amount of white noise in parenthood: music lessons, Little League, letter grades, school volunteering, birthday parties, playdates, social-emotional needs, swim lessons, puberty, managing screen time, and red dye #40. I could go on. Painting removes me from the intense mental space of parenting and creates some available real estate in my mind for other things, like being emotionally available to others, laughter with my husband, and self-love for me. Becoming a mother allowed me to be more fervent in my creativity and more industrious with my time.

What is something in your life (or creative pursuits / art) that you never thought you'd accomplish but did?

I never really imagined every surface of my house being covered in art, art supplies covering our kitchen shelves, or using my living room as a studio, so this whole artist life is still a surprising accomplishment to me. I didn't foresee selling art to interior designers in New York, building myself an art website, or my kids hugging me, saying, "You're the best artist in the whole world." It's not that I never thought I would accomplish this, I just never even considered it! Life is full of surprises; you just have to remain curious, ask questions, and explore each calling.

What are you most proud of as a mother?
I am just proud to be a mother. It wasn't a straight path to pregnancy for us, so I didn't take any of it for granted. I loved being pregnant and am probably most proud of the connection I have with my children. I am on team "the dishes can wait." If my kids ask me to play a game or come see their creation, I drop everything. Life is in the details. Nothing can prepare you for motherhood. The selflessness, the only constant is change, and the juggling . . . I'm proud that I've found painting and can make time for myself in this intense job. There really are no definitive answers in parenting, and the info out there is infinite, so I am often proud of myself at the end of the day when I close their bedroom doors—I survived another day!

Share your tips on finding time to create when you have children.
I didn't create when my kids were babies, but I can imagine it to be extremely difficult. I considered brushing my teeth a win with two littles underfoot. Everyone's situation is different, and children have varying degrees of neediness. If you have a day job you're going to have to carve out time in the evening, or my personal favorite: put yourself on the weekend calendar in bold. For a time, I reduced my sleep to about six hours a night, which I could last on for short periods before I burned out. I don't recommend this at all (ask my husband). Just as you schedule birthday parties and activities on the weekend, schedule yourself in. Put your name in bold for a good chunk of time, and let your partner, grandma, or friend take over childcare for a time. It can feel awkward and even awful at first, but you'll soon grow to love that special time for yourself and you'll be a better parent for it. ■

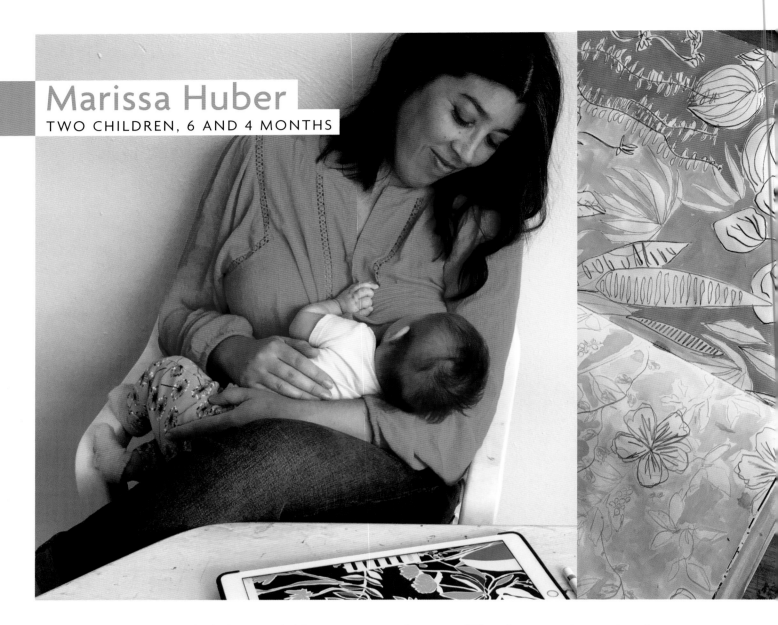

Marissa Huber
TWO CHILDREN, 6 AND 4 MONTHS

Why is it essential for you to create?

When I don't make time to create, it feels like a slog of daily routine and chores. I feel cranky and sad, and I worry about the state of the world. It makes me worry more about the state of the world. When I create, I'm a happier, more positive mom to my kids and feel like a better version of myself. It gives me purpose and fulfillment.

What does creative exploration mean to you?

As an artist, I feel my whole life is creative exploration. It's trusting inklings of an idea or an internal pull to try something different and not care if the result leads to anything or feels like a waste of time. It's being open to inspiration everywhere, whether I notice soap patterns while washing dishes or highway lines and pretty-colored trucks on my commute that influence my work. I don't always have time to make things, but I consider all

coloring the background in, I made loose shapes around the flowers. I had so much fun drawing around the objects, barely thinking, in a meditative way. When I quickly hid the original drawing to check on something, I loved the silhouette of the background by itself even more than the original drawing. I ended up turning that background into a textile pattern on its own. That pattern is one I am very proud of. The playful and meditative coloring exercise has turned into one of my signature design elements.

Did you think you would need to stop making work once you became a mother?

Every time someone told me I wouldn't have a moment for myself ever again after my son was born, I was irritated and determined to do things my own way. Granted, I was also worried that they could be right, but I'd thankfully seen examples of mothers making it work for them from reading craft blogs and had hope. I'm grateful for all the naysayers, as they unknowingly gave me the passion and determination to interview these mothers and create a community.

What ideas or themes do you explore in your work?

This is going to sound so melodramatic, but all my questioning comes back to what is the purpose of life? Everything is so fleeting. I think that's why I'm drawn to flowers so much. They're the perfect example of the cycle of life, and moments of beauty in this entire cycle. A beginning, the big show, the fading life, the end, and then the continuing. We only have the present, and there is beauty and joy and delight alongside grief, boredom, and anger in all stages. It's not black and white ever.

What does my work mean when there is so much going on in the world and I'm making pretty flowers and colorful patterns? Ultimately, the best part of life to me is finding moments of joy.

of these moments creative time, and that feels like I'm doing something.

I used to think I had to be so focused in my art to make progress and move forward, especially with limited time. But it became stifling at one point, and I needed to play again. Playing is crucial to creativity, because anything can feel possible.

An example is that one day I wanted to make a drawing of tropical plants and flowers in my sketchbook just for fun. I liked it so much that I decided to recreate it digitally on my iPad. When

Joy in the mundane, a moment of pure delight watching your child amid a long day of Legos. Smiling because of the perfect shade of pink enamel on a recycling truck will inspire my work. I'm looking to find joy and spread joy when I can, because I believe it's one of my life purposes.

Do you come from a creative family? Was there support in your endeavors?
[When we were] growing up, my mom and dad always encouraged our creativity and were vocal about being proud of us. My Lolo (grandfather) in the Philippines was an architect and loved to paint and read. We liked to think we inherited it from him. My dad loved to write, and I realized how much when he retired and started an almost daily blog for his remaining three years that made me so proud and inspired. Childhood was filled with quiet moments of my brother Andrew and me creating books, drawing, painting. Whenever we visited a new city, our parents always brought us to a children's museum and an art or history museum. They believed in us. Enough to look up local Saturday art classes and send me to a summer art program at age sixteen at University of the Arts in Philadelphia, where I focused on ceramics and getting my eyebrow pierced (ha). I'm so grateful to them for fostering an early love of the arts.

Was there a time when you thought you were not meant to make work?
Of course! Parts of high school, being embarrassed of my work during a portfolio review; in college, when I became friends with "real artists"; when I compare myself to others and think I don't belong. My thinking shifted after having my first kid. I realized if making art was what I most wanted to do in my free time, I must be an artist. And after that I decided not to waste my thoughts on belonging to some club. I didn't need anyone's permission except my own to show up and make. I'd rather spend my life doing what I want instead of wasting it because someone may be judging me.

What was the first thing you remember making after having your first child?
I had a huge opportunity to work with an up-and-coming interior designer, creating watercolor paintings of her interiors. Things were going well and we decided to finish up the remaining parts of the project if it worked out after Henry was born. I remember sitting down in twenty-minute increments while he slept to work. When I started painting, I felt free from the overwhelming responsibility of new motherhood. There was a thread to the person I was before, and it felt like a relief and gift. I knew life was changed forever but I'd find my way and be okay.

What are you not working on that you wish you were?
Large oil paintings on canvas, based on some of my pattern designs. Still-life paintings focusing on color. One-of-a-kind painted silk scarves. Embroidery. Printmaking. A book of the stories and watercolors from a 2015 project. The list goes on.

What does your process look like?
Designing patterns, I have a loose idea of my intention. Big flowers with a background of vines that are intersecting for interest. Or flat shapes focusing on happy colors. Best-case scenario, I'll use a photo of a pencil sketch and reference photos to start drawing the design motifs on my iPad Pro. Then the design is transferred to Adobe Illustrator to create the seamless repeats and create colorways. Other times I just draw on the iPad and create something on a whim. When I'm painting, I may sketch something out, but I go more with the flow. Work could be done in one shot or in a few sessions. It depends on the medium I'm working on, the ideas, and the blocks of time.

What do you do to continually learn, improve, and grow as an artist?
I research the artists, designers, and styles I admire.

I like to go up the family tree of their own influences and random curiosities to create my own unique web of influence. That helps my work feels like my own, with an homage to many. Other ways for me include meeting other artists, visiting museums and galleries, drawing from life, and playing with ideas or collaborating.

How do you know when to walk away versus overwork a piece of art or project?
I think this gets easier over time as you develop your own barometer for overwork. I did a 100-day project in 2016 with the intention to focus on negative space, as I had the tendency to always

> I feel a buzz like I'm playing with fire and have learned after many mistakes to trust it and stop.

use up all of the page or canvas. That project got me comfortable with restraint and later influenced the space I keep in my pattern designs. When painting, I try to step away if I'm not sure if it needs more. I feel a buzz like I'm playing with fire and have learned after many mistakes to trust it and stop. Then I can think before adding marks that can't be erased with Ctrl + Z.

How do you know when it's time to switch it up?

With artwork, if I'm having my "quarterly creative crisis" where I feel like everything has been done before and there is no point to add to this, I know it's time to play with another medium, grab some new books from the library, or take a walk. Or if I'm feeling bored with my work, it's a sign to fill the well again. With parenting, if we're all feeling crabby and angsty, I like to hop in the car and take our family to the beach for fresh air and some digging in the sand. It always helps.

Did you have formal education or were you self-taught?

I have a blend of formal training and being self-taught. I took art classes as a child and had a good art program at my high school, where we did ceramics, observational drawing, and painting. At sixteen I attended a summer art program at University of the Arts in Philadelphia. I started as a studio art major in college at Indiana University in Bloomington, Indiana, but didn't have the confidence that I was cut out to be an artist. I didn't think I was good enough or self-motivated enough. Also, what would I do as a career? I felt the need for a practical career. I ended up with a degree in interior design, which was a perfect fit for me, though part of me always wanted to do art and be "good enough" and part of that community. After my beloved brother, Andrew, died of a heroin overdose in 2005, I was compelled to focus on my art as a way to be brave with my own dreams and help take him along with me since he didn't have that chance. It was also healing because art

was something we did together as children, and it made me closer to him. Years later, I gained my confidence in my art practice and fell in love with digital pattern design, which I taught myself through online videos! I would love to take painting classes one day. But I can also just ask my husband to teach me, since he's painted for 20 years and is a former art professor.

What do you want to tell to future generations of women?

You have every right to be doing what you value most. Take up space. Ask for what you want. Help other women and ask for help when you need it. Don't undervalue things that women have historically done.

How do you know when to share something and when to keep it private?

If I am still figuring out what I think of something, I may keep it private or share with trusted friends so I'm not influenced by outside perspectives. After that, I'm pretty good at sharing most of what I make. If it's a project or something I'm not sure about, I try to hold it in until I'm sure it's something I want to follow through. I hate flaking out on things and am getting better at not announcing things until I'm certain.

What keeps you going during tough times?

When I lost my brother, that was the worst thing imaginable at the time. My own grief, and the deep-cutting grief of seeing my parents'. And you know what—we got through it. Not over it, but through it. It gave me perspective and a strange confidence that I will be able to get through whatever life hands me. Because there's no other choice. Resilience is in my tool kit. Also, a belief in the beauty of humanity makes it all worth it.

What does self-care look like to you?

My self-care is making time in my life for art making

and nurturing friendships with women who feel the same. It also looks like putting in time for an unexpected passion project, like creating this book with Heather and being an instigator at Carve Out Time for Art. Sometimes it is a drive to the beach, hang time with another local family, or beer and chicken nachos with my husband. Whatever energizes me or calms my soul counts, in my opinion.

Do you have moments of resentment or longing for freedom?

Of course I do, and I think it's natural. I'm so grateful to be in the thick of motherhood with young children and know this time is fleeting. So damn grateful. But it can also feel smothering at times. I notice that when I haven't taken any time to myself, the "mom-mom-mom" urgent attention can make me want to crawl out of my skin with all that they need from me. I feel vulnerable saying this but think it's important to share. As my first child got older, I became better at anticipating my own needs, which helped with this. I know I

won't feel stifled if I make a little time for myself and plan it out. I tell myself that for all of the struggles of these ages, there is so much joy in small children, and the big, big love that will shift as they start growing. It's such tenderhearted, epic love that is making me cry right now typing this.

Do you have moments where you have so many ideas you could fill an entire sketchbook?

Yes, I do at times, which is a nice balance when I feel like everything has been done before, and question the point of everything. That's what I like to call my "Quarterly Creative Existential Crisis," which is now just part of my creative cycle of ebbs and flows. I want to explore so many things, and after my child was born, there was a newfound urgency as I contemplated my own mortality. I like to put the ideas into my journal or sketchbook or in an Instagram post, and they can be revisited later. Not all ideas are worth exploring; some need to incubate, and you never know what will lead to something else.

What was a big goal or dream that you accomplished?

Creating a community for artists to feel safe, form deep friendships, and be encouraged in their creative endeavors is one that has been the most important to me. The goal that made me the most giddy was seeing my pattern design on products that people could buy. That felt really cool, and I was so proud of myself for learning the process and tools to do that. Regarding dreams, I always knew I would be a mother. While I wouldn't call this an accomplishment per se, I'd say it's what has added the most to my life and shaped me into the person I was meant to become. The weird thing about big goals is that when you achieve them, they don't seem so huge anymore. I think we need to take more time to celebrate wins, look at how hard we've worked, and remember

that what once seemed so impossible is almost easy now.

How do you keep from comparing yourself to others?

I do it sometimes and have noticed I'm more likely to do it when I haven't created recently, gone for a walk, or taken some time for myself. In that state of mind, it's easy to forget that the snapshots people are sharing about their lives is not the big picture. When I find myself falling into the comparison trap, I try to question what I admire or am feeling envious about that I want in my own life. Is it the medium they're working on, the type of work, how unapologetic they are with their pricing, or how brave they are? Then I try to see how I can translate it into my life in my own way instead of feeling less than. This usually makes me realize it's about me, not them. And I love cheering other women on (genuinely, of course), which makes it hard to compare yourself to others when you're so damn proud of them. Comparison and crankiness are always cured by putting a phone down and making, snuggling with your kids, calling a creative friend, or visiting the ocean.

Do you compartmentalize your life and roles?

When my first child was born, we both worked full time, and I was the primary caregiver. The bulk of responsibility for the household and parenting was on me due to our circumstances. This, in addition to health problems my son had, was exhausting and so stressful that it culminated with me passing out at work facedown on the bathroom floor, with my bottom half hanging out in the hallway. During that time, we knew we had to make a big change for our family and moved from Philadelphia to South Florida, where I'm from.

Now, it's slightly opposite. I'm the sole earner for our family, and he's the stay-at-home dad and paints when he can get that time in. I no longer

feel invisibly tethered and worried about my kid all day. There is a freedom in knowing that the person you trust most in the world with your children has things handled. Also, having both spouses experience both sides adds a level of understanding to our situations. If I feel guilty about staying late at work for a deadline, my husband is the first person telling me not to feel guilty. I also know that when I come home, he needs a break from the children because that is exhausting in another way. The hour-long commute of decompression is a nice buffer to go from my professional to home roles. When it comes to art making, this is less compartmentalized. I love to create alongside my son when a project fosters that, or I find alone time to focus if I'm working on something that needs concentration.

Tell us about a time when you created something that was important to you.

One anniversary of my brother Andrew's death, I made a calavera ink drawing based on symbols and memories that we had together. I printed them with my gocco machine and painted some of them in with watercolor. It was cathartic and special because it represented his short but full life, and how dear he was to so many. Looking back, it was when I started using my art to tell a story, even though I wouldn't realize it for years later. It was also when I started sharing my work more with others and making it a priority in my life.

What do you want to pass on to another mother?

You don't have to let go of your dreams once you become a mother. You are still allowed to have something for yourself, and that does not make you a bad person. Children want to see their parents excited about their life and pursuits! They want to see their mother happy doing something that lights her up. I think it also takes pressure off them thinking their actions makes us happy or

unhappy. Most importantly, I want my son and daughter to know this for themselves and the women in their lives when they grow up.

What do you wish you could tell yourself as a new mother?

Have a big midnight snack and glass of milk before bed so you don't get nauseated in the early days of breastfeeding through the night! And it's okay to high five yourself the first time you catch projectile vomit in your shirt to avoid cleaning the sofa.

What is the best advice on motherhood you received?

Once my son was born, my friend Leya Williams-Albert wrote me one piece of advice, which was "Be gentle with yourself." How simple, lovely, and brilliant. It works for everything. Healing postpartum, letting things slide, being kind to yourself, etc. I think of it as the cure-all of advice and routinely pass that on to anyone becoming a mother.

Was there specific advice or commentary about becoming a mother that made you angry?

I was told constantly once pregnant that my life was over and I would never do anything for myself again. I would never get a full night's sleep. Would never read a book until my kid was eighteen. All my hopes and dreams were over. Most of it was societal norms and new-parent friendly hazing, I think, but it was really unhelpful too. "If you think you're tired now, just wait until that baby is born!" It made me angry because it's already so tough to become a parent, that if you have no other role models you'll quickly think that they're right. It made me sad thinking of how many new moms accept that as truth. That's why creating community was so important to me.

Share your tips on finding time to create when you have children.

Think of the things you want to do, match them to the tasks, and lower your standards. If you practice looking for cracks of time and have materials and sketchbooks at the ready, you can do anything. If your kid is happy with some screen time, that is a perfect time to sit next to them and draw on your iPad, work in Adobe Illustrator on pattern designs, or sketch in your journal. Bring your watercolor set out in the yard while they're digging in the dirt. Let them collaborate with you; it's the best way to be less precious with a sketchbook.

If they're older and you're supervising bath time, sit on the floor and make marks with ink on paper. Some friends paint in their car if the kids are still napping; I sometimes do that before work, but with no kids in the car. Batch bigger projects into many steps so you're able to make progress. For example, for a watercolor painting, get your paper ready and taped down to your surface. Then make your pencil drawing. Next, paint the background. In another session, paint the details. Let it dry and erase your pencil marks.

Leave a big pad of paper and watercolor palette out and paint one stroke of color when you walk by to change a diaper (our second child doesn't have a room; she has a changing table in our art studio for now). Keep a sketchbook and a pencil in the car or in your bag when you have a few minutes, instead of looking at a phone. Use a drawing app on your phone to make quick sketches or digital work.

Give kids their own materials and encourage them to work side by side with you, and let them use your good materials (being safe, of course). Ask their opinion and really listen. Tell your family when you need uninterrupted time for concentrated work, and explain to your kids why it is important. Then use that time and make the most of it! ■

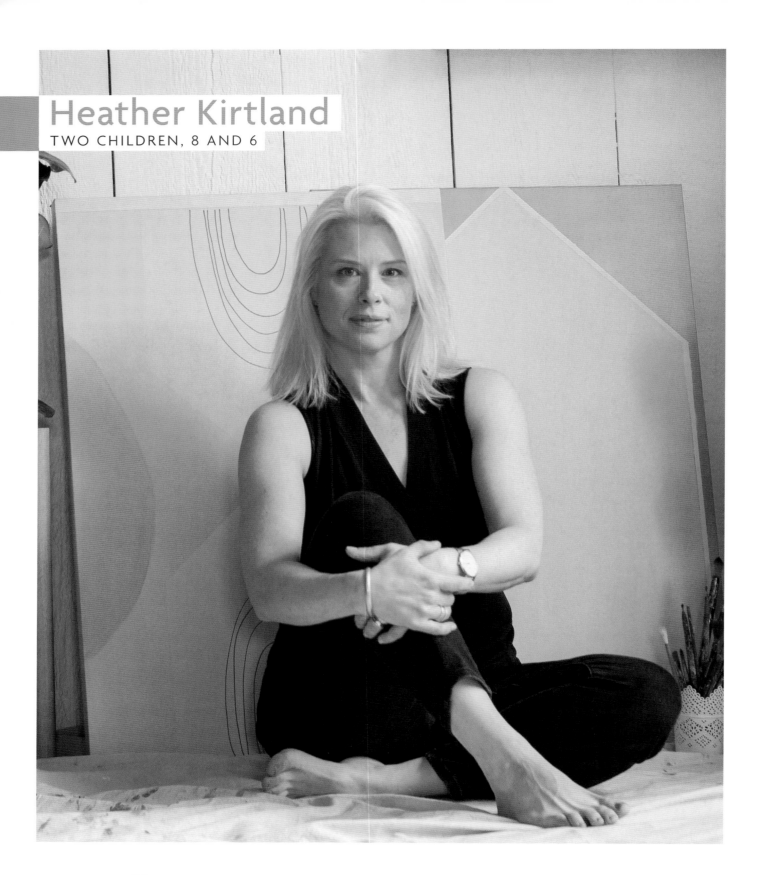

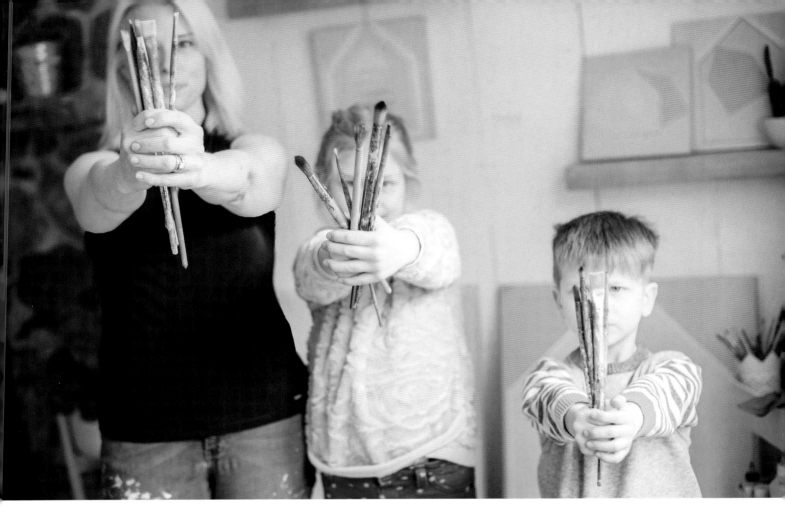

Why is it essential for you to create? What happens if you can't have this time?
I think it's just built into me. I have always found a way to create, a way to be using my hands. Even during periods of my life when my studio practice was interrupted, I would have another creative outlet going. It can happen subconsciously. So I seem to intuitively move toward that, the one exception being when I had my first child.

What does creative exploration mean to you? What does it look like to you?
Creative exploration takes so many forms in my process. I underestimated how much "psychic time" it required until I became a mother. I need mental and physical space to really process an idea, to be able to push it to the next level. There is also the element of sketching and playing in the

studio. One drawing seems to lead to the next, like a continued conversation.

Did you think you would need to stop making work once you became a mother?
No. I knew my life would be radically changed, but I greatly underestimated how much my identity would be swallowed up. If I couldn't find time to do basic life stuff, how was I going to carve out time for a studio practice? I was terrified that my creativity would dry up and that it was finite. I desperately tried to find examples of artist mothers and couldn't. I was mourning the loss of the person I was before I became a mom. Tied up in all these emotions was all the guilt I felt for feeling them. This wasn't what I was "supposed" to be feeling. My other close mom friends weren't creatives,

Photographs by
Little Cuddlebug
Photography

And please remember that creative pursuits do not have to be in conflict with parenting.

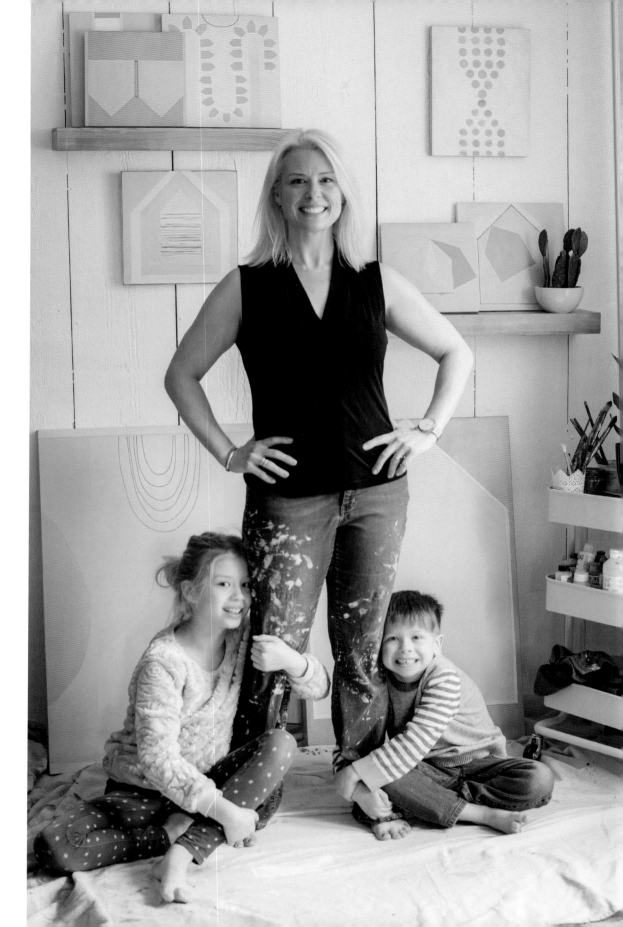

and I didn't feel like they would understand. I kept it all to myself. Not a smart decision.

What ideas or themes do you explore in your work?

I create abstractions based on an element, currently the house form, that represents a persona. My compositions then create environments and situations that explore the human condition. I want to talk about how we are each so unique as individuals, and at the same time, we feel all the same emotions.

Do you come from a creative family? Was there support in your endeavors?

Oh yes! They don't seem to consider themselves creative, which is crazy. My mother can teach herself to do anything. She comes from a large midwestern family, and all of my aunts are exceptional crafters. I grew up watching her tackle any project that came her way. She was always creating in some way as well. She made my clothes, upholstered furniture, caned chairs, canned food, refinished and repaired all sorts of things, did needlepoint, crocheted—I could go on and on. My father was an avid gardener who also built elaborate play sets and clubhouses for me. He also had an extensive model railroad layout in our basement, where he painted the backgrounds and created the cities. My aunt is one of those cooks who make food an art form.

I watched them and they never seemed to doubt what they could do. It's no wonder that both my brother and I are in creative fields. He is an actor who cofounded the New Renaissance Theatre Company. They were always fully supportive of us and our passion to create, even as a career. In fact, knowing that my dad, who has since passed, had a desire for me to never put my art on the back burner, together with my mother's tenacity, was probably what brought me out of my postpartum slump.

What does your process look like?

The majority of my work is created from the process itself. There are times when I have mental space, and ideas start to flow outside the studio. When that happens I make sure to grab a piece of paper to capture it. If I'm lucky I will have a moment to fully process it in my sketchbook, but that is rare. Then I use this sketch as a jumping-off point once I am in the studio. My various bodies of work are approached differently from one another. If I am working on a portrait, that starts with a picture on the computer. Then I create a red ground on canvas or panel and do a loose drawing before I apply paint.

When I'm working abstractly, I typically start with a color palette and loose composition. As I work, things evolve and change within the composition. I am always working more than one abstract painting at a time. I love the way they inform each other and force the work to grow. It feels intuitive and magical. These paintings are done in my home studio, where I mostly work

Photograph by
Heather Kirtland

Often when I feel burnt out, I just scale back the business side of art and keep painting. Reverse the percentages to 80 percent painting / 20 percent business, and life is good.

in acrylic. It's a corner of my den that feels cozy and, when I am working, a million miles away.

My encaustic work is done in a garage studio, which is better for ventilation. Even though the season can make it a bit uncomfortable, I do like feeling like I'm close to the outdoors. It's here that the medium informs my work the most. I love the tactile quality and the ability to carve into the surface. It always challenges me and pushes my ideas. Honestly, working with the blowtorch always makes me feel a little badass too.

What was the first thing you remember making after having your first child? What was that like?
I really wish I could remember the actual first painting. It was encaustic. And I had finally come to terms with knowing that I was worth it, and so was my artistic practice. I was able to find my confidence again and ask for time and help. Just being able to create again started a snowball of work.

How do you know when to walk away versus overwork a piece of art or project?
For me, this has become less of an issue in motherhood. The definitive breaks in studio time let me walk away, and returning fresh helps me access the work in a better light. It has also taught me how to deal with a break in momentum better. To trust that I can return to that space.

Did you have formal education or apprentice to learn your craft or work?
I attended a fine-arts painting program. I felt strongly about wanting to go to a college with a strong studio program. I went into it thinking that I would probably work a regular job once I graduated, and my extra time would be spent in the studio. I was fine with that. Yet, I wanted a strong foundation to be able to do that.

What do you want to tell to future generations of women?
To be mindful of the outside definitions sneaking in. By this, I mean the constant barrage of messages telling us who we can be and what we can do. It makes it so confusing to see what truly lies within you and to be true to your heart's desires. I would also encourage you not to wait till everything is perfect, the perfect idea, the perfect studio space. Do the work and the ideas will come. You may be limited in what you can create with the space that is available to you, but don't let that stop you. These limitations may turn out to be what drives the work in the end.

What keeps you going during tough times?
I try to focus on taking care of me. I know it's easier said than done, but I look at the situation

and if I can find a way to "fix" it, then action helps. If it is out of my control I try to focus inward on what I can do to make me feel better. Read, talk to my best friend, spend time alone, or take a walk. Knowing that I've been through tough times and that I'm still here able to laugh and enjoy the good times is always a good reminder that this too shall pass.

What does self-care look like to you?
I am adamant about my bedtime schedule, and I really think getting enough sleep makes things easier. I try to get outside every day, no matter the weather. Lately, I have been scheduling time on my calendar to do something just for me. I set aside a day when the kids are in school, get a massage, go to the movies alone, read a book, or binge-watch something.

Do you have moments of resentment or longing for freedom?
Oh yes! I have fantasies about traveling, not having to check in about making a decision to do something, having an empty, clean space of my own to work in, etc.; to be untethered. It's easier to dream about when I have all these wonderful things in my life that anchor me. And I am beyond grateful for our home and family. But I still dream about alternate realities.

Was there a moment or time when you could not see how you could make things work? How did you get through that?
When I became a mother. My daughter was not a good sleeper, probably colicky. I was nursing, beyond sleep deprived, and my husband was working crazy hours. This, along with thinking I was supposed to be able to handle it on my own, was not a good combination. I really thought it was the end of me being a "real" artist. I wish I could say I had an "aha" moment. But at some

Photographs by Little Cuddlebug Photography

point, I didn't like feeling helpless and gave myself a reality check. How can I change this? What power do I have in this situation? I finally asked for help. I reached out to my support system (my mom, aunt, mother-in-law, husband) to spend some time with the kids so that I can get some studio time in. (I realize how fortunate I am to have them.)

At first, I felt like everything else had to be finished first—laundry, groceries, cleaning . . . then I realized these never have an end. No one was judging me except myself. And "Myself" recognized that for me to be a good wife, mother, and person, the chores can wait and I need to be able to create.

Do you have moments where you have so many ideas you could fill an entire sketchbook?

I do. When that momentum gets going, it is frenetic and hard to stop. Everything else falls to the wayside, and my studio practice is all encompassing. I hate to admit it, but when I have these moments

I am in a constant state of distraction, thinking about ideas and compositions. It's thrilling and a bit manic, but such an amazing component to my creative process.

What was a big goal or dream that you accomplished?

This very book you're holding in your hands right now. I am overwhelmed just typing that sentence. I have learned so much about myself in this journey. The power of speaking your dream out loud, the tenacity to regroup when you hit a roadblock, the confidence to know that this passion project is important and needs to *be*, and the fulfillment of sharing that dream with someone who was once a stranger and is now a dear friend and partner!

How do you keep from comparing yourself to others?

I don't know that I can help it, although I have come to approach it from a different perspective. I try to access what it is I am drawn to or jealous

Photograph by
Heather Kirtland

of. Why? Pin pointing the "why" can be a great tool to steer yourself to what you truly want. I also am aware that each of us has our struggles, limitations, and doubt.

Do you compartmentalize your life and roles?

This is in a constant state of flux. I do try to. I find that I can be more present when I do. I try to *be* with the kids when they are home from school. I love creating a list and organizing my calendar. I will sit down and color-code blocks of time off, kids' sports and events, family obligations, date nights, studio time, and office work. Knowing that I have time dedicated to each area of my life allows me to focus on the moment I am in. If I can protect my studio time from other scheduling creeping in, I do. Yet, as a parent a lot of the time you have to pivot and be flexible. This is where I think the illusion of "balance" can screw us up. Any given week, I may have a studio deadline and I have to ask my family to bear with me. Or there are sick kids or snow days, and I may not be able to get as much studio work done.

What do you want to pass on to another mother?

You are made for this. Ask for help. Give yourself the grace to be in the moment, even if it doesn't look like you thought it might. Your creativity is there even if you're not cultivating it right now. Your life is different, and you will discover yourself all over again. In a new way, and in an even better way.

What do you wish you could tell yourself as a new mother?

You are not expected to do this by yourself. Do what makes things easier even if it's not perfect. Supplement if that means you are less stressed. Keep the baby in your room if that means you'll sleep better. Ask someone to take over for one night, to get eight hours of sleep.

Photograph by Heather Kirtland

Ask for help, talk to other mothers, reach out to creatives, find time to just be you. It's not selfish to require space, because if you're not okay, you can't be the best for your family. Most of all I wish I knew that being a mother and having a creative practice was possible and that I was at the beginning of what would be the most-fulfilling moments of my life and my most creative period as an artist.

Becoming a mother allowed me to be more fervent in my creativity and more industrious with my time.

Was there specific advice or commentary about becoming a mother that made you angry?

I heard over and over again in art school that it was either one or the other. That being a serious artist meant not becoming a mother. I had hope that over a decade later that things had shifted, but I couldn't find the mother/artist conversation happening anywhere. When I was struggling with my identity as an artist and new mom I tried to Google variations on the topic and only got information on famous male artist mothers.

Do you experience guilt as a mother? What are your thoughts on this?

Always. I wish I could say I didn't. I do think I have a better handle on it thanks to compartmentalizing, and valuing my own needs more.

How do you handle people in your life who criticize or diminish your creative pursuits?

If the person is close to me, I am ashamed to say, it will crush me. It takes me awhile to crawl out from underneath believing their words as truth, and realizing that their judgment has more to do with themselves than me. After surviving grueling critiques in classes, I have developed a fairly tough skin in response to comment from anyone outside my inner circle.

What has your role as a mother taught you about yourself?

That I am capable. That's given me confidence as I navigate hard things.

Did you experience postpartum depression or "baby blues"? How did you find the support you needed?

I definitely suffered from baby blues with my first daughter. I didn't realize it while I was in it. Mostly because I had no ideas about what was "normal." I was afraid of being judged when I wasn't blissed out about my new baby. I really wish our postnatal care of mothers was as comprehensive as it is during pregnancy. The postnatal care seems to highlight the fact that in this whole process, we are secondary to our child. And at that point I would have done anything for the health and happiness of my kids, but I didn't realize that taking care of myself is a part of that.

What do your kids teach you about life and yourself?

How truly simple joy can be. To take me less seriously. I love to see them create without a filter, and I try hard to emulate that. Parenting is like turning a large magnifying glass on yourself. They really do emulate your behavior. I am forced to take a good hard look at my habits and behavior.

Tell us about a role model or supportive person in your journey.

My family makes it possible for me to continue to get into the studio. My husband has a very demanding job and crazy work hours. He is a big support with the business side of things and is the best at surprising me with electronic gadgets that make life easier.

My aunt is my main source of childcare, and she makes my house run so much smoother. I don't know how we would have this life without her. My mother is an amazing role model, and champion for my artistic journey. She takes the kids on adventures on my studio days. My mother-in-law helps so much too. She loves spending time and is always there to offer her time. This is crucial to my art but also such a luxury for the kids to have so much time with these women, and I love how close their relationship is. My best friend is a theater director and is always there to listen and offer advice. They are my village.

Did you experience a sense of loss or grief for the life you had before you became a mother?

I felt like I lost my identity. I didn't know how to define myself. A big part of that was I couldn't find examples of what a mother-artist's life looks like. About the time my daughter was a year old, I came back to myself and decided I was the only thing standing in my way. I could ask for help. Once I made that conscious decision, the floodgates opened and I looked at creating in a new way.

How does being an artist / creative person influence you as a mother?

I hope as a mother I encourage my kids to think about things from a different angle. I want them to take notice of the world in a wondrous way and understand that the way they see things is advantageous to them. It is a way to find joy all the time. Being creative can help fulfill a need and be an anchor to return to when you need it. I also want them to know that they can do something they love and find a way to make it happen. I feel like an artistic practice teaches a type of ingenuity and problem solving that can serve them well.

How does being a mother influence you as an artist / creative person?

I have become much more prolific in the studio since becoming a mother. I've been able to focus more and trust myself. I am much better at time management and being kind to myself now. I have

Photograph by
Heather Kirtland

gained such confidence in my work, and I have no doubt that navigating motherhood gave me that. Being a mother has become the antithesis of everything I feared. It's certainly a lot harder, but that makes it more rewarding.

Has becoming a mother changed what you want to do with your work? How?
In a sense, yes. It has given me this insatiable drive to encourage others. Particularly those that feel they can't find the space in their lives to be creative. It has uncovered a more intense need for connection and artistic community. I don't want to just be an artist . . . I want to be a champion of other artists.

Describe how you find ways to make work and keep at it through changing seasons of life.
I have broadened my definition of what my practice looks like. I have more confidence in the ebb and flow and certainty that even if I am not in the studio at this period, I will be. I know I need to take a step back at times and reassess where we are as a family, and have a realistic expectation of project timelines. I may say "not right now" to some opportunities and approach them again when possible. I do try to continue to be active in my sketchbook and journal as a lifeline and to stave off grumpiness.

How have your studio practice and art changed over time? Especially before and after children.
Since having children it has become more focused. There is a lot less wasted time. Even though there is still time I set aside to just play when possible, I enter the studio most days with a plan. Before kids, I questioned myself so much more and would spend too much time overthinking and assuming

I needed to have it all figured out. That would lead to paralysis. I think overall I spend more time in my studio than I ever have. I allow it to feel like a meditation on the good days and get lost in the act of creating. A freedom that I didn't allow myself before. My art is more open, more playful, and I feel like I have a better sense of the vulnerability in it without the fear attached.

Share your tips on finding time to create when you have a baby. Small children. Older children.

The big lesson that I learned about myself by the time I had my second child was that it was okay to give myself maternity leave from the studio. Having learned that my creativity wasn't going anywhere, like I had worried when I had my daughter, it allowed me to relax into that fourth trimester much better. Yet, when you feel you need it, ask for help! Communicate to those around you that you need some time to create, and take the time you can. As my children have gotten a bit older, it's a combination of finding things for them to work alongside me with drawing, Legos. and reading to me (my favorite). Most recently I've been able to talk with my daughter about what I am doing and why it's important to me and how she can help me accomplish it. Talk about rewarding!

How have you overcome struggles or times of feeling overwhelmed?

Triage. I sit down and make a plan. It gives me the illusion of being in control. I decide what really has to get done, and focus on that. Then I try to find time to do something simple that makes me feel better: reading, exercise, rest, a long talk with my bestie, or a date night with my husband.

What helps you through creative slumps or times when life is full?

I try to accept that this is all part of the process. If I can find the time, I sketch with no agenda, go for a walk, focus on my kids. I make sure I am getting enough sleep and exercise and focus on taking care of myself.

What is something in your life (or creative pursuits / art) that you never thought you'd accomplish but did?

This book!

What do the easy times feel like?

They feel like it's all rolling smoothly. Kids are happy and healthy, the house is clean, the studio is full of good work, and my husband and I have a moment to enjoy a glass of wine and acknowledge that indeed life is good.

What barrier or circumstance do you wish you could change? How would it affect your life or work?

I don't think I want to refer to it as a barrier, because it hasn't held me back exactly. I really want to build my dream studio. A place of my own, where I can invite other artists in, teach a bit, and work on a large scale.

Describe a time when you felt exhilarated—like anything was possible.

While finishing this project. I had such an intense feeling of being on the correct path, and it truly felt like the sky was the limit. ▨

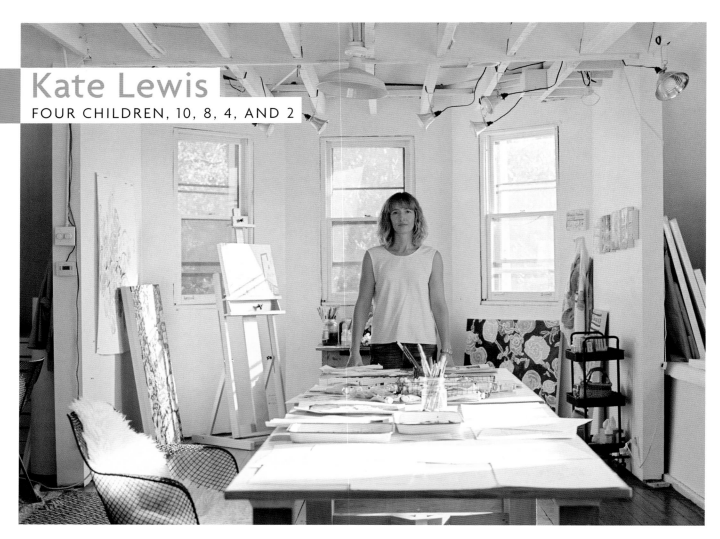

Kate Lewis
FOUR CHILDREN, 10, 8, 4, AND 2

Photographs by
Simply by Suzy

Why is it essential for you to create? What happens if you can't have this time?
I get antsy. I don't feel grounded if I don't create. The more I create, the more energy I have to create even more, not only in the studio but in other areas in my life. Creating is my fuel for living a full life.

Did you think you would need to stop making work once you became a mother?
I never even considered stopping my studio practice once I had kids. I remember trying to prep my studio (which was outside my home at the time) as much as I could while pregnant with my first child. I had a Pack 'n Play and a little floor rocker swing. I was envisioning the baby sleeping soundly while I created. I think that happened once.

Do you come from a creative family? Was there support in your endeavors?
I do come from a very creative family. I'm actually working on a collaborative project right now with my mom, who is a potter. My father is a woodworker and my grandmother and great aunts were always making, quilting, sewing, cooking, and crafting. My parents were very supportive of my creative endeavors and did not resist my intention

to study art in college and pursue it as a career. Also, I grew up surrounded by a family of farmers, who I think are some of the most creative, inventive, and hardworking people.

What do you want to tell to future generations of women?

Be obedient to your call and do the work. Follow your call even if you think it seems selfish. It's not.

What does self-care look like to you?

Self-care means knowing and taking time to step away and be alone with my journal or in the studio. I've slowly learned over the years that I need time alone to recharge. With four kids, that can be challenging, but it's the greatest gift I can give myself. Also, dedicating time to move and connect with my body paired with eating a clean, whole-foods diet is essential to my self-care practice.

Do you have moments where you have so many ideas you could fill an entire sketchbook?

I often have moments of overwhelmingness and frustration because I have so many ideas that I could fill up multiple sketchbooks/canvases/walls, etc. I get frustrated with time, and this has been an ongoing, internal battle for me. I would love to be able to execute ideas when they surface, but that's just not happening. I have come to peace about this by likening it to Darwin's theory of evolution by natural selection. When I do have the magic of time, energy, and focus present, only the best ideas are borne onto the canvas. Lately, I'm taking on narrowing my focus and going deep into one idea at a time, and trusting that the others will be there when it's time. When I allow myself this freedom of focus, it gives me peace. And I'm not irritated when I leave the studio.

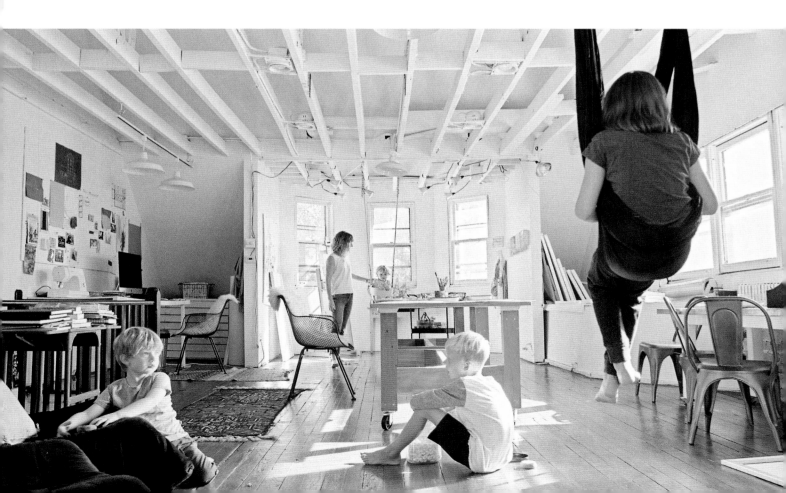

> I deeply longed for separation and felt my work calling me to dive deeper. I longed for space that was only mine.

Do you compartmentalize your life and roles? Why and how so?

This has been an evolution for me. In the first nine years of motherhood I did very little compartmentalizing of my roles. I was all in when it came to mothering, being a wife, and being an artist. I tried to do everything for everyone at all times. However, until my youngest was one year old my kids shared the studio with me. It was a combo playroom/studio and made for beautiful social media posts. At the time it was what I needed and what we all wanted. I wanted to be with my kids all of the time. I wanted to know what they were playing with, how they were developing, etc.

However, something switched for me after my youngest was one. I deeply longed for separation and felt my work calling me to dive deeper. I longed for space that was only mine. Fortunately, we were able to make room in our house elsewhere for their toys, and I was able to spread out and take over the entire top floor of our house. The physical action of moving their toys out of the studio was a real and tangible way for them (and me) to see me as an artist. It was not easy for me and clearly took time—nine years! Now, it has been almost two years with the studio set up this way, and I can feel my work expanding because of it!

What do you wish you could tell yourself as a new mother?

Relax and enjoy. Know that there is not one right way for things to go. Each child is unique and you are unique. Find your path and embrace it.

What is the best advice on motherhood you received?

I'm not sure this is the best advice, but it's what stands out the most. At my first baby shower in my rural hometown in Tennessee, an elder told me to be sure to take the baby outside every day, no matter what the weather. I've tried to make sure the kids get out of the house every day, no matter what!

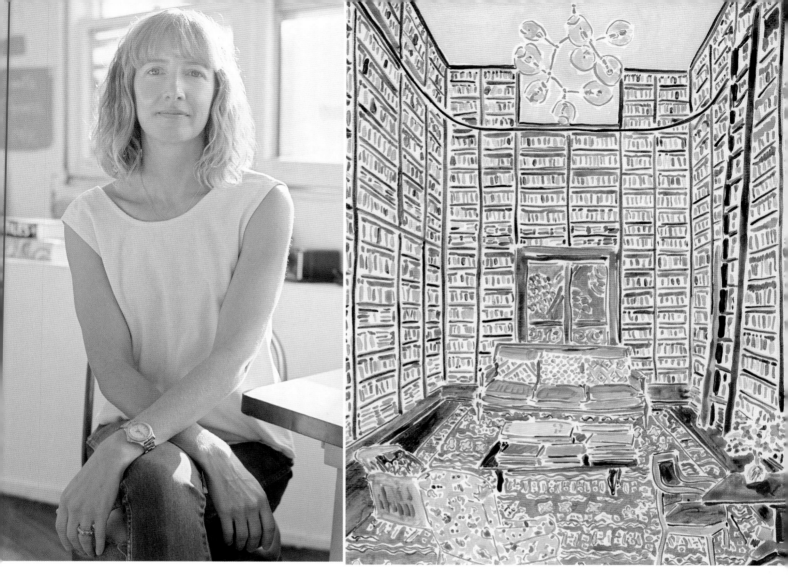

Do you experience guilt as a mother? What are your thoughts on this?

I experience guilt all the time about almost everything. I acknowledge it and move forward anyway.

What joy does being a mother bring to your life? What hardships?

More joy than can be expressed. The joy of having a front-row seat to watch (and help guide a little) someone's life on earth is awesome. Accepting and championing each child's unique abilities and gifts is both a huge joy and great hardship.

Describe how you find ways to make work and keep at it through changing seasons of life.

I find that during the day when the children are at school or with a sitter is the optimal time to create. As the seasons change I've found that my most productive seasons are fall and spring, when the kids are in a groove. Winter, with holidays, school breaks, and dark days, is not my most productive time, nor is summer. I'm slowly learning to embrace the seasons for creating, and learning how to work with this cycle instead of fighting it.

Share your tips on finding time to create when you have children.

While pregnant I found it comforting and motivating to have paintings started, so that once the baby was here I could jump right in and enjoy painting. Once the kids start becoming active, I find it best to create when they are either sleeping, at school, or with a sitter. If the kids are around in the studio, I use this time as an opportunity to clean, organize, prep canvases, and talk to them about the work. I've found it's always a boost in confidence to get acknowledged by my children.

How do you deal with periods of no time to create or make things?

I don't like it, but I try to anticipate those times—school holidays, kids sick, vacations. I try to embrace the no-making time and tell myself it's fueling my work to be away from the studio. I used to bring a sketchbook or travel watercolors on vacation and never got them out of my bag. I would leave feeling frustrated and guilty for not creating anything. Now, I take advantage of the time "off" and fully engage with my family.

Does seeing the world through your child's point of view inspire you in your work?

Always. I find their views to be free, creative, and full of endless opportunities.

How have you overcome struggles or times of feeling overwhelmed?

Crying. Baths. Therapy. Lifting weights. Yoga.

What do the easy times feel like?

Carefree and peaceful. Beautiful weather. Kids happy and healthy. Husband working downtown and coming home early to cook dinner. I have uninterrupted time to paint in the studio with the windows open and sunshine streaming in. ■

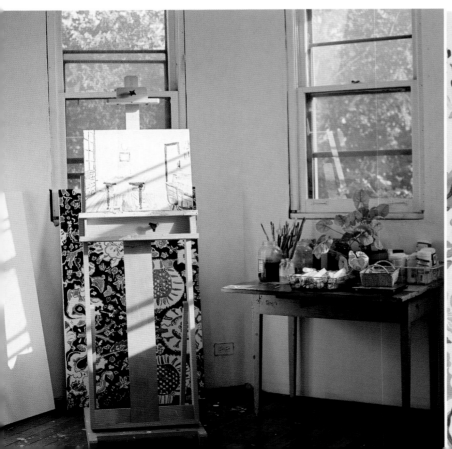

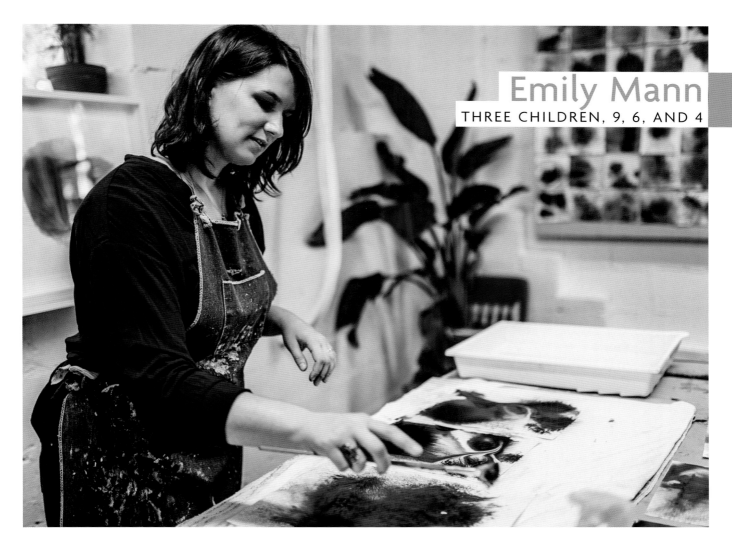

Emily Mann
THREE CHILDREN, 9, 6, AND 4

How has your studio practice and art changed over time? Especially before and after children.

I might be in the minority of people who really and truly always believed they would be an artist when they grew up. It helped to grow up in a family of craftspeople who were just always making things—"maker" seemed like a perfectly reasonable reality. As impractical as that may have been in actuality, there is no confidence quite like the very passionate / little bit ignorant artist who simply HAS to make art. In some ways this has always been my secret weapon and guiding star. I would be an artist because I am an artist, and making things is who I am. For me, the path to making this a feasible, fruitful reality goes straight through motherhood.

After graduating from college I went straight into a career in the art world, working at art-consulting firms and learning first hand what an art career could look like from the business and client side of things. These years I was largely working on a computer, in an office, and away from anything that remotely looked like a studio. Creative side hustles and passion projects consumed my free time, and for the most part I was satisfied with that.

When we found out we were having our first baby, my husband and I were in a big shift from working full time to enrolling in graduate school

Photographs by Amy
Parry Photography

113

programs—we were very much focused on shaping our future careers, moving away from our hometown, and doing all the things we thought people in their twentie's were supposed to do. When our first baby arrived, pretty much everything changed in that way that only babies can change things.

Almost from the start it was apparent that motherhood was not a side hustle, and my very sweet, impossibly loud, barnacle of a blue-eyed baby wasn't going to work with an accelerated graduate program, and she certainly wasn't having any of the daycare drop-off business I had always thought would be so easy. Leaving her in anyone else's care proved persistently dramatic and draining, and the adaptation phase never really kicked in for either of us. We probably didn't even make it six months or so before deciding that I couldn't finish grad school and couldn't really go back to work and do the full-time office thing anymore. We pulled my daughter out of daycare, and that little peanut rode in a sling on me all day, every day, almost all the way to toddlerhood.

It was during this transition from her infancy to toddlerhood that I started to shift my work focus more to what I could make and offer as an artist and away from consulting, where I was in charge of showing other artist's work all day, every day. Fast forward another five or six years, two more kids, hundreds of pieces of art, a bunch of amazing clients, and I was working nearly full time as an artist from a makeshift basement studio in our small ranch house. I got the most out of every inch of that space and every bit of time I could possibly squeeze out of a day. As projects and opportunities poured in, I felt more and more overwhelmed and frustrated. I had no free time, no free space, and I was limited to how I could grow my work in scale and production from our home. I was staying up till the wee hours every night to work so I could be with my little ones for the maximum amount during the day. I was cracking, and the situation was a strain on our whole family.

My breaking point might have been the ridiculous feat of creating a giant 25-foot piece of art in more than a dozen separate panels in the basement studio, which then had to be jigsawed together, that I finally admitted that I HAD to prioritize finding somewhere outside my house to work. This also meant getting more care for

our kids and asking for (and paying for!) more help with all of the daily logistics of family life. This shift to an off-site studio has totally transformed how I work and my relationship to my job and my kids. Motherhood has honed my time management skills, forcing me to be endlessly productive, motivated, and focused. It has not always been easy, and I feel like things are still always in flux and we are adapting as the needs of the kiddos and my work changes. There is so much cross-pollination and flow between my two worlds, but for the most part my studio is where work happens and home is where I can focus on all the other goodness in my life. The reality is that what I have today was simply not possible ten years ago, when I had a brand-new baby girl; the artist and person I am now is precisely because of the journey of motherhood.

There is certainly no one-size solution to making an art practice work for motherhood, but for me it's been really powerful to help me realize what I am capable of, and most definitely what I am not capable of, and to keep focused on what I value: creating and nurturing beauty, security, and self-expression. I'm hoping that my kiddos are experiencing and witnessing the joy that making every day brings to their mom and their lives. ▩

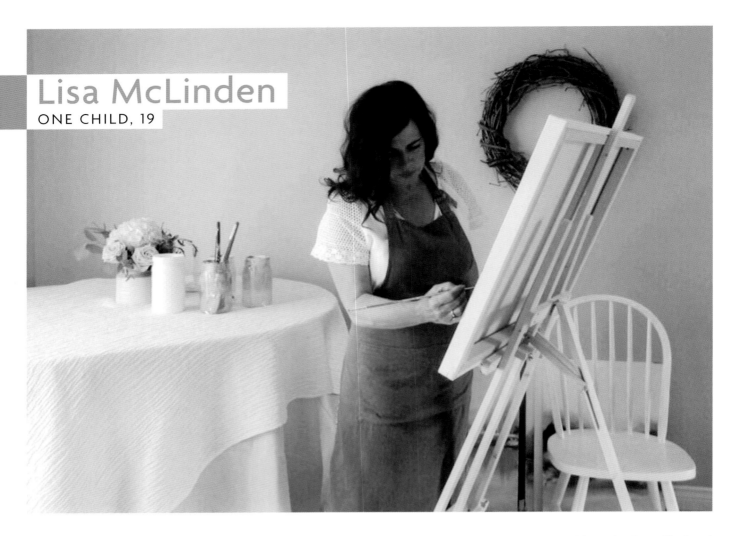

Lisa McLinden
ONE CHILD, 19

What does creative exploration meant to you?

Creative exploration transcends simply painting and begins long before I step into my studio. The moment I stand on the edge of the water or deep in the forest, the process of gathering inspiration begins. The stimulation of my senses, the foraging of twigs, rocks, and other collectibles, is equally important to the process of producing tangible art, such as painting itself.

Did you think you would need to stop making work once you became a mother?

No, never. I knew early on that in order to mother effectively, to be present with the love, patience, creativity, and immense nurturing that mothering demands, my cup would need to be refilled, and often. The only way for me to do that was to be in nature and to create. It was, and still remains, the single greatest outlet I have for processing emotion—good or bad.

What ideas or themes do you explore in your work?

A consistent theme throughout my work is nature. The interconnection between art and nature is so tightly interwoven for me, that to experience one without the other is nearly impossible. When in nature, I process all of life's beauty, mystery, pain, and tenderness and then pour the emotion into my work.

How do you know when to share something and when to keep it private?

This continues to present considerable angst in my life. I've painted a very long time, certainly long before social media and the ability to freely share what we create. Although I see some huge benefits is openly sharing work, I do think there are times that we need to hold pieces closely, privately, only for us to experience. Strangely enough, some of my best work is held privately.

Do you have moments of resentment of longing for freedom?

Watching my daughter enter young adulthood has been the most joyful period in my journey of mothering, but through this season of change, I've come to accept that I did indeed carry feelings of resentment—resentment toward the demands of mothering. I'm a nurturer by nature and overextended myself in so many areas of my life. I readily admit I parented for many, many years through a lens of guilt, and my art journey paid a price for this guilt. It's only standing here and looking back that I see this more clearly, vividly. My hope is that by sharing my experience with other creative women that they see there is another way, a path that allows us to foster the balance we need to live an authentic, creative life.

What do you want to pass on to other mothers?

The single greatest wish I have is that every mother has the knowledge, understanding, and belief that she is worthy. To truly live an authentic life believing that her goals, passions, fears, insecurities, and dreams deserve a voice and need to be heard. That only through example do we teach our children to pursue their passions, to experience their insecurities, and to triumph over fears of failure. We deserve nothing less.

What do you wish you could tell yourself as a new mother?

Oh, how I wish I could have whispered one, sweet, tender message to myself: "This season of your life will pull you in every imaginable direction. There will be days when you won't recognize the woman you've become, nor will you know what it is that brings you the greatest joy. But, in time, this season will pass and present opportunities to rediscover you! In the meantime, be kind and gentle, love big, and allow yourself periods of weakness and vulnerability. Rejoice in times of strength. You are worthy."

What are you most proud of as a mother?
Without question, I'm so proud that not only through words, but actions, I've demonstrated to my daughter to believe in possibility. To envision the life you want and to carve out a path to living that life.

Share tips on finding time to create when you have a baby.
I readily admit I was horrible at carving out time for art when my daughter was very young, and the single greatest reason for this was I didn't believe I was worthy—that my art wasn't worthy. I put the needs of everyone, everything, ahead of my own. I was miserable. So I soon recognized that I needed to make it a priority, for everyone's sake, for everyone's sanity. So, a creature of routine, I literally set a schedule that I adhered to for years. I painted three nights a week and one day on the weekend, and short of a catastrophe, I stuck with it. Soon, it became the norm and I began to accept that I deserved the time and space to create.

How do you deal with periods of no time to create or make things?
I learned early on to redefine what creating meant to me. I used to think it was about painting, to pouring onto a canvas, something tangible and relatable. When long periods of time would pass and time wouldn't allow me to create, I'd experience immense guilt and sadness, so I set forth to redefine my art practice. Creating now includes foraging in nature, seeking inspiration in music and magazines, making a vision board, spending time collecting images of inspiration from other artists, or visiting a local gallery or art store. It all contributes to the development of an artist. To simply stand in front of a canvas and paint is only one facet of creating.

Who is an artist mother you look up to?
I admire so many artist mothers, but at the top of my list would be Jodi Sparber. Her tender paintings, thoughtful messages, and never-ending support of the artist community is so authentic and refreshing. Even through grief, she managed to pull herself up and spread love and kindness to others. Truly, a remarkable human being. ■

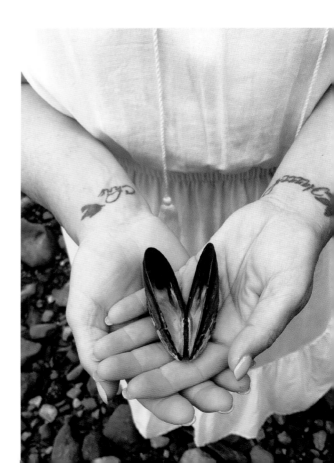

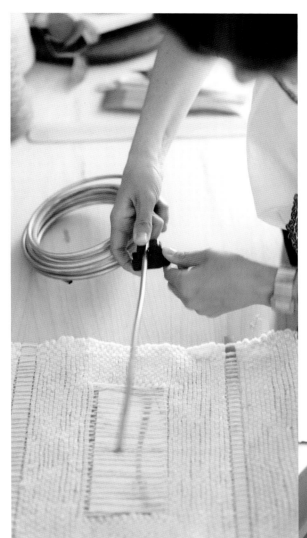

Maryanne Moodie
TWO CHILDREN, 5.5 AND 2.5

Why is it essential for you to create? What happens if you can't have this time?

When I am weaving for myself, I try to use it as an art therapy. Let's say I am feeling envious or anxious. I sit with an emotion and dawdle ideas on the page in a loose format of looking closely at the things right in front of me. Then I use some of these shapes to create a plan for a envious weave or an anxious weave. Then I allow my subconscious to work on the feeling while my hands are busy. I find a lot of peace working through these tough feelings in a really soft and nonjudgmental way.

Did you think you would need to stop making work once you became a mother?

I started making when I became a mother. It was the birth of my child and me as an artist.

Do you come from a creative family? Was there support in your endeavors?

Not at all. My family all made fun of me (good-naturedly) when I started weaving. My family are all very practical people. I am the youngest of six and by far the most creative of the family.

Photographs by
Paul Vincent

I started making when I became a mother. It was the birth of my child and me as an artist.

119

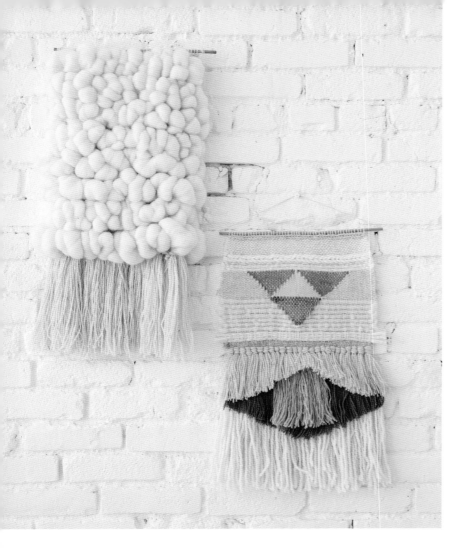

What was the first thing you remember making after having your first child?
I loved the way sharing my work on the internet allowed me to feel connected to the big wide world while I was tucked away in my little baby bubble. I loved the calming influence of repetitive movements during a time of crazy transition.

What does your process look like?
Usually two at a time; one for money (commissions) and one for heart / peace of mind. I always sketch a design and work out the color palette before warping up the loom to begin a piece. It may change over the course of applying to the loom, but I like to begin with some sort of idea.

What things do you do to continually learn, improve, and grow as an artist?
Always trying new fibers, effects and skills. I am a lifelong learner, and I love the challenge!

Were you self-taught? What did that look like?
A lot of trial and error. There were not lots of internet tutorials at the time, so I bought vintage weaving books and just played with yarn until it looked a bit like the vintage '70s wall hanging I was inspired by.

What do you want to tell to future generations of women?
SUPPORT EACH OTHER! It is not a competition. We need to share our knowledge and acknowledge our privilege and listen to the stories of others. Lift each other up and know when to shut up and let others speak.

What does self-care look like to you?
Yoga, lots of walking, eating the best I can, lots of cuddles from my family, checking in with each other that "Things are ALL RIGHT," and making small changes/alterations to make sure everyone in our family is feeling comfortable.

> We need to share our knowledge and acknowledge our privilege and listen to the stories of others. Lift each other up and know when to shut up and let others speak.

When did you first learn your craft/ medium? Do you have a strong memory about this?
I started to weave while pregnant with my first child. I was just trying to keep my hands busy while I was growing my babe. But it was like someone turned on the light, and I just wanted to weave every moment.

Was there a time when you thought you were not meant to make work?
No. I can work so flexibly around the care of my two children that it feels so natural. I also need the therapy of it to cope with the ups and downs of motherhood and family life.

Do you have moments of resentment or longing for freedom?
I would like more time in the day. I would love to be able to travel for longer periods of time and more often for work. I love the in-person connections created when I travel. But with two little guys, it is just not possible.

Was there a moment or time when you could not see how you could make things work?
We moved back from NYC to Australia. When we were all cooked, we knew it was time to head back to the softness and "laid backness" of home.

How do you keep from comparing yourself to others?
UNFOLLOW.

Do you compartmentalize your life and roles? Why and how so?
Yes. I have a studio that I work from three days a week. I leave my work there, and when I am home I can focus completely on my family and myself.

What do you want to pass on to another mother?
It doesn't "get better"; it just gets different. It is hard. It is so hard. No matter what you do to them, they will always be the little personality that came out. It is our job just to love them and support them.

What do you wish you could tell yourself as a new mother?
You didn't/won't/can't break them. They are their own little people.

What is something you needed to hear when you were in the early stages of motherhood?
Take on all the advice and pop it in your toolbox. Things change all the time, and one day you might

Photograph by
Julia Stotz

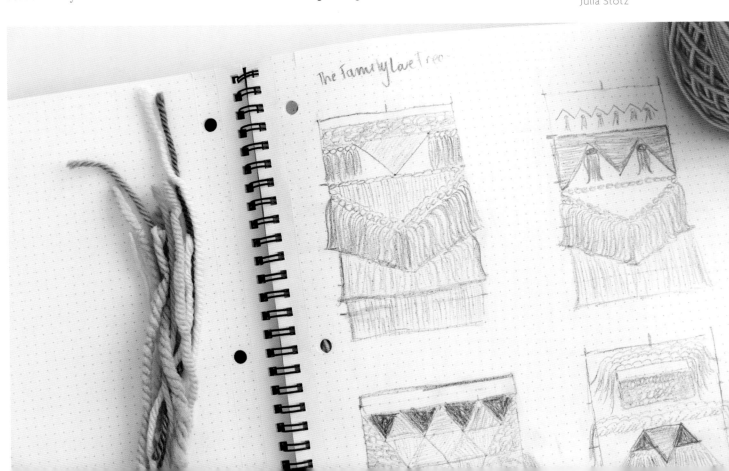

just need to try something different, and you will be happy that you didn't throw that one away.

Do you experience guilt as a mother? What are your thoughts on this?

I was raised a Catholic, and so I experience guilt over *everything*! I think having two boys who are *very*, *very* different allowed me to forgive myself. They both came out of the same mixing bowl from the same ingredients and turned out completely differently. So, I just have to love them and love myself 'cause there's no changing them.

What's the hardest thing about being a mother? The easiest? The funniest?

I think that the "ides of terrible twos" were the worst. My son was a perfect baby who slept and fed beautifully. So easy! Now he is very rigid and has been going through the terrible twos for three and a half years.

How does being an artist influence you as a mother and vice versa?

I have loads of creative things set up around my home for the boys. I try to encourage them to be creative and artistic, but they just want to run and climb and fight and ride! I try to be very sensitive to their emotions and struggling times. I try to empathize and give them the opportunity to work through emotions rather than using fists. This does not really work, but ya gotta give it a go, right?

Has becoming a mother changed what you want to do with your work?

Being very efficient. I have limited time to devote completely to my art, and so when I get into the studio I go for it!

What are you most proud of as a mother?

Just keeping it all together. It is a juggling act, and when things get hard, then you have to choose a ball to drop before one drops, and it might be

Photograph by
Paul Vincent

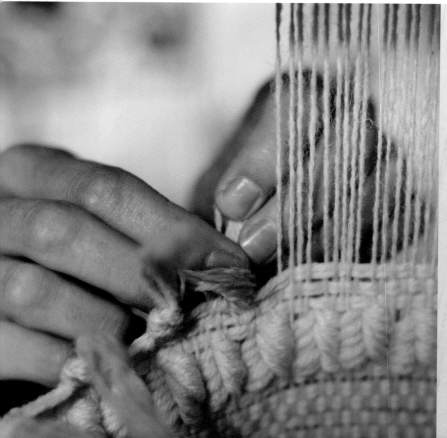

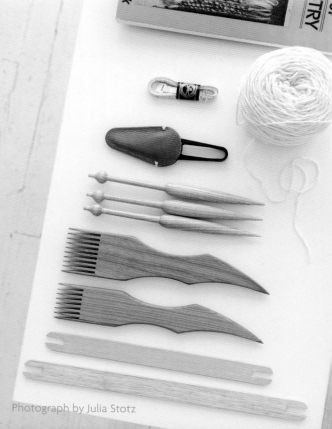

Photograph by Julia Stotz

one that you don't want to. We are super flexible in my family, and I am privileged that my husband has a full-time job, and so I can have time to devote to both my family and my art.

Describe how you find ways to make work and keep at it through changing seasons of life.

I have a few different parts of my business (kits, workshops, and weaving commissions) that require different levels of energy and time and involvement. I can be flexible depending on what my family needs.

What has one of your biggest struggles been as an artist? As a mother?

I guess the balance is the struggle, right? And you might get it right for a moment before it all changes. Having a supportive and nurturing husband really helps!

Share tips on finding time to create when you have a baby. Small children. Older children.

It takes a village—whom you pay—to raise a child. Currently, my kids have care or school three days a week, and as long as my work pays completely for the childcare and the rent of my studio, then it's all good. If my work doesn't cover the costs, it is time to let the studio go or cut down on paid care.

How have you overcome struggles or times of feeling overwhelmed?

My friends and family. Speaking about it with them face to face and showing them that I am struggling and need help. People can help you only if they know.

Describe what the feeling of flow is to you. What does it mean to you?

A meditation at the loom where my hands are busy and my mind and spirit are free. A place where I am able to really connect deeply with myself, without all the bullshit of expectations. A moment where I am both fully conscious as well as in a dreamlike state.

When was a time you felt like giving up? How did you get through this?

Finance stuff has always killed me. Its not my wheelhouse, and I have always handed it off to others. I think it is still my challenge, and I need to know more about that side of my business. ▪

Photograph by
Julia Stotz

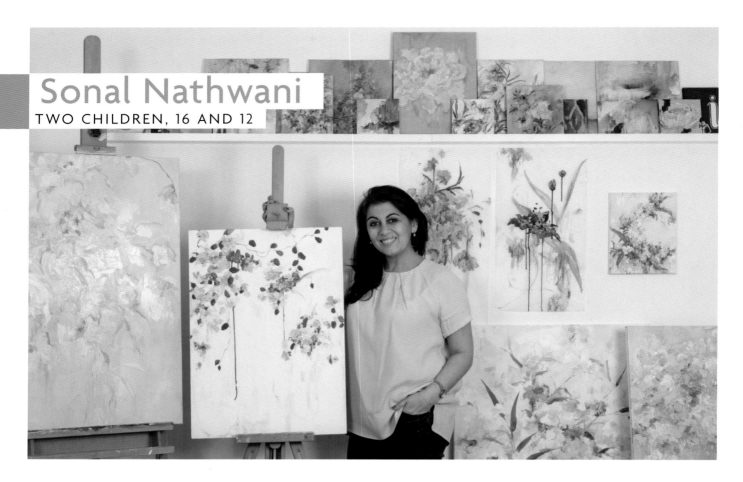

Sonal Nathwani
TWO CHILDREN, 16 AND 12

Photograph by
Miriam Mehlman

Why is it essential for you to create? What happens if you can't have this time?
Simply put, if I don't create, I become grumpy. If I don't create, I feel unproductive and agitated and unbalanced. It doesn't have to be a fabulous, large oil painting; even a simple pencil sketch is enough to alleviate this compulsion to make something where there was nothing before. A doodle a day keeps the doctor away.

What does creative exploration mean to you? What does it look like to you?
My whole life is made up of moments of creative exploration. Sometimes just the act of looking out my window (which I do countless times a day) can ignite an idea. Exploration implies trying to find new things. It's the concept of being receptive to even the most ordinary things or moments and finding a sliver of beauty in them, which then

compels me to pick up my pencil and make my mark. Each time I pick up a pencil or brush is creative exploration.

In a more general way, creative exploration involves just having fun with my materials without worrying too much about the outcome. Nothing has to be permanent, and over the years, art making has become more intuitive and a free-flowing activity for me. There will always be challenges when you want to create something . . . this is simply part of the art-making process. I'm no longer afraid of creating something ugly—ha!

Did you think you would need to stop making work once you became a mother?
Not at all. It was quite the opposite for me, in fact. Having a child made me realize how wonderful life can be. Becoming a parent makes you see time in

124

a different light. I'm not talking about the very early months, but once my baby and I had learnt to get used to each other, I wanted to use any precious spare time to paint. It was my "me time," and it gave me sense of escape from the challenging aspects of early motherhood.

What ideas or themes do you explore in your work?

It's taken me years of practicing painting to develop a style that feels authentic and honest and somehow natural now. Nature is my infinite source of inspiration. My abstract floral work began as a simple exploration of color and mark making. Having created hundreds of pieces over the past couple of years has made me realize that what I am actually doing is creating a sense of beauty out of a mishmash of colors and scribbles. I like to think of it as creating some order out of the chaos. Like life itself, I suppose. I also wholeheartedly embrace the beauty of imperfection in my work because we all are a little imperfect and that's what makes us all special.

What things do you do to continually learn, improve, and grow as an artist?

Draw, paint over ugly paintings, read, do other nonart activities that make me happy.

How do you know when to share something and when to keep it private?

I would classify myself as a friendly shy person, so I generally do not have the urge to share too much of my private life. I have a quiet nature and was brought up to keep personal matters within the family. I think that still affects what I am comfortable in sharing. However, with regard to my work, I've learnt that for my art business to grow I just had to overcome those fears that many of us have of not being good/interesting/exciting enough.

To be honest, having had an overwhelming positive response to some of my work has make

me more confident and less precious about sharing it. I love that it is possible to inspire people all over the world just by posting a sketchbook page.

What keeps you going during tough times?

Things are changing continuously, and I know that while some days are difficult, I have faith that things will change. I am not afraid to take time off when I need to. Reading self-help and spiritual texts often helps make me feel better in the moment, as if by magic. I also try to cultivate the practice of gratitude, so that I see all the beautiful stuff in my life. Even when times seem tough, I am well aware of how privileged we all are here in the "first world."

and I remember the thought when it originated. There are some days when everything I think about seems possible . . . and over time I find out that most of them are.

What do you want to pass on to another mother?

You're doing the most important work there is—raising a human being is a superhuman task, and you're doing it. You're amazing, you're beautiful, and you are loved.

What do you wish you could tell yourself as a new mother?

It's not easy and that's okay. Everything is a phase. Some days are going to challenge you to the core, and some days will be truly blissful . . . and that's okay. Things are changing all the time. You are trying to do the best you can, and there is no such thing as perfect . . . and that's okay. Your baby is not you. They have their own light; you have to help him/her learn to see what makes that light shine.

Why do you think so many mothers express that they're not good enough? How can we support each other and shift this?

We are continually exposed to the images of mothers who are 100 percent present for their family; mothers who are patient and kind and understanding while achieving success in their careers or following their dreams; mothers who make their homes beautiful. This, of course, makes the more-average ones among us make us feel like we're not good enough. While on the one hand it can inspire us into thinking that we can have family and career or whatever we want if we just make the effort, the depiction in the media of the perfectly groomed, happy, calm mother who feeds her family with wholesome meals and has immaculate wardrobes is just an illusion. Most of us do not have a limitless well of time, energy,

Most of us do not have a limitless well of time, energy, money, good humor, and patience so we just have to do what we can in our given circumstances.

What does self-care look like to you?

Taking a nap whenever I feel like it. Making time to listen to music, read books, and talk to my favorite people. Also, generous quantities of peanut butter on apple slices.

Do you have moments where you have so many ideas you could fill an entire sketchbook?

Very often, ideas seems to fall into my head when I'm walking either to or from my studio. It's a ten-minute walk through a residential area that isn't particularly beautiful, and I'm there on that path almost every day, so it's not anything new that I see. Yet, there is something about that little walk that frees up my mind and makes it receptive for new things to enter. I might not always act on each idea, but sometimes the seeds grow over time and finally something appears on the canvas,

money, good humor, and patience so we just have to do what we can in our given circumstances. Comparison is indeed the thief of joy.

If we are open and honest in how we are handling whatever challenging situation we are dealing with, it can show other mothers that everybody struggles. Social media only gives you the sparkling glimpses of a person's life (and that's why we all love it so much), so it's especially good to meet local mothers in person, if possible. Above all, remember that being a mother is not a competition.

What joy does being a mother bring to your life? What hardships?

The joy is indescribable, and it's not just on big days like birthdays and graduations and concert or theater days; you experience it in the moments of everyday life. It is beautiful and it might be transitory but it lingers in your psyche, like poetry. The difficult part of motherhood is the never-ending worries—the desire to protect them, while at the same time wanting them to be able to live without you . . .will they be happy, will they be successful in their endeavors, will someone break their heart? Will they be able to handle the big, wide world? Another hard part of motherhood for me was learning to cope with the continuous list of household chores . . . it's not easy and it's not fun, but it has to be done. Sometimes it is overwhelming, and we just have a happy, messy home for a while and let that be okay.

What has your role as a mother taught you about yourself?

I can do stuff . . . a lot of stuff . . . a lot of different stuff . . . all at the same time.

How does being an artist influence you as a mother and vice versa?

I tend to see beauty in ordinary moments. I trust my intuition and I enjoy a free spirit. Like all artists,

I have a heightened sense of seeing the details. I use these traits in all aspects of my life, and this has made me more accepting and open toward my children's needs. I am aware that each of us is a unique individual and may or may not fit in with what we are "normally supposed" to do to be seen as successful. Being a mother has shown me that mental flexibility is important and necessary. Motherhood is so much more fun if you can "bend the rules" when you feel you have to. It is much the same with art.

Above all, remember that being a mother is not a competition.

> Although I might not be able to work on that inspiration immediately, I know that it has entered my subconscious and it will reappear when I'm ready.

What are you most proud of as a mother?
My boys are nice, kind, intelligent, funny people.

Describe how you find ways to make work and keep at it through changing seasons of life.
Flexibility is the key concept here. I try to be aware of changing energy levels and the time I have available each day. It is not easy, but I try to focus on what is important at that time. I take advantage of days when I really feel like making work. On days I don't or can't for whatever reason, I've learnt to be gentle on myself.

When the boys were small, I had much less time, and so I worked late nights on the dining table. I wasn't selling much work then, but I was still creating regularly. I was driven in a different way then and was still trying to prove that I could be an artist, because I wanted it so much. Now I gratefully have a studio and more time (as teenagers don't always want to hang out with their mother—ha!). Some days I paint for many hours—and it is exhilarating—but sometimes due to life, it might just be for half an hour, and I accept that too.

One thing that has not changed over time is my desire to keep getting better and learning how to develop my art. As long as I have that, I'll keep creating.

What has one of your biggest struggles been as an artist? As a mother?
The feeling of not being good enough; this applies for both roles. However, when you keep doing thing over and over again, you do get better, of course. So, over the years, I've learnt to see that I am good enough, in both roles.

How do you deal with periods of no time to create or make things?
I doodle and sketch even on scraps of paper. Even a five-minute sketch activates that happy feeling.

How have you overcome struggles or times of feeling overwhelmed?
I force myself to just stop and rebalance by asking why I'm feeling whatever it is that I'm feeling. Often it's just a case of realizing that the world is not going to end if I can't manage something. Although we hear it all the time, I have to remind myself that the way forward is one step at a time.

What helps you through creative slumps or times when life is full?
First, I accept that it is completely normal to have a creative slump sometimes. To help me through it, reading books about artists or anybody I find remotely interesting always manages to create a spark of inspiration, and although I might not be able to work on that inspiration immediately, I know that it has entered my subconscious and it will reappear when I'm ready. Also, a stroll outside, a simple sketch, or a quick scroll through my favorite florist feeds on Instagram is often a quick fix.

What is something in your life (or creative pursuits / art) that you never thought you'd accomplish but did?
Having thousands of people from all over the world who are interested in my work and being able to connect with them. ◾

Why is it essential for you to create? What happens if you can't have this time?

I'm an introvert driven by an insatiable desire for self-expression. Even if I don't channel that into creating something with my hands, or speaking out loud, I will still find a way to express my mood/thoughts/creativity through my hair, clothing, how I carry myself.

Creating is literally like oxygen for me; it's how I live, even if I haven't touched a paintbrush or written a word in months. If I don't express myself or create anything at all, it's usually due to a pretty severe depression or side effects of medication that have dulled my senses or given me such intense brain fog I can't really function.

Tell us about your work.

I discovered a love for writing early on in grade school, and by seventh grade I was writing short stories, essays, and poetry. I wanted to study journalism (my dream was to be a music critic who wrote for *Rolling Stone* but also did long-form pieces on social justice issues and humanitarian work). I started art journaling at age nineteen. I discovered painting by accident at age twenty-nine, after my therapist suggested I find something "constructive" to do with my hands as a way to manage my symptoms of hypomania and impulses to self-harm.

I'm a self-taught painter—I literally learned by playing and experimenting for months before jumping into watching other artists paint on

Photograph by Steven Cotton

YouTube and looking at the works of other abstract expressionist painters online and in person at museums. I still write, but painting has become my primary medium.

What ideas or themes do you explore in your work?

My work focuses largely on the impact and presence of trauma, how it shapes our identity over time and the impact it has on our bodies and psyche. I'm a Black woman and mother living with bipolar disorder, and a feminist, so those themes are present in and influence my work as well.

What are you not working on that you wish you were?

Sculpture. I'm longing to branch out into working with clay, papier-mâché, mannequins, and other materials to build sculptures that explore the body's reaction to and relationship with trauma.

What things do you do to continually learn, improve, and grow as an artist?

I buy a lot of art books on my favorite artists and study pictures of their work. I watch videos of other artists painting, sculpting, sewing, and creating mixed-media pieces, to watch how their process works and to see what materials they use and how they use them. I talk to friends who are artists, and I ask a lot of questions and solicit critique and feedback.

What keeps you going during tough times?
Medication, my SAD lamp, sleep, therapy, binge-watching comedies, staying out of the studio, or keeping my hands immersed in paint, depending on whether I need a break because I've got fatigue or burnout, or I just need to stay grounded and rooted to my practice and my why for creating. Anything by Prince playing through my headphones or in my car. Detaching from my husband and kids for a few hours or a day if I need solitude or to simply not be needed by anyone (because introvert, hello!).

What does self-care look like to you?
Managing my expectations of myself and others (I'm always questioning or evaluating what they are and what's driving them). Saying no. Asking for help. Taking my meds. Calling my psychiatrist. Telling my kids and my partner what I'm feeling and why. Showing up for myself. Focusing on accomplishing just one thing on my to-do list versus trying to tackle the whole thing. Advocating for myself and trusting my intuition.

Do you have moments of resentment or longing for freedom?
I do—both, actually. I probably shouldn't say this, but here goes. I didn't plan on having them, but I love my children fiercely. I love my partner—he's one of my dearest friends. But there are times when I wish I could go back and tell my younger self to make different choices . . . there are times I long to just be committed to my art and no one (and nothing) else. I don't think I was selfish enough with my time and energy when I was single and before I had children. I can say I took my creative flow for granted before I had kids. I definitely crave solitude and the ability to fully immerse myself in my work, unencumbered by the demands and responsibilities of motherhood, marriage/relationships, needing things like money to eat and buy supplies (laugh).

What is something you needed to hear when you were in the early stages of motherhood?
I suffered from depression and anxiety during and

What do you want to pass on to another mother?

You don't have to lose yourself to motherhood or parenting to be a good parent to your child. YOU still matter, and your kid needs to see you prioritize your well-being and see the range of your humanity and personhood. Be yourself. Be honest with your kid. You are their mother, yes, but you are also a whole person with interests and longings and ambitions outside of parenting—show them that. Show them that you belong to them but you also belong to yourself.

What do you wish you could tell yourself as a new mother?

It won't actually get any easier, but you'll continuously learn how to navigate the learning curves.

Was there specific advice or commentary about becoming a mother that made you angry? What was it and why did it?

I've always disliked the idea or expectation that when you become a mother, you have to give up all of who you are so that you can focus on your kid, and if you don't, you're not a good parent. We expect mothers to be martyrs or shells of their former selves. We're constantly covertly and overtly telling moms their personhood doesn't matter. It starts the minute you tell your OB or anyone close to you that you're pregnant—everything becomes about the baby and the baby's health. Then, once you have the baby, there's this expectation and demand on us to simply abandon who we were before we became mothers, and just be defined by that identity alone. I think it's really weird and unhealthy, and, not to mention, we don't have this expectation of men. We encourage women to lose themselves to motherhood, and it really burns my grits.

> We encourage women to lose themselves to motherhood, and it really burns my grits.

after pregnancy with my second son, and I wish someone had told me that experiencing either one (or both) is hell, but very common. I needed to hear I wasn't a monster for having those symptoms. I needed to hear that treatment and recovery are possible. I needed to hear that it wasn't my fault—developing a mood disorder during or after pregnancy isn't due to any "failure." I needed to hear I was still a good mom and the right mother for my sons.

What is the best advice on motherhood you received?

"Be kind to yourself." I practice saying this out loud pretty much daily. Also, "Well, of course this is hard—you've never done it before! Being overwhelmed by how challenging it is to parent another human being is normal for this reason. I don't know a parent who isn't—and if they say they aren't, I bet they're lying."

Do you experience guilt as a mother? What are your thoughts on this?

Mom guilt is both excruciating and infuriating, and when I feel it trying to claw at my throat or scream that I'm a terrible mom because I chose myself or fell short, I honestly squash it by wondering if Dad guilt is a thing. I'd love to hear more men discuss the guilt they experience in their parenting journeys, if they do at all, and what triggers it.

Did you experience postpartum depression or "baby blues"? How did you find the support you needed?

I suffered from postpartum depression and debilitating anxiety during and after my pregnancy with my second child. It nearly killed me, but thankfully I was able to recover. Postpartum Progress's website, with information and resources along with the community of mothers I connected with during that experience, enabled me to do so. Therapy at the Postpartum Stress Center in Pennsylvania helped me as well.

What do your kids teach you about life and yourself?

My kids pretty much teach me that I don't know nearly as much as I think I do, that there's always something to learn, and that there's great value and healing in unlearning the things that were modeled for us by others that won't help us be whole beings.

What do you want to teach to your children?

Their lives and personhood matter—regardless of what society thinks about their Black and Brown skin and culture. That women (all who identify as such) matter too. I want to model inclusion and advocacy for them. I want them to know how to speak up for themselves and other people.

Describe how you find ways to make work and keep at it through changing seasons of life.

I remind myself that creating is crucial to maintaining my mental health. If all I do is sit in my

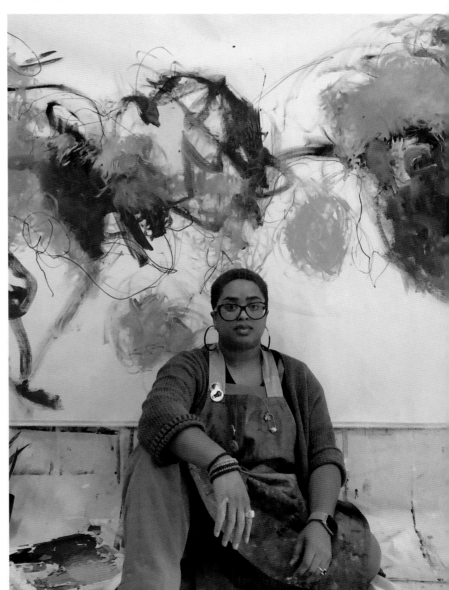

I don't think I could really sit down and paint when my youngest was a baby, so I found other ways to channel my creativity—dyed my hair various colors, decorated our home, danced, wrote ideas and notes on scraps of paper or Post-its or in my journal.

As my kids have gotten older (toddlerhood and up), stealing time gets a bit easier as they become more self-sufficient, can be left with a babysitter, can be occupied for a certain amount of time with a toy or show, or can sit in the studio with me and play without getting too much in the way. I use toys, the television, iPads, or make my partner take them out of the house for a few hours . . . and also, I get vocal. I express to my kids what it is I do and why I need to do it. They know it's something I love to do, but it's also my job, and if I'm working, they have to respect that. I steal time but also work with the ebb and flow of our daily life and what their needs are. Some days it works; others it doesn't.

How do you deal with periods of no time to create or make things?

I try to immerse myself in different sensory experiences, even if it's just taking a drive or a walk. I read. I immerse myself in learning about other people's work. I try to get creative with movement, using my body as a tool when music is playing.

What barrier or circumstance do you wish you could change?

I honestly wish I had reliable childcare and could be gone for a couple of days or a week or two at a time even just a few times a year. It would help me have more focus and energy to create. I'd produce more higher-quality work, or at least that's what I hope would happen.

studio with a book or stare at a painting in progress, or lie on the floor of my studio and mediate, that's still part of the creative process; that's still work.

What has one of your biggest struggles been as an artist? As a mother?

Making time to be engaged and immersed in my practice. My attention is always split, you know? As a mother, my biggest struggle has been adopting motherhood as an identity, learning to mother myself, and also healing the wounds that have existed in my relationship with my own mother.

What helps you through creative slumps or times when life is full?

I tend to put a lot of pressure on myself (recovering overachiever, hello!), so when I'm in a slump or when life is too full of demands on my time and energy (I guess the kids really do have to eat everyday, huh?), I try to adjust the expectations I have of myself and my work. I take a step back and remind myself that my work isn't going anywhere and neither is my creativity. I remind myself that barring something happening to take me out of here prematurely, I have time. I go read about artists who are still creating at seventy, eighty, ninety years old and crushing it. I remind myself that if I can continue to show up for myself and my work and still be doing this when I'm a senior citizen, then that's the ultimate success. ◼

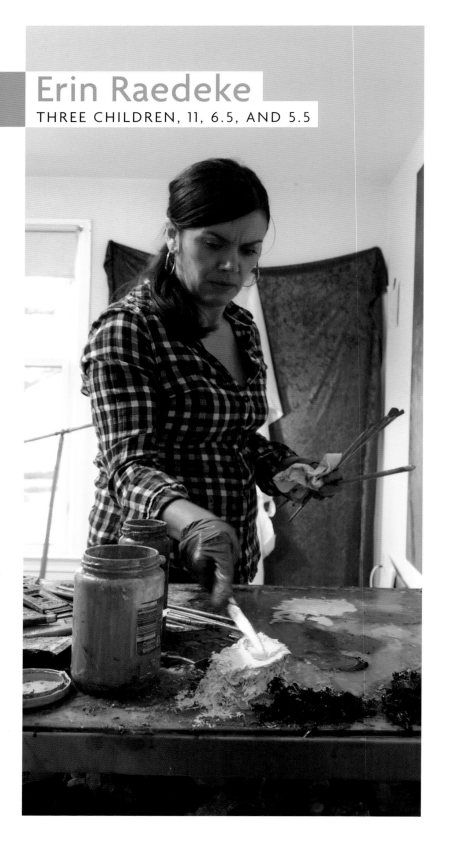

Tell us about your work.

I'm an observational painter. I started painting my junior year in college. I studied with several really strong and inspirational professors in undergrad, and they helped me build a strong foundation. I've always loved the flexibility and limitless quality that's inherent in working with oils—and the fact that they can be taken anywhere.

What ideas do you explore in your work?

I explore my mind and my history—relationships, interactions, thought patterns, memories, and projections. I had a very traumatic childhood, and I explore in my paintings many of the intense experiences and feelings that I encountered growing up. All of my work is autobiographical. There is often a misconception by the viewer about my work. The paintings aren't about my children; they are about my childhood and all the loss and trauma that went along with it.

How do you know when to share something and when to keep it private?

This is a question that I've been thinking a lot about. I'm still trying to find the right balance. There is desire to speak truths about my childhood experience. I had a very traumatic childhood, and there is a desire to speak to the truths of it. I want some of these experiences out in the open, yet there is the question of how vulnerable that would make me.

Do you have moments of resentment or longing for freedom?

After I had my first child in 2007, I was getting ready for a group show that I was a part of. I had been consistently working on-site in the landscape before Elsa was born, and was hoping to have another landscape ready for this show. There was this overwhelming realization—which seems obvious, but at the time it was such an intense

reality check—but I couldn't just grab my paints and go outside. I now had this baby that needed me. It really forced me to be more creative and flexible in terms of finding time for the studio.

What do you want to pass on to another mother?

It gets easier. The baby years are tough, but there are ways to make it work. It takes a lot of determination, creativity, and patience. It's wonderful to feel so passionate about creating, and I really feel that it benefits my children when I'm in a positive place with painting.

What do you wish you could tell yourself as a new mother?

I would have loved to hear and be reassured that I would find a good rhythm again in the studio—that my children will grow more independent and that there will be more time opened up for the studio. I would have also loved to hear that my continuing to paint would have such an important, healthy impact on my children. Working in the studio is a necessary aspect to self-care.

Do you experience guilt as a mother? What are your thoughts on this?

There is guilt. Guilt when I want to be in the studio rather than playing Candyland—then guilt when

Photographs by
Erin Raedeke

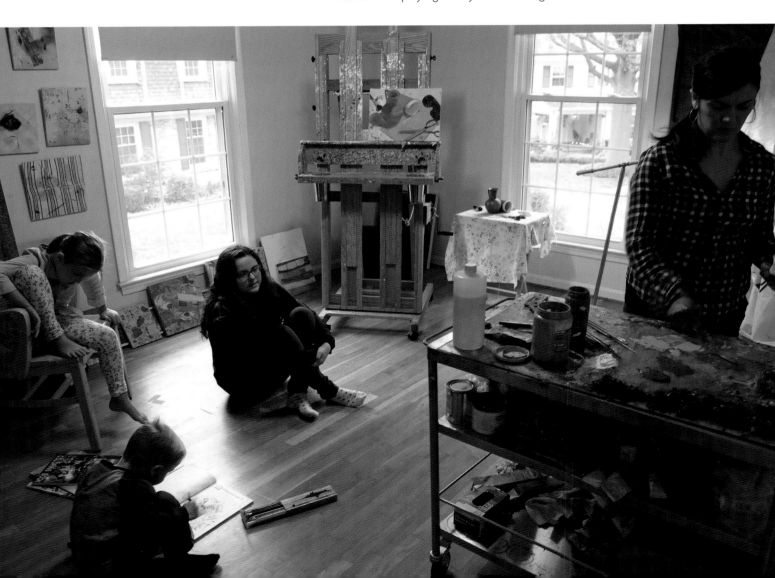

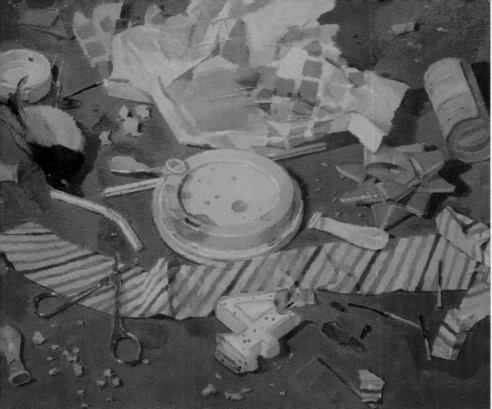

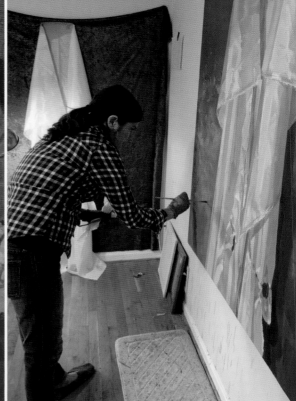

I am in the studio and not playing Candyland. Sometimes it feels like a no-win situation. It's all a balance, and I often remind myself that the kids will be little only once—I have a lifetime to paint. That being said, I am also a better mother (and wife, and person) when I do find time to paint.

Did you experience a sense of loss or grief for the life you had before becoming a mother?

There were isolated moments when I would reminisce about not being tied down to someone else's schedule after having kids. But those times were few and far between. Motherhood has really been life giving to my work as well.

How does being an artist/creative influence you as a mother?

As an observational painter, I'm always on the lookout for subject matter. Even throwaway items that are overlooked become potential objects to paint. I think that way of approaching the still life carries over to being a mother. Everything has meaning, and each interaction with my children, no matter how trivial or benign it might appear, holds meaning too. It offers another opportunity to know my kids that much more deeply.

How have your studio practice and art changed over time? Especially before and after children?

Since having children I have become much more decisive and determined. I used to second-guess every decision that I made in the studio. Now there is simply no time for it. This has been a huge benefit from the limited studio time. I am actually more productive now after having three kids. ■

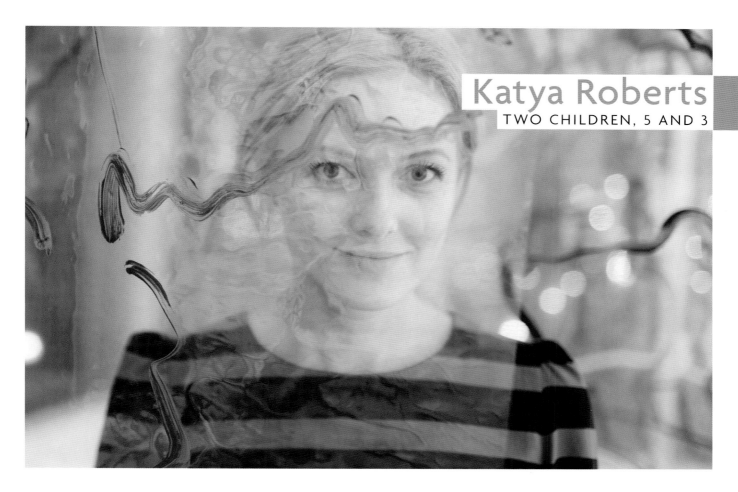

Katya Roberts
TWO CHILDREN, 5 AND 3

Why is it essential for you to create? What happens if you can't have this time?

"Creating is such a part of who I am." How many of us say that? But what does that mean? A few years ago, when I didn't think it was a necessity to create my own work because my hands were too full with two kids under two years old, a husband in medical school, and work, followed by moving across the country from sunny California to wintery Wisconsin and then Minnesota, I learned the answer to those questions. In addition to moving, I stayed home for the first time and had to adjust to losing my vocational title and purpose. I was a high school art teacher prior to moving, and art projects with my tiny kids weren't filling what I felt I was missing.

The days were long and my body always ached by the end of the day, from being a human jungle gym to nursing to chasing two kids still in diapers. My thoughts grew dull, though filled with longing for something. I felt I became out of touch with myself. At times I felt I was an anonymous being in a place where I didn't know a soul and where no one knew me, just drifting through space and time. Over time I began to recognize that I felt an internal scream welling inside, though I was not unhappy. I had much to be thankful for and felt blessed in the midst of my circumstances.

I started to recognize I needed time for myself and managed to squeeze out a few dates with myself out of my husband's demanding medical residency schedule. I got dressed up, put on makeup for the first time in a long time, even took some selfies that I didn't hate. Then, I took

Photographs by
Erika Leitch

Becoming intentional about that time, letting it be known that I need it, taking it, and owning it made all the difference.

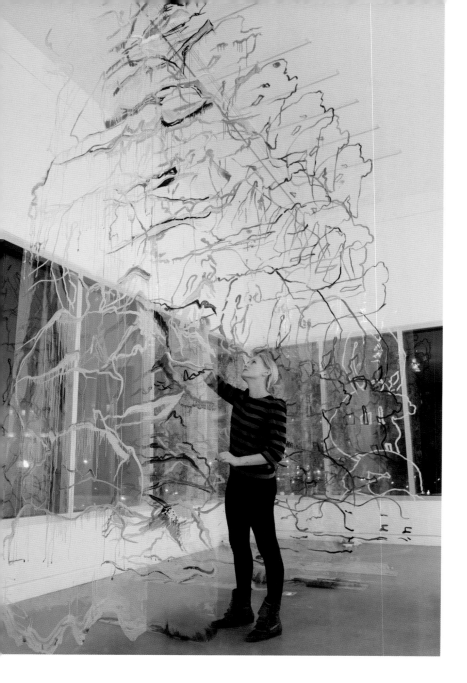

myself to dine and feast my eyes on contemporary art at the gorgeous contemporary art museum in Milwaukee. I saw great works by some of my favorite artists and recalled sharing them with my students when I was a teacher, I felt like I was coming home. I started to scribble notes and sketches in my sketchbook. As I watched Lake Michigan through the windows of the museum, a feeling began to well inside and a small fire was

ignited. I had a very simple installation art piece loosely sketched out by the end of that day. It had to involve my children, since my days were always with them, and it had to involve being okay with me not being in control of everything. Letting go of stuff seemed to be something life had me practicing already anyway for a few years now.

Fast forward a little over a year, and that little fire grew into a force of nature inside me. After one year in Milwaukee, we moved to Rochester, Minnesota, to continue my husband's education. I was determined to meet and bring together other creative people in the same boat as myself and started an art group for medical spouses. I sought out local art events, attended everything, introduced myself to everyone, and began to write proposals for various local art opportunities. I hustled, I worked. I spent my evenings creating, writing, searching, trying, just saying yes to the process and saying yes to myself. I also started to pray about my art for the first time. In our house, I let it be known that on weekends I needed my husband to take the kids out of the house for a few hours. I would not clean, or sleep, or shower, or anything else. I would drop everything in whatever state it was in, and go to the smallest room in our basement, a.k.a. my studio, and do something. I've vowed that any time in the studio is time well spent. I have my bookshelf with art books. If I just sit and think, that's valid use of time. If I thumb through beautiful art books, still valid. If I hit upon a new, amazing artistic discovery, that is time spent in a valuable way just as all of those other ways. They are all steps in the right direction. An artist needs food. You've got to feed yourself to keep the fire burning. Additionally, becoming intentional about that time, letting it be known that I need it, taking it, and owning it made all the difference. This makes me able to say that I have an art practice. It is something I'm committed to doing. I will find

a way, and people around me need to know that this is my thing and I need to do it. And you know, it works!

The installation I sketched out on one of those dates with myself in Milwaukee was accepted into a juried exhibition at the local museum. My kids, hubby, and I got to go to the opening and artist talk, and it brought my journey of returning to art full circle! Or was it the journey of returning to myself? I'll never forget it, and my kids will remember going to see the work they made with mama at the museum.

Today I'm continuing to challenge myself to grow and push my art practice to new levels. That fire burns bright, and I treasure it, protect it, and nurture it. ▪

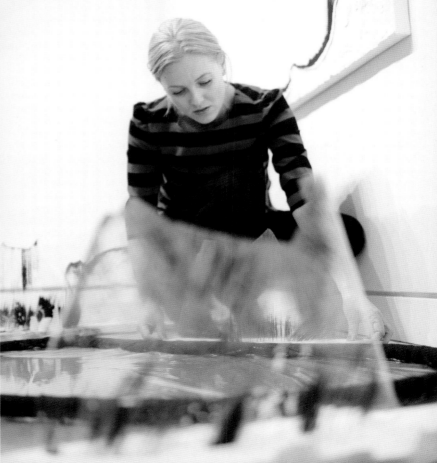

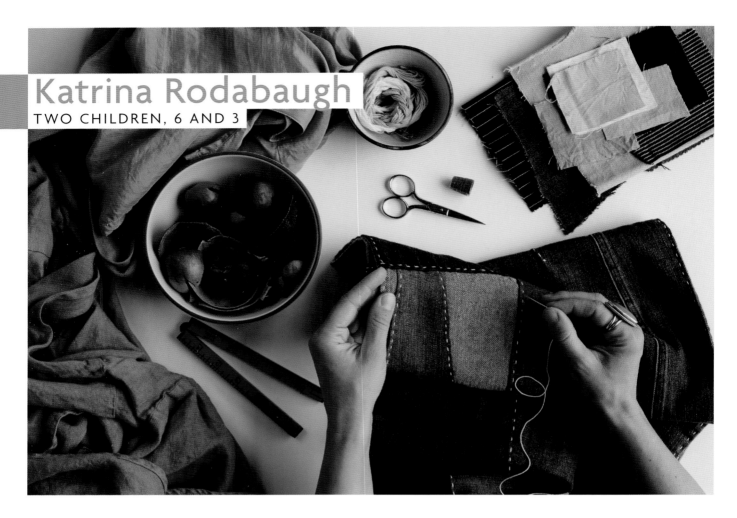

Katrina Rodabaugh
TWO CHILDREN, 6 AND 3

Original work by
Katrina Rodabaugh.
Photographs by Karen
Pearson

Tell us about your work.

I'm an artist, crafter, and writer working across disciplines to explore environmental and social issues through traditional craft techniques. Mostly, I rethink the relationship between fiber art, sustainability, and slow fashion. I earned a BA in environmental studies and an MFA in creative writing with a focus in poetry and book arts, but my fiber arts training started at the side of my mother's sewing machine.

What ideas or themes do you explore in your work?

Since August 2013, I've been on a fast-fashion fast, Make Thrift Mend, to focus on mending, using local plant dyes, and prioritizing handmade, secondhand, or sustainably made clothes. Prior, I made fiber art objects for exhibition or craft fairs and worked on large-scale mixed-media installations with writers and performing artists. Since 2013 my studio has been focused on slow fashion as fiber art and social practice or "art as action."

What was the first thing you remember making after having your first child? What was that like?

I started mending by hand because it was silent, transportable, and easily interrupted. I was living and working in a tiny apartment in Oakland, with my husband and our first son. I loved hand stitching because it let me continue my studio work while my baby napped nearby.

What do you want to tell to future generations of women?

Just keep going. If it's a question, then keep re-searching, writing, reading, making art, visiting exhibitions, and building up a community of supportive people to reveal the answer. Just keep going. Even when you're convinced you aren't good enough, don't have the resources, can't carve out the time—just keep going. The world needs your words and your work. It needs your wisdom.

What was a big goal or dream that you accomplished? How did you make that happen? What did that feel like?

Publishing my first book was a dream come true. I wanted to be a writer when I was fourteen years old but didn't admit it to myself until a decade later. Then a decade after that, I published my first book, *The Paper Playhouse*. It wasn't the book I imagined my first book might be, but regardless, I did it. Against all my doubts. Against all the challenges. I did it. And then I swiftly set out to create the next book, *Mending Matters*.

What do you wish you could tell yourself as a new mother?

That I'd find a deep courage in motherhood that would whittle away so much second-guessing and self-doubt. That my children would become the focus of my life in a way that would allow me to expand, deepen, and gain great clarity in my work. That I wouldn't lose myself in motherhood and work—that I'd find a new version of myself there. And that new version would have the confidence to chase the wildest dreams.

What is the best advice on motherhood you received?

All things in time, but not all things at once.

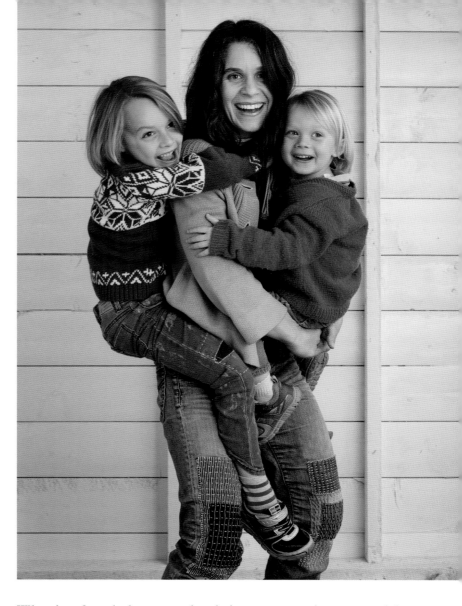

What joy does being a mother bring to your life? What hardships?

So much joy. Such a deeper joy than I ever imagined. It's transforming. The hardships are always about time or bandwidth—how to balance work and caregiving especially in unforeseen moments like sudden illnesses, school cancellations, or snow delays. I try to look at those challenges as exceptions and be gentle with my expectations. Most things can wait. The joy of mothering is so powerful. It's expanded my capacity for love. It's truly the profoundest relationship, the deepest joy.

> That I wouldn't lose myself in motherhood and work—that I'd find a new version of myself there.

Even when you're convinced you aren't good enough, don't have the resources, can't carve out the time—just keep going. The world needs your words and your work. It needs your wisdom.

What has your role as a mother taught you about yourself?
Time management and prioritizing—getting really clear on what has to happen and letting everything else go. Also, the boundless human capacity for love, healing, and joy.

What do you want to teach to your children?
Be kind, be tender, be bold, be brave, be gentle, be thoughtful, and consider how your actions impact other people and the planet. Ultimately, lead with love.

Tell us about a role model or supportive person in your journey.
My own mother. She's such a force of love and goodness. If my kids think half as highly of me as I think of her, I'll be content.

Have there been shifts in your work related to your role as a mother? How so?
Yes, my work shifted quite a bit when I became a mother. It became focused on sustainable fashion specifically instead of fiber arts, at large. There wasn't time for too many projects anymore. So I leaned into mending, natural dyes, and slow fashion as social practice. I started teaching, publishing, and identifying ways I could work from home with a flexible schedule during the week and teach workshops or retreats on the weekends. It was a great shift.

Share your tips on finding time to create when you have children.
I always have projects in motion because a thing in motion tends to stay in motion. So if I'm sewing a garment, I try to leave each work session ready for the next—iron and pin the garment so I can sew it the next time, etc. It's a great trick for keeping momentum without longer stretches of time. Also, I find ways to work while I'm with my kids—we

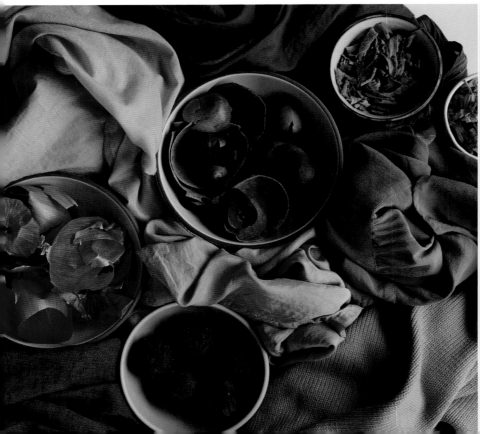
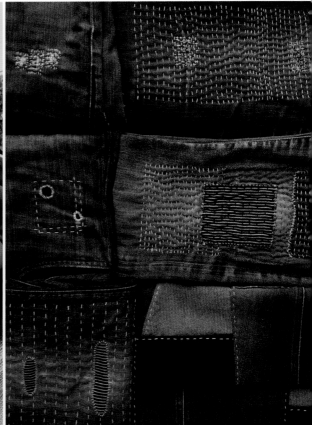

forage dye plants together and tend the garden with my dye plants and herbs, and I can have a dye pot on the stove and be mending while my boys are drawing at the table.

Finding ways to blur the boundaries has been important for me because I typically have only short stretches of time to work alone, so those moments of solitude need to be reserved for tasks like writing, editing, or meetings. It turns out, young children are incredibly interested in foraging and gardening. So it's easy to do that work with them by my side.

How do you deal with periods of no time to create or make things?

By always having a project in progress, even if it's something very small that gets my attention only in twenty- or thirty-minute spurts. It keeps my work moving forward and keeps me connected to my studio too, even if I'm just stitching from the kitchen.

How have you overcome struggles or times of feeling overwhelmed?

One day at a time. It's the only way. Everything has to slow down to gain focus in those most hectic times. I'm still learning that doing less actually results in experiencing more. It's a life lesson.

What is something in your life (or creative pursuits / art) that you never thought you'd accomplish but did?

Making a living as an artist and a working mom. It sounds so obvious, but before becoming a mother I never dared to pursue my creative work as a full-time job. In hindsight, it probably would've been much easier! But life doesn't work that way. We push ourselves when we have to push and sometimes not until then. Being a mom has given me the fortitude to turn my art studio into a business and chase after two busy boys simultaneously. That's the biggest accomplishment yet. ▪

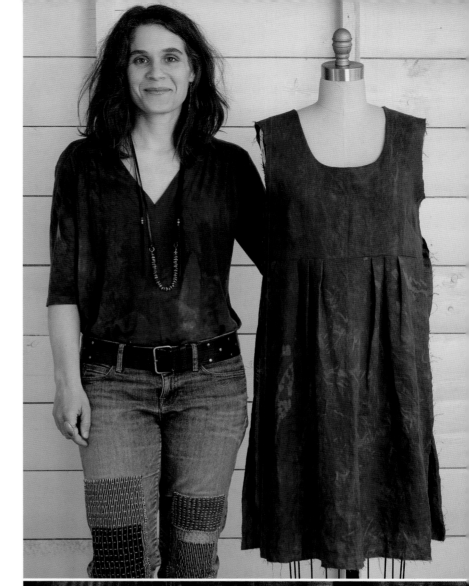

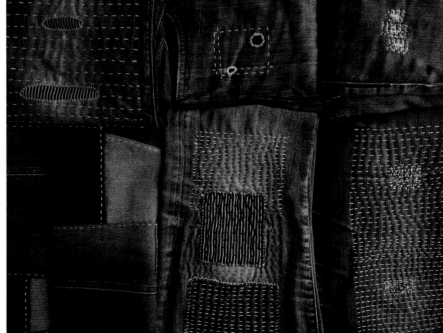

Lisa Anderson Shaffer

ONE CHILD, 7

Photograph by
Melissa McArdle

Do you come from a creative family? Was there support in your endeavors?

I come from a family of artists. Some by hobby and some by trade. My mom worked in advertising illustration for years before moving on to visual merchandising. She was part of an influential group of artists working in the late 1960s and early '70s that created window displays at Bloomingdale's and other high-end department stores.

My uncle, her brother, is a working artist and currently creates intricate inlay custom wood furniture. Rose Marie, my grandmother and their mother, was always creative. She taught me how to knit and crochet and spent a good deal of time as a ceramicist. My grandfather Kingston on my dad's side was a carpenter and could build anything. He was taught by his father and then taught my dad. Zelma, my grandmother, was also

creative and loved needlepoint. She taught me how to embroider when I was about nine or so.

While my dad went into finance, in his spare time he and my mom renovated every house we ever lived in. From putting down flooring to busting down walls. I've been taught how to do everything from laying pipe to fixing a hole in drywall. For the past three years, I, my husband, and my parents have been renovating a 1950s modern farmhouse in the mountains. Work is never done!

Was there a time when you thought you were not meant to make work?

I had been a working artist in San Francisco for a handful of years. I was a California Arts Council Artist in Residence at UCSF Mount Zion before it was a world-renowned cancer center. While there

I facilitated art-based support groups for adults living with cancer, created art at the bedside with patients nearing the end of life, and facilitated art projects with adults receiving cancer treatment at the infusion center. It was an incredible time and one that I would have gladly continued had my grant funding not been cut short.

I decided to go back to school and pursue psychology, an interest awakened in me while working with people toward the end of life. I spent the next seven years attending graduate school, completing 3,000 hours of training, and passing exams to become a licensed psychotherapist. It was a very interesting journey that certainly influenced the way I think about life, death, love, all the big things.

While I was going through those seven years I felt incredibly creative. It was like the work I was doing with patients was a living canvas of sorts. But I never actually picked up a brush or a pencil, or a camera. Divorcing myself from art was one of the single greatest mistakes I've made. I was suffering greatly, incredibly unhappy, and so focused on my intellectual achievements, I had forgotten the creative blood that coursed through my veins. What made me breathe, what gave me life. In retrospect I think all the intellectual stimulation made me think I was happy, but stimulation is very different than happiness.

I came home from my private practice one day, looked at my husband and said, "I don't think I can do this anymore." He looked like he had been waiting to hear that and said, "Good. I don't think you've been happy this whole time." I fell to the floor crying because in that moment I knew he was right. I made him a promise that day that no matter what I did next, I would never stop making again. And I've stood by that promise for the last nearly eight years.

Were you self-taught?

I always find this question so interesting. There

Photograph by
Sarah Deragon

seems to be a great divide now between those of us who attended art school and those who are self-taught. I often wonder if anyone is really truly self-taught. Especially in the creative realm. If we are lucky, we all have mentors. People who guide us, inspire us, and push us forward. I get asked a lot by younger people interested in entering a creative profession whether or not they should go to art school. It's a good question. Art school costs a lot of money and is hard. Really, really hard. Like ten times harder than two years of graduate school, 3,000 hours of training, and working in a locked psychiatric hospital. If there is something that those of us who do go to art school share, it's this immediate sense of "oh yeah, you get it." I think what art school gives you that is very hard to find when you are self-taught is an extreme and often-terrifying push to be authentic in your vision. It is horrifyingly difficult to create your own aesthetic and vision when everywhere you look, amazing and inspiring art is happening. I mean art

that sets your soul on fire. Art that makes you feel envy like you have never known. Art that makes you think that what you are trying to say is completely meaningless. Art that is way better than anything you could ever dream up. It's like getting punched in the face every time you walk in the studio. But this is precisely the kind of training that makes for a very good boxer. This process of thinking you have it, then going to class and finding you are still so far off, is training that no one in their right mind would seek out. It feels terrible! But the fact that even if you think you are seeking

it out, that kind of critique, deep examination of your work both by yourself and others is a hard thing to enter into willingly. I think you can get close, and the friends that I have that are self-taught and successful have tried to seek it out.

What do you want to tell to future generations of women?

You can ask for what you want in life, but you do not always get to decide the how and when. And this is okay. Often it doesn't come when we want or how we imagined. This is something most of us learn through motherhood, experience, and age. Things arriving at a different pace or in a different package doesn't make them worthless. Quite the opposite.

How do you keep from comparing yourself to others?

I don't. I think trying to do this completely sets us up for failure. For artists the act of self-comparison is kind of second nature. At fourteen years old I was drawing the female nude. I can see every single line, wrinkle, fat deposit, hair, freckle, bone,

Photograph by
Melissa McArdle

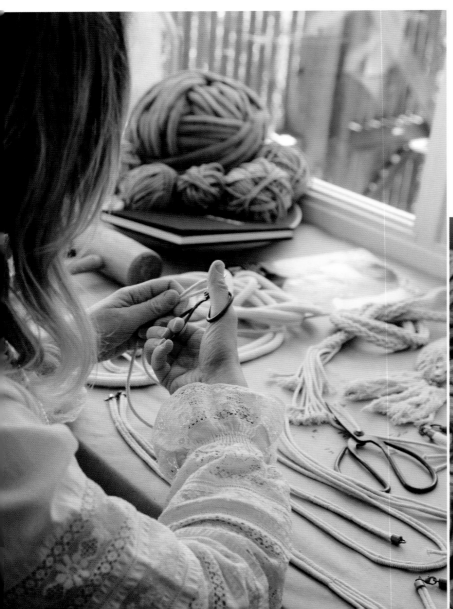

muscle of the human body. I have trained my eye to do so. Turning this off or pretending I don't see distorts the vision and ability to see that I have worked so hard to attain. And this ability to see pertains to so much more than the physical body. On any given day I can compare myself to others based on my art, my parenting, whether or not I can do a handstand, and on and on. I've accepted it as a part of being an artist, and no longer blame myself for it. Being able to see the similarities and differences is what makes me an artist. It's important. It's an asset.

What do you want to pass on to another mother?
You know how to do this.

Tell us about a role model or supportive person in your journey.
Other mothers. When I feel like I do not know what direction to go in, I'm not sure if I've made the right choice for my family, or I doubt every single move I've made in a single day, I stop and look around. Every minute of every day there is

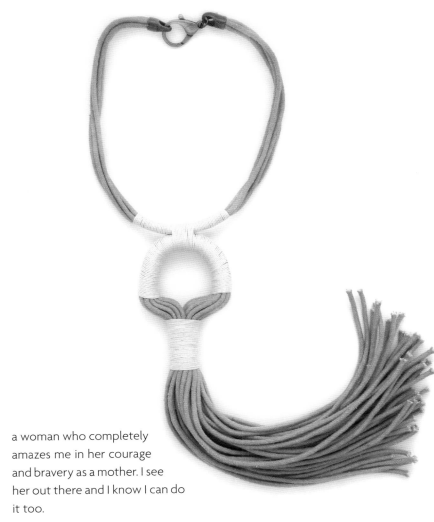

a woman who completely amazes me in her courage and bravery as a mother. I see her out there and I know I can do it too.

How have your studio practice and art changed over time, before and after children?
When I was in art school I was the hare and not the tortoise. It was all or nothing, no slow and steady. That's how I learn. I would pull all-nighters, stay in the studio for sixteen hours straight (my husband would pop in to remind me to go to the bathroom)—this was my jam. What I learned very quickly through pregnancy and later motherhood is that there is zero recovery time. Pulling all-nighters is for amateurs. I had to retrain myself to pace myself. Sometimes I would only be able to work in fifteen-minute intervals. If I had a deadline, I had to plan for this and know I would be working on something for three weeks instead of three

Photograph by Melissa McArdle

Lisa Anderson Shaffer **149**

days. At the beginning this was really hard. There is little drama in slow and steady. I now had to create and generate the energy, inspiration, and high from overworking in very concentrated chunks of time. But after years of doing so, knowing this and working this way have enabled me to be the kind of parent I want and an artist. And that's what winning the race looks like for me now.

Share your tips on finding time to create when you have children.

Be smart. Be flexible. The art you CAN create might not be the same art you WANT to create. Right now. And that's okay. That will change, I promise. But don't not create just because it can't be 100 percent how you want. Find something you can carry with you. You don't realize this now, but you will be spending a lot of time in your car. Sitting with a sleeping infant or toddler and then waiting to pick up an older kid. Having something to work on that's portable can save your sanity. Even if it's just a sketchbook. Be mobile. As my daughter has gotten older, I still have parts of my creative process that I can participate in while I'm waiting in the car or at the dentist. It keeps me plugged into my creativity when I am 99 percent in suburban mom mode.

How do you deal with periods of no time to create or make things?

This funny thing happens that I refer to as creative constipation. Mostly it happens after a long school break or my daughter has missed a bunch of days of school when she is sick. I have learned that it feels best to me to shelve a lot of my work during these times. I want to be present and enjoy time with her while she is on break with school, and when she is sick I want to be nurturing and not resentful. During these times, I get work done at night after she is in bed and on the weekends when my husband is home. But toward the end of a vacation or a bout of sickness, I literally get itchy. I know I need to get back to work full time before I explode. I remind myself to take a deep breath and that I will get the time back. When it does come back, I am amazed at how much work I can get done in just a few hours!

When was a time you felt like giving up? How did you get through this?

I've accepted that feeling like I want to give up happens all the time. It happens so often that I laugh now and say, "Oh, you want to give up again? If that was really the case, you would have given up a long time ago. Get back to work." ■

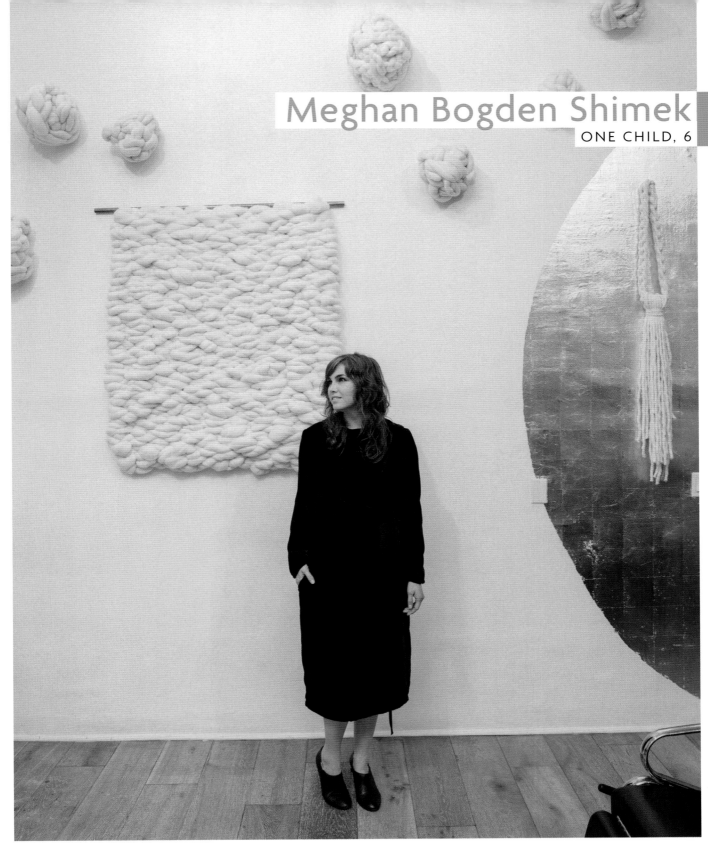

Photograph by Erin Conger

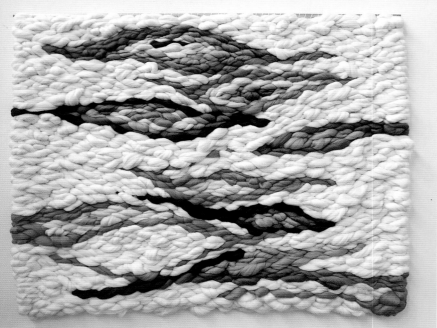

Photograph by
Erin Conger

Photograph by Jessa Carter

Tell us about your work.

I am a fiber artist, I mostly make large-scale wall hangings and sculptural objects out of wool. I was always interested in fiber art, but I feel that it found me; after I had my son and continued exploring my interest in agriculture I found myself becoming more and more interested in the fiber that farmers were growing. Through this I began knitting again and eventually weaving. I had never experienced a creative outlet like weaving; it felt like I already knew what to do.

What ideas or themes do you explore in your work?

I explore movement, loss, vulnerability, trust, and openness.

Do you come from a creative family? Was there support in your endeavors?

My family was not a creative family; they are very practical and pragmatic. However, my ex-husband's family is very creative and really supported and inspired me to get started and put my artwork out into the world. My family now supports me endlessly and will do anything to help me in my journey. I don't know if they have ever been more proud of me than they are now.

What does your process look like?

A giant mess! My studio is always a disaster; when I start a project I often pull all my materials off the shelves so I can see them all in front of me. Sometimes I concentrate on one thing at a time, and other times I will have multiple projects going.

How do you know when to walk away versus overwork a piece of art or project?

I work a lot at night. If I get to a point where I am stuck or unhappy or unsure about what to do next, I go to bed. Usually by the time I wake up, I know what to do. If I am working on a deadline and don't have the luxury of taking a six- to eight-hour break, I will go for a walk. Walking always helps to clear my head and bring me back to a beginner's mind.

Do you have moments of resentment or longing for freedom?

Oh yes. As my son gets older, this has faded a lot. But I remember after he was born, and all the moms I knew would talk about how great it was to be a mom and how they loved being a mother and how rewarding and wonderful it was and that every moment was a miracle. And here I was,

bored out of my mind and remembering a time when I was Meghan and my entire life wasn't about motherhood, or breastfeeding, or which natural diapers I was using. I felt very trapped and alone. Getting a divorce and really finding my voice as an artist helped immensely. I gained so much self-confidence and self-worth when I started to feel like myself again.

How do you keep from comparing yourself to others?

A long time ago I learned that we all have important, valuable, and beautiful roles to play in the world. There are things I will excel at and things I will fail at, and that is okay. I also have a belief that we all come to the place we are at in our own time. Sometimes I will meet people so much younger than I am and wish I had the wisdom they have, and other times I meet people much older than me and realize they are still hung up on things that haven't been important to me in years! As a child I was never very competitive (probably because I have zero athletic skill), so I learned to like myself for the things that I am good at, and those things were never really highly regarded, so I didn't have competition.

What do you wish you could tell yourself as a new mother?

The time goes by so fast, but the days are so slow. You will have time to be a person again who is not only defined by motherhood.

What were some physical limitations you experienced postpartum or during the first year?

My son had really horrible colic that lasted until he was almost nine months old. He was in constant pain and wanted to be in a baby carrier most of the time. It was hard on my body physically to hold him so much and felt so difficult to watch him be so uncomfortable.

The Motherhood of Art

Why do you think so many mothers express that they're not good enough? How can we support each other and shift this?

I think there is a lot of judgment in motherhood, especially at the beginning, when you have no idea what you're doing. We all want to do what is best for our child, but there is so much information and advice that it becomes difficult (in your sleep-deprived state) to sort out what is best for you and your family. I think if we could all learn to listen instead of talk, we would be able to support each other more fully.

Do you experience guilt as a mother? What are your thoughts on this?

Yes, definitely. I feel a lot of guilt for not spending more time with my child, and I feel guilt for letting down people who are buying my work, and not having the time I need to communicate or sometimes meet deadlines because things come up with my child. I am trying to find a balance of what

Photograph by Robert Parker Blackburn

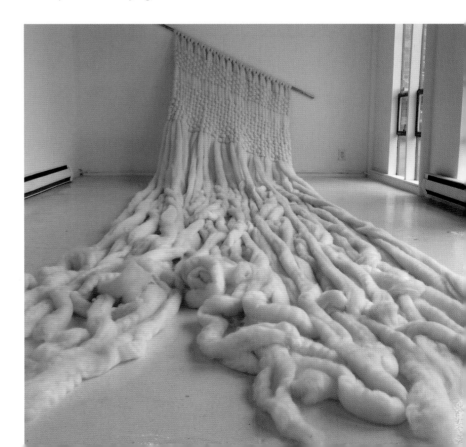

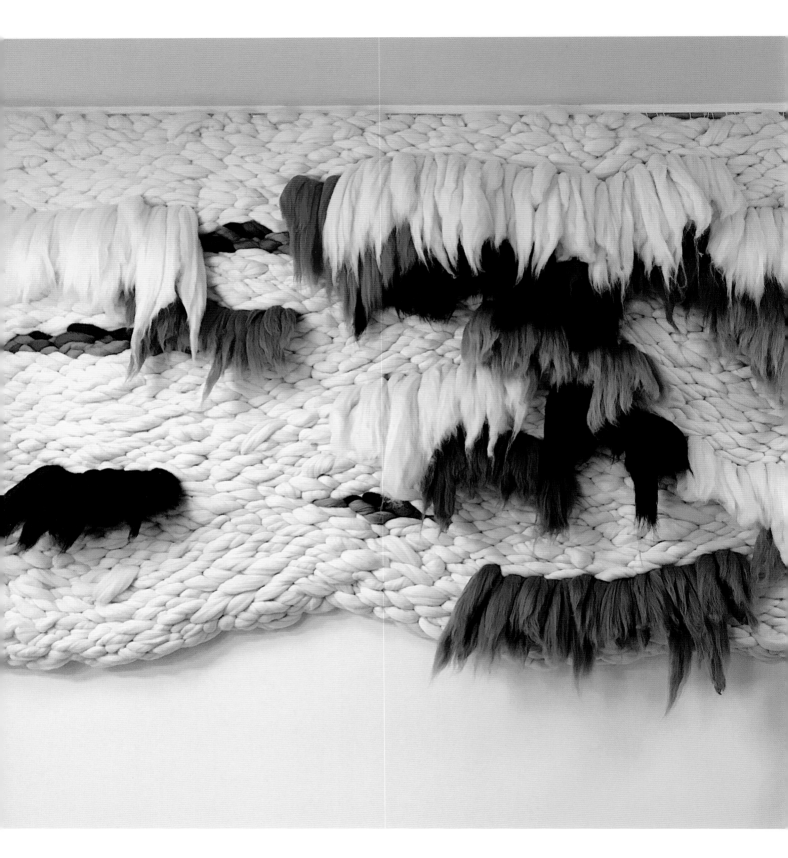

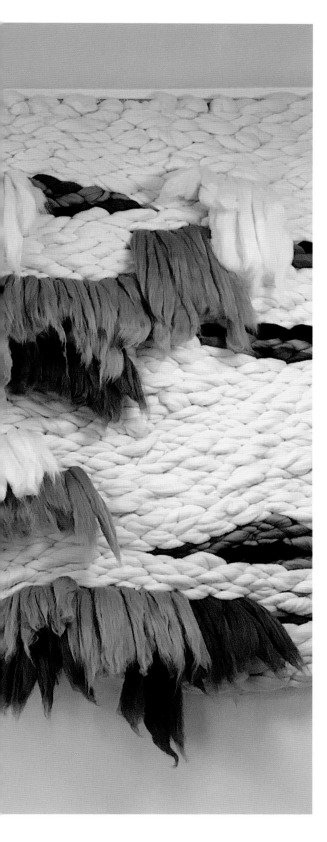

works and allowing myself to feel the guilt and then move on from it. My ex-husband used to tell me that guilt was a useless feeling because there usually isn't anything you can do about it. But for me it helps me to think about what I am doing and if I could be using my time better. If it has been a long day and I am exhausted and I look at my son watching another episode of *Scooby Doo* and feel guilty for the amount of screen time he has, I can right then decide we are going to read a book together, or, at a minimum, I can watch his show with him so we can spend time together.

Photography by
Erin Conger

What do your kids teach you about life and yourself?

I was one of those people who never even knew if I wanted to be a mother, so motherhood hit me hard! I had no idea what to expect, and it completely uprooted my life as I knew it. Being a mother caused me to slow way down. I have learned an enormous amount of patience and to sometimes stop what I am doing and take in the sights and sounds and be present in every moment. If it weren't for my son I never would have started weaving. I don't think I would have had the patience. I also have learned that there are things I never thought I would say that just come streaming out of my mouth.

More than anything, having a child has allowed me to touch a part of myself I didn't know existed. I have become a much-happier and whole person, and I don't mean having a child completed me or something; I mean that I finally realized I am enough, I have everything I need inside me.

How have your studio practice and art changed over time? Especially before and after children.

The biggest change has occurred for me after my divorce. When I was married I often would wake up before everyone to work; I worked during naptimes and when everyone went to bed. I found

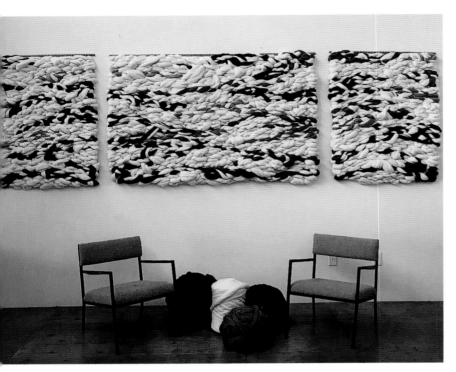

Photograph by
Robert Parker
Blackburn

Who is an artist mother you look up to? Why?

Sheila Hicks! She is in her eighties, still creating work, and often has her grandkids in the studio with her. I love that becoming a mother never stopped her from creating work and becoming a powerhouse in the fiber art world.

Does seeing the world through your child's point of view inspire you in your work?

Absolutely. Having a child is a reminder to always keep a beginner's mind. There is always more to learn, more to let in. Watching a child see the world and new places for the first time is such an incredible gift; they don't have preconceived notions and they are just taking it in.

little moments to work but rarely had dedicated time to my practice. Initially after my divorce I had four days a month when my son would be with his dad, and those days were precious to complete as much work as possible. Now we split custody and I am able to work a lot more. It also means I have really found when I work best, which is at night.

What has one of your biggest struggles been as an artist? As a mother?

Finding the balance. Being a single mom means that when my son is home, I am in full-mom mode, I have to get up with him, make breakfast, do laundry, all that stuff. Even if I feel inspired, I often have to put it to the side to take care of my son. And the reverse is true. There are times when he is not home and I miss him incredibly and I don't feel inspired to work but have to try to push through because, before I know it, he will be home and I won't have as much time to work.

What is something in your life (or creative pursuits / art) that you never thought you'd accomplish but did?

Supporting myself and my son as a single mother living in the Bay Area, just getting by feels like a huge accomplishment here! There have been two shows that I am extremely proud of. One was showing my work in Paris in 2016. I never dreamt I would have the opportunity to show work there, and it felt like pure magic. The other was a show I had in 2015 in Seattle called *ROVE*, in which I was able to fully express so much of what I was going through at the time and be so open and vulnerable.

What barrier or circumstance do you wish you could change? How would it affect your life or work?

I wish there was more access to affordable artist housing. I would be able to focus more on pursuing other artistic mediums and designs and less on the hustle of trying to make a living. I would also be able to spend more time with my son. ■

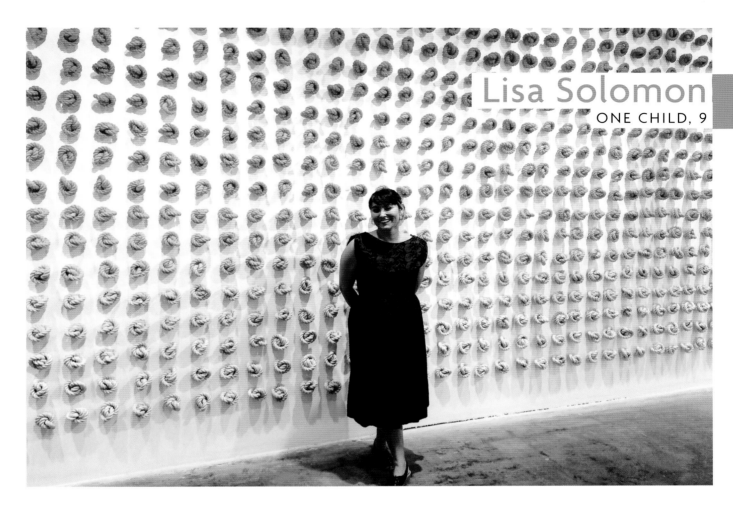

What does creative exploration mean to you? What does it look like to you?

Creative exploration to me means willingness to fail and to take risks. My work is research based, so I find a topic that interests me (lately it's a lot of getting in touch with / understanding my Japanese heritage) and then proceed to find things that I want to represent/interpret visually. I try really hard not to live in a world of platitudes or restrictions. It's funny because I *love* parameters—pushing against those is incredibly helpful, but I have learned that I should say things like "I never work figuratively," because invariably I will. I work well with deadlines—set either externally or by me. I also constantly use daily projects or prompts to explore.

Did you think you would need to stop making work once you became a mother? Explain please.

I was incredibly motivated to make sure that *didn't* happen. I actually had a studio built in my backyard and wanted it completed before my daughter was born. For me, momentum is key, so while I was prepared to slow down, I was not going to quit—at any cost.

What ideas or themes do you explore in your work?

My work often explores ideas/materials that have been relegated to a more "feminine"/"craft" sphere—think embroidery, crochet (particularly doilies). I'm often subtly trying to "elevate" crafts to the platform of "fine art." I'm interested in

domesticity, the practice of it, the repetitiveness of it, and how that mirrors my studio practice.

I also am continually exploring my own heritage. I'm a Hapa—half Japanese (my mother was born and raised in Japan), half Jewish Caucasian. When I grew up there were very few biracial or mixed kids. I didn't see myself reflected in culture very often. I wasn't sure if I was Asian enough or white enough. And people constantly asked me where I was from or what my nationality was—answering American was rarely enough.

As an adult I have become more and more interested in cellular memory and connecting more to my Japanese heritage. For example, for the last six years I've been exploring the number 1,000 as it works in Japanese culture as a marker of luck; there are so many iterations of it: 1,000 buddhas, 1,000 cranes, 1,000 French knot stitch belts, 1,000 samurai . . . lately I've been exploring Japanese internment camps during WWII in the US.

Photograph by
Sarah Deragon

Do you come from a creative family? Was there support in your endeavors?
No one in my family claims to be creative—although my mom is definitely on that spectrum. *But I have so much support from my family.* In fact, my parents moved up to the Bay Area from Southern California about a year after my daughter was born and they were retiring.

So much of what I do and have done creatively since my daughter's birth is possible because I have a husband who supports it, and my parents. They have gone with me to residencies/exhibitions in places far and wide—Wichita to Milan—and have made it possible for me to work with my daughter nearby.

How do you know when to share something and when to keep it private?
That's a great question. I struggle with this all the time, especially in our highly curated, "Instagram worthy" (I despise that phrase!) social media lives.

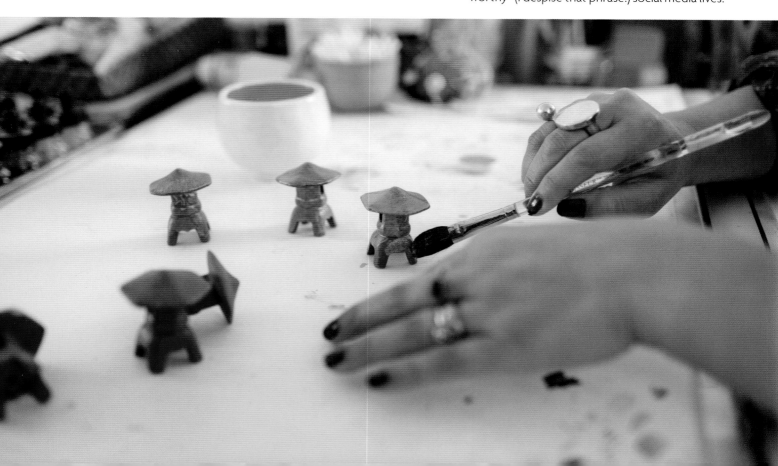

I try really hard to do what I want, say what I want online when I want to. That doesn't mean I don't second-guess myself. *I do—all the time*, but if it feels scary or just a little bit wrong to share a bad day or imperfect moment, I often try to go against that impulse and do it anyway. I'm most drawn to people who are authentic, whose feeds are not just perfect, who share real struggles and successes in ways that seem genuine to their personalities.

I do keep my child private. I don't pretend she doesn't exist, and the back of her or her hands show up in things I post publicly, but her face does *not*. I don't judge other moms who share their kids (in fact, I often *love* when they do), but for me that crosses a line. She can decide what she wants to put online about herself when she's older.

Do you have moments of resentment or longing for freedom?

Oh my God, yes. I love my family. I love the work I'm doing, but of course there are days when I wish I could go to a tropical island for a few days and not make anyone lunch or pick up Legos or answer ten emails. I'm an only child, so I really love and am used to being by myself in the quiet. I love traveling at my own pace, exploring by myself. It is really important to me. Luckily my family knows and supports this, so I do get moments of what feels like "freedom" to me.

How do you keep from comparing yourself to others?

I don't; it's impossible. I just try to acknowledge what I feel when I do it. If I'm envious, I question why. I try to be empathetic. How does that person feel? Are they just celebrating something they should? Does it feel like it's showing off? Why? Is that me or them or both? They don't mean to make me feel bad. I'm doing that to myself. WHY. Just asking myself why I am comparing often shuts the whole process down.

I do think that we shouldn't shame ourselves about our feelings. It's okay to compare. It's okay to want something that someone else has. If it makes you feel *so bad*, then turn away. I take breaks from looking at feeds or posts that simply make me feel like my life is lacking. I purposefully engage with *real* friends (in life and online) who support one another.

Do you compartmentalize your life and roles? Why and how so?

YES! I actually love compartmentalizing. I'm a wife, a mom, an artist, an author, a college professor, a workshop facilitator, an illustrator and occasional graphic designer, a crafter. Those things overlap, but I really try to focus on one thing at a time.

Different projects get different bags/boxes to live in. Each area of research has its own binder, folder. All my embroidery threads live on bobbins arranged

Photographs by
Sarah Deragon

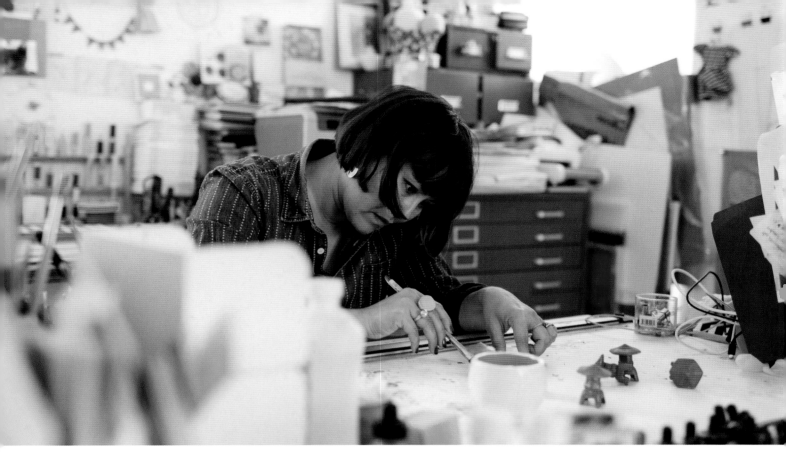

Photograph by
Sarah Deragon

in rainbow order in boxes. Inks live in a tray.

For me it's easiest to keep things separate bilaterally and physically separating them (with labels, of course). But I also have learned that life gets messy and sometimes you have to adapt. So while I have rules and restrictions, I also break them as I need to. I have been known to apologize to my kid while at the park for answering a work email that is urgent.

I have found that attempting to be present with whatever you are engaging with helps. It's not magic. I multitask and slip up *all the time*, but just noticing that is helpful.

What do you wish you could tell yourself as a new mother?

Stop reading all the books and thinking you are doing something wrong! You will get your space back; you will laugh a lot, get frustrated, experience extreme joy and sorrow. Find like-minded moms as fast as you can to share with.

> Parenting is by any means necessary.

Do you experience guilt as a mother?

Parenting is by any means necessary. Do what you need to do to get through whatever moment you are in. Forget thinking about if it is "right" or "wrong" or if you will be judged. You know yourself and your baby best, and honor that. Don't feel guilty if you can, and even at your worst moment you can recover (and most likely won't scar your kid for life).

How do you handle people in your life who criticize or diminish your creative pursuits? Do you feel the need to defend it—how do you do this?

I remove these people from my life. Seriously. I don't defend what I do. It's important to *me*, and anyone who wants to say something demeaning I either push back HARD—oh, do you live in a white cube with no pictures on the wall and nothing that has been designed/created (your clothes, your music, your plates, your phone for

god's sake), or I just stop interacting with them. I feel like not accepting that art and creativity is important in life is frankly such a limited point of view and I have so little time. It's not my job to open up the eyes of closed-minded people.

What joy does being a mother bring to your life? What hardships?

The truest form of unconditional love I've ever felt. When my daughter was a newborn, the physical and mental connection (leaking milk when she cried, waking up five minutes before she did—*all the time*) was incredible. There's no way to really describe it or understand it until you have it happen.

The loss of time and flexibility is the hardest for me. It's much easier now that she's older, but the daily slog of lunches, homework, diapers, whatever it is . . . the initial loss of sleep—you get that back, but by the time you do there are so many other things on the plate. My kid is also a lover of routine and scheduling, so it's harder to be spontaneous and just wing it.

What do your kids teach you about life and yourself?

That I'm a control freak and I can't control everything. I think this is why I'm so controlling in the studio—ha ha. That it's hard to both push independence and keep your kid safe and secure. That I love seeing the world through her eyes—you get a whole new perspective on things. Things that were once boring are suddenly new (like the first time she went to the beach and splashed in the water as a toddler). That life is so interconnected and we are so dependent on each other, and that love and care are so important to our overall health.

What are you most proud of as a mother?

That I see my child being inherently creative. That she loves to build and make things. That she has a social conscience and is kind and empathetic to others. That she has a sense of humor.

Have there been shifts in your work related to your role as a mother?

I'd say so. I think my studio work has become even more obsessive and in some ways meditative. My work is how I deal with life and the world; it's the one thing I can control in any way, shape, or form I please, so I do that. More intently now than ever.

Share your tips on finding time to create when you have children.

I printed gocco prints with my daughter in a Baby Bjorn. I tried to find small projects that I could do while holding her or while she slept. I had another artist mother tell me that when her son was a newborn, she had boxes with which she created a mini portable studio. One box had the supplies, one box had work in progress, and the last box had works that she thought were done. When she had even twenty minutes of quiet, she could pull out the boxes and work. That stuck with me and is a brilliant strategy. I also unabashedly pay for my kid to be in after-school classes or care so that I can have time to myself and in the studio. I don't feel guilty about it. Now that she's older she can sit with me in the studio and watch a movie, or read, or do her own thing for a couple of hours at a time too.

How do you deal with periods of no time to create or make things?

I honestly don't let that happen. If things are feeling so hectic, I use my sketchbook, even if it's just a list of ideas, or inspiration, or doodling, or a one-minute contour drawing of a pet. I believe wholeheartedly that it's like a muscle. If you use it, it works. If you don't, it gets harder and harder to get back on the horse—at least for me. It doesn't take a huge chunk of time to do something. You can always even just cut out pretty pictures and colors in magazines and paste them down.

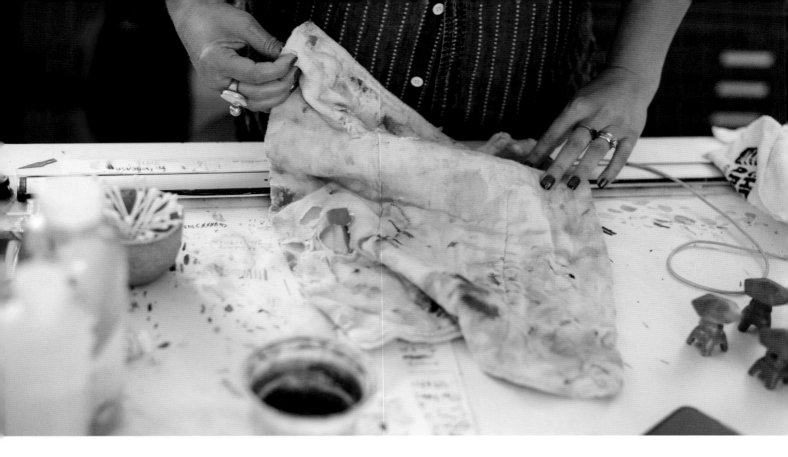

Photograph by
Sarah Deragon

Just do something. Even just looking at something that might be done. Or maybe it needs one more thing. Looking for ten minutes might solve that visual problem.

Who is an artist mother you look up to? Why?

Oh so many. My whole Instagram feed is full of these amazingly inspiring, creative, working mothers. But if you want a more well-known one, I'd say Ruth Asawa.

How have you overcome struggles or times of feeling overwhelmed?

Laughter. And the company of other women/makers. Prioritizing what needs to happen first/NOW and taking care of that. Trying to accept failure or seeing the positive side to mistakes or accepting the outcome that I didn't think I wanted, but actually is okay.

What do the easy times feel like?

What are these easy times of which you speak? I don't feel like life is easy, but I don't want it or expect it to be. I'm okay with feeling deeply, looking carefully, examining . . . it's dumb, but easy is too easy.

What barrier or circumstance do you wish you could change? How would it affect your life or work?

I wish that the work of mothers/women—especially of women of color—was as valued in society as the work of white men and white women. I wish museums owned and showed more work by women/mothers. I wish people would stop saying that you can have it all. I wish our society was more supportive of mothers/children and had better resources for them to utilize. I wish childcare and healthcare were rights, not privileges. I wish creative pursuits were as valued in our society as fame, surgeons, technology. ■

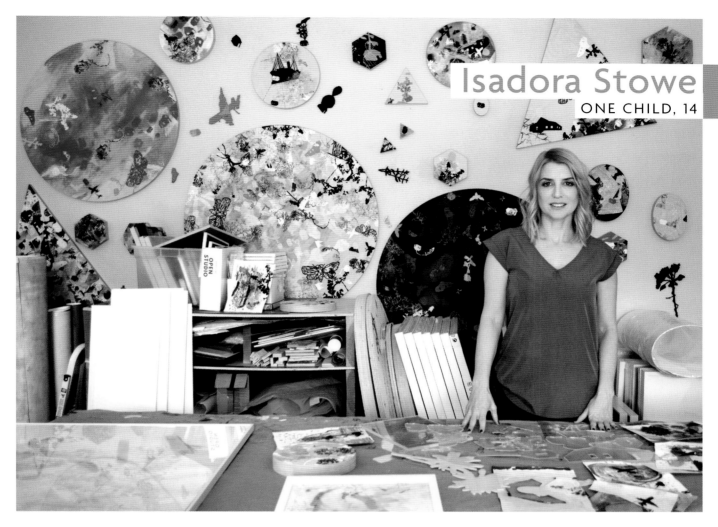

Do you come from a creative family? Was there support in your endeavors?

I come from a creative family, as my father, a printmaker and art professor, had a strong influence on my childhood. Art was part of the way I learned to see the world. While other children were given cars or dolls, we were given crayons and clay. While other families vacationed in the sunshine, we spent our days wandering museums. Our family home was filled with artists and their craft. Because of this unique upbringing, I find art to be the best way to express myself and interpret the world. I feel like art chose me, and I am fascinated by those who, unique to their family's values, find themselves living a life in art.

Why are the arts/creativity/craft/ making so important?

Art, I believe, is one of the most undervalued contributions in our public educational systems. A lack of art fosters a culture where people see themselves as separate from their potential to make and be a part of creative contributions. My vision as an artist and arts educator is to help people find value in art and find within themselves their own unique capacity to create. There are countless reasons why art is vital to our society, but I will give you two important ones: (1) the arts engage students in ways that are not accessible in other disciplines, and (2) it helps one acquire skills that will be essential to their emotional and creative success in the new millennium. The arts

Photograph by
Jasmine Woodrul

163

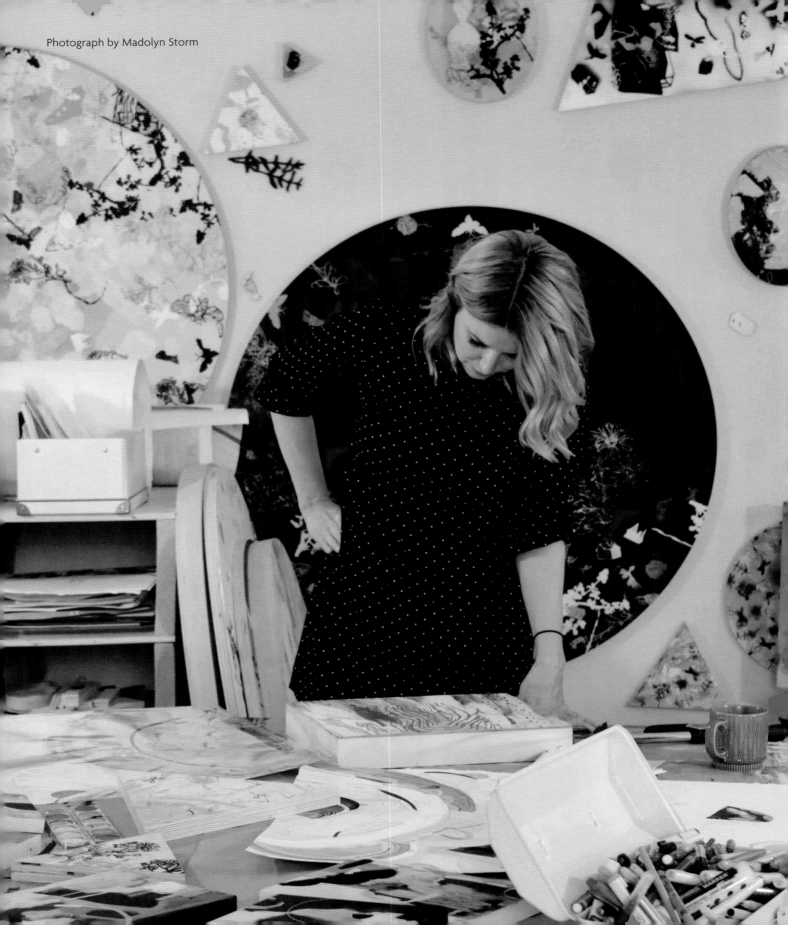

Photograph by Madolyn Storm

promote development of analytical skills, critical thinking, and emotional intelligence.

Every time someone is curious about art, it is important to encourage them and welcome them into this world. I believe cultivating creativity and using curiosity as a teaching moment are crucial to changing culture. Too often the arts are seen as exclusive endeavors that not everyone can access. Times are changing; art is becoming more democratized than before. Art inspires, and all of us on this planet have the capacity to inspire and be inspired.

What do you want to tell to future generations of women?

Let's work together to eradicate objectification of women in visual media; let's educate others and ourselves about equal representation of women in visual culture. When we see visual inequities, let's call them out. I feel very strongly about the power of imagery in media; historically the way women have been represented in Western culture has played a part in creating stereotypes and sexism.

Understanding the progression of archetypes, objectification, self-objectification, inequitable visual representation, and the male gaze are ways to subvert sometimes-unconscious undermining of women. Awareness is the first step to transformation. My greatest wish is for each member of society to recognize these inequities, to become aware of them, and then the unconscious influence of these images begins to lose its power.

How do you keep from comparing yourself to others?

A dear friend and artist, Melissa Dubbin, once told me, "There is room for everyone; someone else's success does not take away from yours." Melissa modeled generosity and philosophy of an inclusive art community, and this greatly influenced my confidence and belief in honoring my own voice.

What do you want to pass on to another mother?

First, you are a badass, because you are a mother to a child. Second, your motherhood amplifies that artistic flame in you to create and produce. Third, your child and your art are two distinct and sacred relationships. Cultivating both raises you to a certain level of creative openness—you have tapped into another level in the goddess arena.

Photograph courtesy of Isadora Stowe

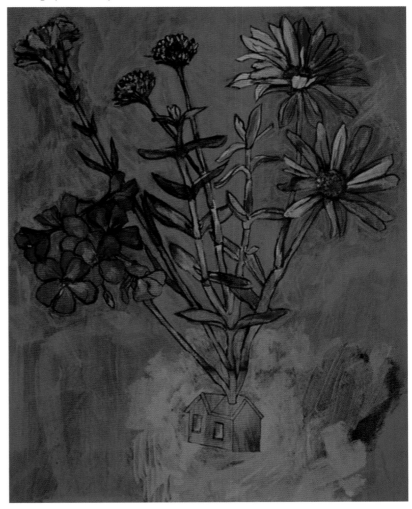

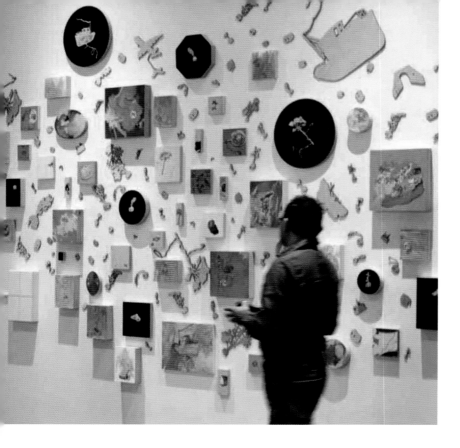

Photograph courtesy
of Isadora Stowe

I stay grounded from comparison knowing that my voice is not for everyone, but there is room for all of us at the table.

What do you wish you could tell yourself as a new mother?

I wish I would have known that it is up to me to turn every dismissal, every rejection, every backward step, every negative comment into an opportunity. Everything, in the right context, can be turned into an opportunity. An opportunity to look at things differently, an opportunity to forgive, an opportunity to transform, an opportunity to say "fuck off."

Have faith; you are conjuring up a kind of magic, making things appear from the unknown. To keep that space sacred, continue to do what you do, and believe in your creative process. Yes, there is so much negativity stacked against you, but your work is important; your vision and voice need to be seen and heard. When doubt in yourself as a mother or artist sneaks in, let it be

a guest, not the homeowner. See it for what it is, and then stay grounded in your faith and passion.

What is the best advice on motherhood you received?

"What other people think about you is none of your business." I gave other people's opinions of how I was living my life and raising my child too much power. When my child was a toddler and I went to back to school to pursue my MFA, I was straddling two different worlds that seemed completely opposite to each other. I was like Charon, the ferryman of Hades, shifting back and forth between the "land of the stay-at-home moms" and the "realm of the graduate art student." It seemed I was criticized in both worlds for not being loyal to one land.

Looking back, I wish I wouldn't have cared so much about the criticisms of others. Their negativity says more about them then about me, and in any case I could never please everyone's agenda. Anaïs Nin wrote, "We don't see things as they are; we see them as we are." People project their own ideas on others, especially, it seems, on mothers. And understanding this allows room for understanding and compassion.

What are you most proud of as a mother?

I have always had sections of art supplies specifically for my child, making my studio a space for the both of us. When it works and we can both be in the studio sharing time and independently working, it's a beautiful thing. I like to think I am giving a gift of process and practice in the arts, and this will be something that my child can feel comfortable tapping into.

My father, a printmaker, made sure I saw and participated in the arts; he made sure we shared that language. It's because of his mentorship that I find art to be the best way for me to express

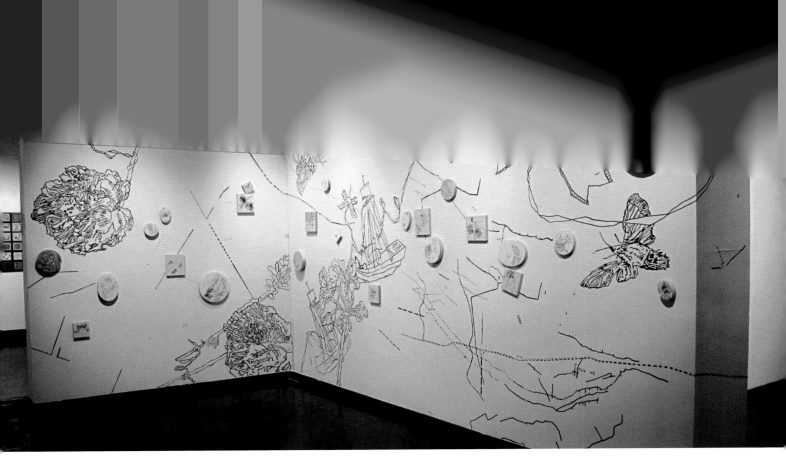

myself and interpret the world, so I am really hoping to pass that on.

Share your tips on finding time to create when you have children.

When I first had my baby, I worked on small, 4-by-4-inch pieces of paper with oil pastel and ink, I had previously been working on large, 6-by-8-foot canvases of female portraiture with oil paint. I knew I couldn't have those chemicals in the house anymore. I also realized that for me trying to get a large piece completed was causing too much frustration and stress; most days I didn't have time to brush my teeth or eat, because adapting to my new mothering schedule was intense for me. Working on the smaller scale felt very manageable, and I felt like I had accomplished something, even if I only got in twenty minutes.

It was small and portable, so I placed everything in a toolbox that I would cart around to whatever room I needed to be in. This work would eventually be the catalyst for the thesis work I pursued for my MFA. At the time it seemed like the work didn't have much meaning, but in fact it was in that space of not knowing and not having expectations that the work started to reveal itself and grow into a new direction.

Who is an artist mother you look up to? Why?

I think it's vital to surround yourself with people who are modeling the artist-mother role in the world. I look up to and look to my artist mother friends whenever possible as a springboard to contextualize what it is I am struggling with. Sometimes just articulating it to someone who understands what you are going through is very cathartic.

Sharbani Das Gupta is a close friend and talented artist and mother who also is my partner in a public art studio business we started together.

Photograph courtesy of Isadora Stowe

Photograph by
Flannery Barney

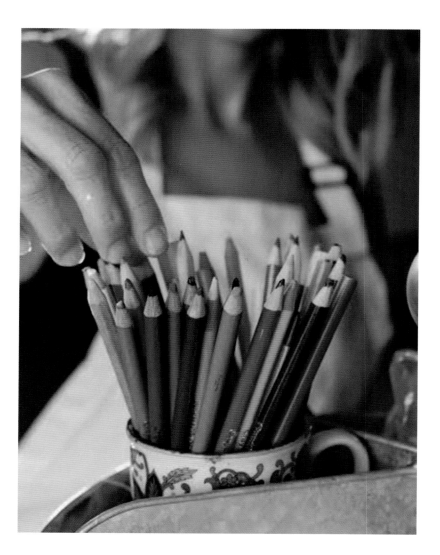

As an artist she is very good about prioritizing her studio time, and holding that space sacred while still being a generous mother and friend. She is also a 3-D artist, and as a 2-D artist I learn a lot from watching her and talking to her about her practice and how she interprets the world. So she is inspiring in multiple facets to me, and I hear her voice in my head when I am feeling guilty about the time I spent in the studio or on my work instead of doing something like mopping the floors in the house.

It is a balance, and trying to balance the guilt and the feeling that there isn't enough time is something I struggle with; she brings a lot of clarity to those times. I highly recommend finding your people; it makes all the difference.

Describe what the feeling of flow is to you. What does it mean to you?

Flow for me is the liminal space. I think art occupies a space opposite of certainty; it comes from a realm of the Absolute. Flow is moving in that realm, and we each have a different relationship with that liminal space. I value the roles that uncertainty and unfolding play in creativity, and I think that flow is that time in your studio where past, present, and future become one and you are in another space. South African artist William Kentridge, whose lifework revolves around these concepts, says, "There is a desperation in all certainty. The category of political uncertainty, philosophical uncertainty, uncertainty of images is much closer to how the world is . . . you can see the world as a series of facts or photographs or you can see it as a process of unfolding."

I think the cultivation of that unfolding, and creating a consistent relationship with that space, is an integral part of being an artist or a creative—and building and exploring your work without expectations. ■

Photograph by Madolyn Storm

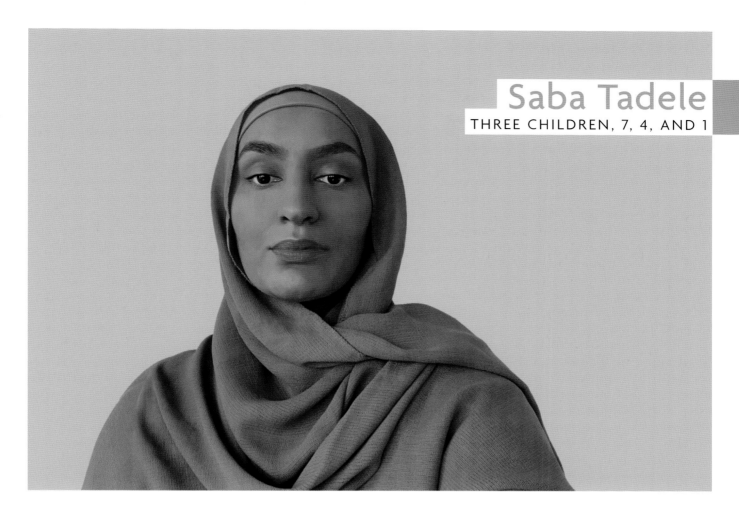

Why is it essential for you to create? What happens if you can't have this time?

Creating is one of the ways for me to explore my true self. Art gives me the freedom to express myself without judgment and to dig deeper into unknown territories. I have always been drawn to visual art and truly believe that we all are creative beings at our core. We just use different mediums as tools for our expression. When I don't create, I can definitely feel some kind of emptiness and restlessness. I am sure my family can sense it too. Creating is a part of me, and without it I am not fully myself or the best version of myself.

What ideas or themes do you explore in your work?

I started painting during a time when there were a lot of political issues in the world related to xenophobia, Islamophobia, and racism. As a Muslim woman of color with an immigrant background, I didn't feel safe and I was hurting in many ways because of the hatred that was growing toward people with similar background as me. I had friends who were physically and verbally attacked because of their ethnicity or religion. I was seeking answers, and when I couldn't get them from others I turned inward and started to paint.

My abstract pieces carry a lot of emotions and history. The contrasts, balance, sharp edges, hierarchy, etc. are all metaphors for our current state in the world we are living in, expressed from my perspective.

sketching wherever we went, even if it was on a napkin. During the weekends he took us to art galleries and exhibitions, and that is how my love for art developed at a very young age.

Was there a time when you thought you were not meant to make work?

Even though I was raised in a creative family, there were times that I questioned whether I could work with my art full time. Being raised in my culture/cultures, where there was an underlying expectation that you would either become a doctor, an engineer, or a lawyer, makes it really difficult to explore a more nontraditional pursuit. So therefore, being an artist wasn't really something that I believed could be my future, so I didn't really focus on it and I kind of pushed it aside for a long time. Instead I tried to become successful in a way that was expected from me, and the price was very high, because I was left with a void and a deep lack of fulfillment.

It wasn't until my uncle died in November 2014 that I realized how quickly life can come to an end. I started to ask myself: What happens if you die now and never really used the gifts that you have been blessed with? I thought to myself that it is now or never. I knew that I needed to create and to express myself through my art. I couldn't waste such a precious gift any longer. Shortly after his death I started to paint, and that was the beginning of my art journey.

What keeps you going during tough times?

When I feel low on energy, am going through some hardship, or am just lacking inspiration, I normally take a break to recenter and to find peace. I try to remind myself that it is temporary and creativity and inspiration will find its way back. Tough times are times for me to set new intentions and reaffirm the old ones.

Do you come from a creative family? Was there support in your endeavors?

Creativity has always been part of my family. On my mother's side there is a deep love for literature and poetry. My father is an artist and architect, and he has been my biggest influence when growing up when it comes to my creativity. He started painting as a young child in Ethiopia and used to sell paintings of the Queen of Sheba (Saba) on the streets of Addis Abeba to provide for his family. That is how I got my name. His story and influence have played a major role in my becoming the artist I am today.

I still remember the different smells of paint in our home as a child, and how he was constantly

What does self-care look like to you?

I have learned to make self-care a part of my life and not a separate practice, because I have suffered the consequences of not being aware of my body's signals. I start my day with some quiet time, grounding myself and connecting to God through prayer, followed by sipping herbal tea while reading my affirmations, doing some visualization, and writing in my journal. It is a great way to slow down and to focus on myself and my goals for the day.

No day is perfect, but I try my best to eat nourishing food, drink enough water, and make an effort to exercise. Moving my body helps me get the blood circulating and to release energy that I need in my work. Self-care is also related to any decisions I make throughout the day, such as what I choose to focus on or to let dwell in my mind. Being grateful and intentionally looking for the good in each day is another thing that is incredibly important in strengthening my self-love and overall happiness.

How do you keep from comparing yourself to others?

I believe each and every one of us are unique beings on this earth, and therefore we can never be properly compared to anyone else. No one has your exact experiences, wisdom, or gifts. Comparison is a huge distraction from what really matters and our passions. I think a lot of comparison comes from insecurities and lack of self-worth, so it's important to remember that we all can contribute in a special way and that there is an abundance of success and joy that is enough for us all.

Why do you think so many mothers express that they're not good enough? How can we support each other and shift this?

As we become mothers we are expected to be fully devoted to our children at all times, giving all of ourselves to these small humans, and usually

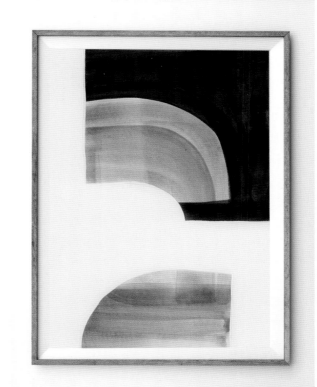

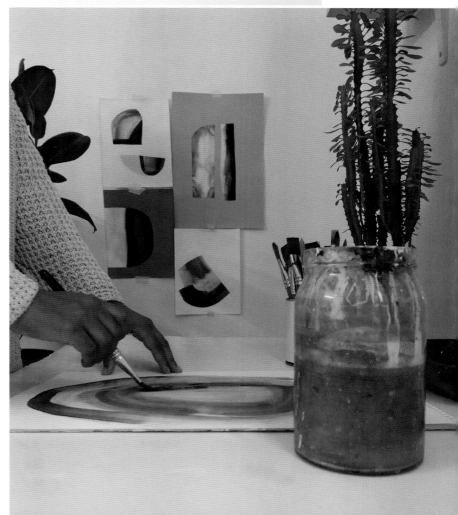

> So I have learned over time that it is not about the amount of time spent with them, but it is about the amount of quality time that I spend with them, being mindful and fully present.

there is this unattainable fantasy of how we imagine a good mother to be that contributes to a deep feeling of guilt and shame. I also think that living in a world filled with social media makes you think that you're the only one who doesn't have a perfect life and deepens these emotions of not being good enough.

To change this, we need to start being more vulnerable about our own motherhood with other women, without sugarcoating the truth and showing that we are all struggling to raise our children one way or another. Being over-whelmed or flawed and trying to balance it all somehow is just a natural part of parenting. If we share the struggles, I think it will empower women to strengthen their confidence as mothers and to feel connected with others who are going through the same wide range of emotions that comes with motherhood.

Do you experience guilt as a mother? What are your thoughts on this?

I think we all feel guilt and I personally don't think there has been a day I haven't felt guilt since I became a mother. There is always a wish I could do more, spend more time with my children, be more present, and so on. When I started my entrepreneurial journey, it was tough to make the time to work while my children were at home. I felt like I was missing out and that I wasn't a good mother.

It took a lot of time for me to understand that I would never be the best mother that I can be if I didn't honor my gifts and passions. This was ultimately what I needed to teach my children, that it was okay to take the time to focus on your own growth and visions. It doesn't make you a bad person; it makes you the person you are supposed to be.

What joy does being a mother bring to your life? What hardships?

Being a mother and raising my children is probably the greatest accomplishment of my life.

It is life altering in so many ways to be given the privilege of seeing the evolution of a little

human and feeling myself change as a consequence every step of the way. But motherhood also entails a lot of other feelings; even before the child is born, we start to feel worry, anxiety, and a myriad of other overwhelming feelings about this great responsibility that we have been entrusted with. Balance between work and the family life has been a huge concern for me, and I am still trying to find a way to combine both. My children can sense when I am stressed or not fully focused when I spend time with them. So I have learned over time that it is not about the amount of time spent with them, but it is about the amount of quality time that I spend with them, being mindful and fully present.

Did you experience postpartum depression or "baby blues"? How did you find the support you needed?

When my youngest son was born, I had a combination of postpartum depression and a severe burnout. No matter how much I wanted to create, my body could not do it physically, and I felt incredibly powerless and fragile. My cup was completely empty, and I realized it had been for a long time. So, I had to learn how to fill it up again. I took a break from everything business related and started to just slowly practice self-care and to be still as much as possible. It was a very tough and dark time, and I had to really reevaluate my life and how I had spent my time. I was desperately searching for healing and started to prioritize myself and to practice self-care. It didn't come easy to me, because I had associated self-care with guilt for a very long time.

I am a natural people pleaser and a highly sensitive person, so I wasn't used to putting myself first. But I now know I need to say no to the things that are out of alignment with my values and passions to simultaneously create space for all that is. There is no other way around it, and it is a huge relief to have learned this very crucial lesson.

What do you want to teach to your children?

There are a multitude of things I wish to teach my children about life. Some of the things I wish I was reminded of as a child are to not let fear stand in the way of your dreams and aspirations, to always continue to invest in yourself through knowledge, self-awareness, creativity, spirituality, and self-care. To be kind, empathetic, understanding, and compassionate to others. I struggled a lot with finding acceptance and a sense of belonging because of prejudice and discrimination during my childhood. Therefore, I also hope I will be able to instill confidence in my children when it comes to their heritage and identity.

How does being an artist influence you as a mother and vice versa?

I believe my love for art has played a major role in the way I raise my children. I really want to help them channel their innate inner creativity as much as possible and to teach them how to use it as a tool for expression and healing.

Does seeing the world through your child's point of view inspire you in your work?

Seeing my children and how effortlessly they can use their imagination to express themselves creatively is one the best ways to find inspiration for me. Sometimes when I am feeling like I am in a rut, I just sit down with them and try to do something creative with them. To see them create so freely without all the pressure of the outcome often helps me find my way back to why I started my artistic journey.

Describe what the feeling of flow is to you. What does it mean to you?

Flow to me is to be present, to be completely mindful of life. When I am in the flow while painting, it is effortless and just pours out of me like water. It is one of the best feelings to just let inspiration flow through you without questioning it or hesitation.

What kind of impact has your cultural identity and being a woman from a minority background had on your work?

My cultural heritage and exploring the concept of identity have been some of the main themes of my work. I have a multiethnic background, and it has always been hard to find a way to identify with my mixed identities. Sometimes you feel incomplete and never being enough of both or accepted by them. I want to show people that there are other voices that need to be heard, because, unfortunately, women with my background are very rarely given the spotlight in the art world, and representation is severely lacking in many areas. I hope that there will be a change and that one day the art community will get better at promoting cultural diversity in the arts, because without diversity, art will never reach its full potential. ▪

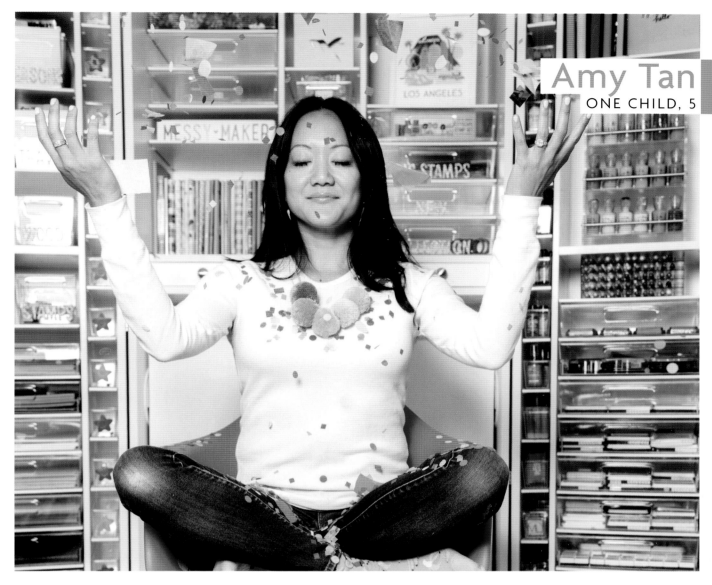

Did you think you would need to stop making work once you became a mother? Explain please.

Honestly, I thought I would be able to do it all. I've always had an immense amount of energy, and while I was pregnant I began delegating even more to my team. Though I didn't take a formal maternity leave, I thought I would be able to go back to work seamlessly after about six weeks. Sleep deprivation and adjusting to motherhood definitely took me longer. This thing called guilt, which I had rarely experienced before becoming a mom, was real, and it was invading my life.

I felt guilty when I was working and not with my newborn, and when I was with my newborn, I felt guilty that I wasn't able to dedicate time to work. Thankfully, things got better and I gave myself grace. As a scrapbooker and a mom, I really wanted to document every single moment, hold on to every single drawing— it was definitely a lot.

As a Libra, I have always been drawn to balance, but as my time as a mother has continued, I've learned to strive for harmony. What makes me

Photograph courtesy of Amy Tangerine

I have always been drawn to balance, but as my time as a mother has continued, I've learned to strive for harmony.

Photograph courtesy
of Amy Tangerine

and hand-stitched shirts, it seemed fitting to have it all under the same name— Amy Tangerine. In my twenties, I focused on branding without realizing. Then, at some point, things changed for me. I think my soul had been searching for something new; I was feeling consumed by my small business and a shift in the economy.

I realized that although I loved what I was doing, I wasn't making enough time to be creative just for the sake of it. Finally, I walked into a scrapbook store I had passed so often, took a class, and immediately was hooked. I loved every aspect of it— not just the supplies and photos — but the bonding of women as they shared their stories and spent time on a hobby they loved. I work in all aspects of design and marketing.

Scrapbooking and daily documentation of life on paper is my favorite. I consider myself a modern-day memory keeper. I gravitate toward infusing color and whimsy into my work and play. Watercolors, stationery supplies, art journaling, vision boarding, and traveler's notebooks are my current favorites.

What do you want to tell to future generations of women?

That your creative passion is not a selfish pursuit and that creativity is not only about talent. To me, creativity is a lifestyle, and it's something that anyone and everyone on this planet of capable of choosing. It's really about making the decision to live life in flow while embracing who you are.

I think that every woman on this planet should do what they love and what they feel a passionate about. I think so often, we feel like we're obligated to do all these other things in our lives, and slowly those obligations overwhelm our dreams. We must grant ourselves permission to be our whole selves, so that our inner lights may shine the brightest.

happy? Are my priorities in alignment? I have a whole set of questions I ask myself to help me keep track where I am and how I'm doing as a person. At this point, I'm so grateful my son is old enough to want to participate in creating art and enjoy it in his own unique ways.

Tell us about your work. (What mediums, crafts, etc. do you work in? How did you learn and start? What made you gravitate toward that particular medium?)

Initially, I worked as a fashion stylist and produced photo shoots. I came up with my business name at that point. When I started making arm warmers

What was a big goal or dream that you accomplished? How did you make that happen? What did that feel like?

I am so proud of my book *Craft a Life You Love*. I poured my heart and soul into it and really wanted to create something where I share my personal and professional struggles and the go-to exercises that have helped me with self-care, a positive mindset, and making things happen. It was a passion project.

A couple of my friends had self-published and had a great experience, so it was awesome being able to get their advice on the process. I hired an editor, book layout designer for the interior pages, and a cover designer. My editor told me that I would never write a book until I wrote a bad first draft, and after I did that, I could just hand it over to her.

It was super helpful for me to have an expert lay out the flow of the book; I just wanted it to inspire enough people to get the money back that I had put into it, but the return was so much more than I could have ever dreamed. A couple of months after it was released, it was picked up by Abrams. We worked on the revised and expanded edition, which is out and available now! I wanted to be sure there was value in it if people had already gotten the first one but also wanted the new version. The book experience also just shows the value of pursuing your dreams, even if you have no idea what the outcome will be. This has surpassed my expectations.

What do your kids teach you about life and yourself?

What do you want to teach to your children?

I want Jack to know that it's important for him to stay true to himself, that kindness and empathy are important skills in addition to hard work. I'm so glad that he gets to grow up watching me work in the studio because he's going to have such a unique perspective on what "work" really

is. Sometimes it means drawing a new piece or shooting a different video. Sometimes it really means sitting and answering emails all day. All of those things and more are work, and if I get to model success to him in a way that shows him that your passion can actually be your career, then I'll feel satisfied.

Photograph by
Gray Malin

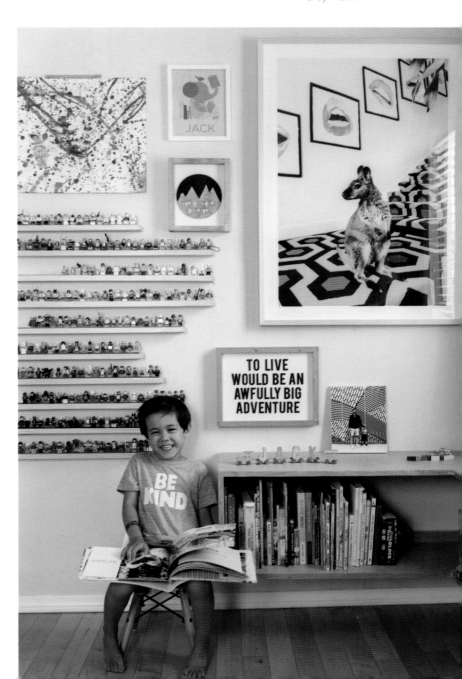

Photograph by
ographr/Lin Marty
Photography

What do you wish you could tell yourself as a new mother?

The importance of pressing the pause button when you can. What you are doing is enough, and that things will actually be okay. At the time I didn't think I was documenting enough and I didn't go all in chronological order at first, but seeing it in the album makes me really appreciate the fact that I took the time to do it, even while I was sleep deprived. Our hobbies are really important to not lose sight of, and as a new mom, I would often just steal ten minutes here and there to get something down on paper. It would take days to finish a layout sometimes, but now when we look back on them, we are so grateful to have it documented.

Do you experience guilt as a mother? What are your thoughts on this?

I like to say that I didn't really know what it was like to feel guilty until I became a mother. The pressure to be a good parent is so strong, and when you're also a small business owner and an artist, there's so much that requires your attention.

I actually have a new theory on balance. I'm a Libra, and the concept of balance is something I have focused on my entire life. At different points I have definitely felt like I achieved a state of balance, but it wouldn't necessarily last, and outside circumstances would throw it all off. Well, I recently decided to basically say F balance; it's more about harmony. I came up with an acronym for it, which has been my guiding

principle through struggles and times when my anxiety is at a high.

The basics of what I am calling the Harmony Principle: Happiness—head in this direction; what will make you happy? Align with your values. Redirect if necessary—it's okay to change course. Money—know your worth. Original—there's only one you; surround yourself with authentic and original people. No—know when to say "no thank you." You—it's all up to you. You have the power within you to craft a life you love.

What is the best advice on motherhood you received?

Everything is a phase, so enjoy the moments you are in right now. Also don't spend too much time worrying about the future—it comes soon enough; just be present and enjoy this ride!

How does being an artist influence you as a mother and vice versa?

When I find myself in flow, I am able to do my best work. I used to be a bit of a control freak and had to do a lot of things myself. Learning the lessons the hard way was something I knew I had to go through as a young entrepreneur. But with motherhood, I knew there was a better way. I could listen to people's advice but trust my intuition and do things they way I thought was best.

Just like in business, motherhood has shown me that you win some, you learn some. I have learned to try to relinquish a bit of control so that the creativity and the ideas can evolve as they should. Motherhood has taught me patience, acceptance, and even surrender in a way my business never did. Work is more about the hustle, and motherhood is more about the heart.

Does seeing the world through your child's point of view inspire you in your work?

Recently, I was sorting through a bunch of Jack's drawings and papers from a few years ago and just marveling at the way he drew pictures on these sticky notes. Some of the drawings were of really simple things, but there's something so amazing about how he did them. He has a unique way of seeing the world that just fascinates me. But maybe the best thing about his art is the way he describes it. He explains what he was thinking, how the robot works, or what kind of lollipops they are. He has a lot of precision and expectations around what he draws and how it looks on paper. It's inspiring to me but it also reminds me of how important it is to separate from perfectionism.

I don't want to constantly judge my art by impossible standards, and I definitely don't want Jack to, either. Enjoying the creative process is paramount, and seeing his face light up when he makes new discoveries is the best.

Photograph courtesy of Amy Tangerine

Each day is a blank canvas... Go and make some marks.

Photograph courtesy of Amy Tangerine

How do you find ways to make work and keep at it through changing seasons of life?

As a workaholic, I have definitely had to shift and adapt through the many changes. Though I love what I get to do for work, it doesn't mean I have to be doing it from the time I wake up until the time I go to bed. There was a season of that in my twenties, and though it served me well as a small business at that time, now that I am older, I am more focused on wellness and what truly matters for me and my family.

Finding clarity on what sets your soul on fire and how you're using your time (our most valuable asset) is key to finding happiness and joy in your work. Also it doesn't hurt to celebrate the little things. Little wins may not feel like much at the time, but they add up and grow into a heap of gratitude and momentum.

Photograph by ographr/Lin Marty Photography

How have you overcome struggles or times of feeling overwhelmed?

I used to think anxiety and feeling overwhelmed were just a part of the deal when it came to being a mom and an entrepreneur. Thankfully I was wrong. Now when I get overwhelmed, I have a practice that is a combination or pausing, reflecting, and assessing. Then I can gain clarity on what the best next steps are. I used to be super reactive, and though it has served me in the past, I have learned that there needs to be a more mindful approach in place for my overall well-being. My journaling practice and morning meditations have made a huge difference in my life too.

What helps you through creative slumps or times when life is full?

Taking at least ten minutes a day to do something creative has definitely made a huge impact on my life—even if it's just jotting down things in my planner or playing with stickers with my son. If I am not feeling particularly inspired workwise,

sometimes I will just do some mundane or routine things that get me doing something. I also have a ritual of exercises and practices that I like to dive into on paper that have definitely gotten the creative juices flowing. And to be honest, I have not found myself in a creative slump in a very long time. Crafting a life I love is essential to my being.

What is something in your life (or creative pursuits / art) that you never thought you'd accomplish but did?

My parents always dreamed about being entrepreneurs. I never thought I would be getting paid to do such fun and creative projects and to share them on social networks. One of my goals is to donate more each and every year, and I am proud to say that I have been able to do that. Though it seems random and super niche, I have been able to create a sustainable business where I get to do what I love on a daily basis while helping and inspiring others. ■

Photograph by
Lish Creative

Left: Photograph by
ographr/Stephanie
Day

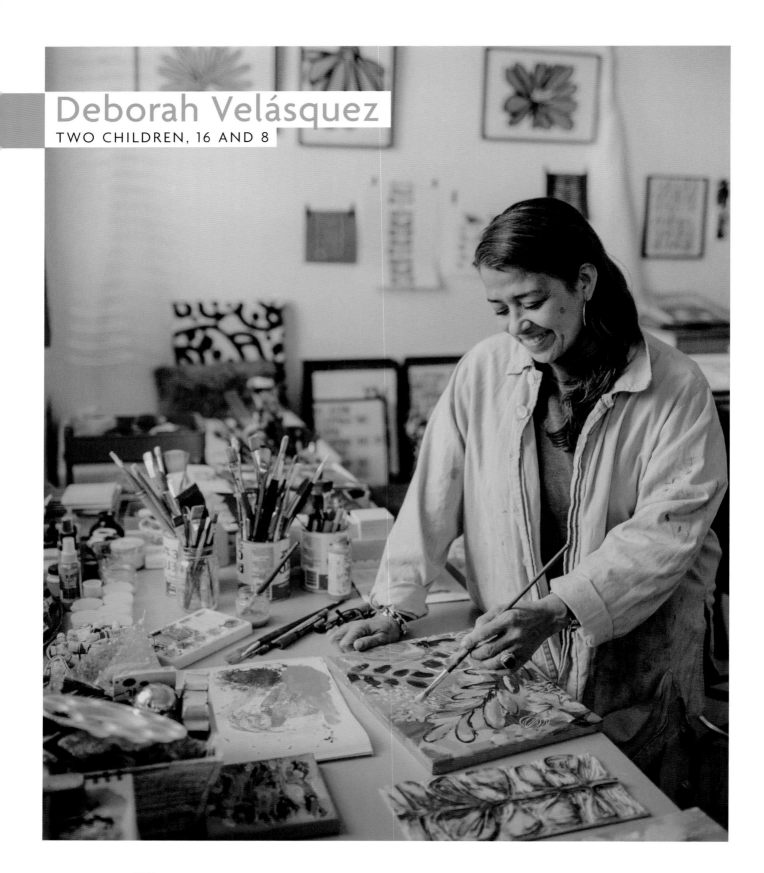

Deborah Velásquez
TWO CHILDREN, 16 AND 8

Why is it essential for you to create? What happens if you can't have this time?

I enjoy being creative; nothing lights me up more. I cannot breathe without creating. It is part of my every day. Art has always been like being in love for me, It's another relationship in my world besides mother and wife. I have always said, "When I am making art, I know this is what I should be doing." It brings me to another level, to another place. One of great joy.

What does creative exploration mean to you? What does it look like to you?

I take pride in being prolific, which is evident with my sketchbook projects on Instagram. I am in my fourth year of drawing or painting every day. I have learned so much from this discipline, and it has been lucrative as well. I have become a better artist, and I have had such fun experimenting with new techniques and supplies; I believe you learn from your materials and grow as an artist. I love being an artist. Three things drive me and my art: possibility and accessibility for others and curiosity.

Did you think you would need to stop making work once you became a mother?

No, never thought I would, but I did. As I became used to my new world and role, I would eventually come back to making my own art after my first child was born, I became a stay-at-home mom; I became that "artist mom." I created art side by side with my son as he grew and my body of work grew. That is how it all started.

I am inspired by my children, and because of their sense of wonder I enjoy and see the beauty in every day. It is not always easy to make art as a stay-at-home mom. I found myself making art in bits between naptime, playdates, and school pickup, but I do get to do what I love and that's a good thing.

My hope was to have flexibility as an artist and raise children at the same time. I took whatever free time I had and made art. At times it would be only an hour; I made that the best hour ever! I also did not get too caught up on what I made art on. I kept things simple.

Those were the days of 5-by-7-inch tan craft cardstock cards and a pen. That was the only art I made for a while.

Tell us about your work.

My real art training started in art school. I love gouache (it is so forgiving), watercolor, and printmaking. Hand-rendered techniques have always been a strength. My expression of creativity has taken and continues to take many avenues and is represented in many forms. As of late I have been expressing myself on large canvasses, working in acrylics.

> When I am making art, I know this is what I should be doing.

What ideas or themes do you explore in your work?

Garden life plant life, stems, flowers birds, butterflies. Graphic shapes and patterns with a Scandi influence.

Do you come from a creative family? Was there support in your endeavors?

Yes somewhat; more like writers, stylist, and musicians. There was always support. Especially from my mother, aunts, and older cousins.

When did you first learn your craft/ medium? Do you have a strong memory about this?

I went to school for graphic design and textile design. My creative history contains art school and creative jobs in design. I worked in the fashion industry before kids, and my jobs have included graphic design, textile design, and millinery. I continue to learn and explore different mediums of art to express what I feel and think. I know this is what I am meant to be doing, and I have known since a young age.

My love affair with art and creating has been with me since childhood. I could never have enough paper or pencils. I had a difficult time deciding if I wanted to go into fine art or commercial art. What is so wonderful now is that you can do both. My mom used to buy me *Vogue* magazines growing up, and I drew a lot of faces and fashion. I believe that influenced my early creative career in the fashion industry.

Was there a time when you thought you were not meant to make work?

Never. I have always said, "When I am making art, I know this is what I should be doing."

What are you not working on that you wish you were?

Right now as I sit typing, I wish I were painting on a canvas, really large pieces like 4 feet by 6 feet. Making a big mess without a deadline.

What does your process look like?

I jump right in; I rarely sketch first. I love the freedom and flow of following the line, so to speak. If I were doing a portrait or animal, I might put a light line down first.

What things do you do to continually learn, improve, and grow as an artist?

Every day I do something that moves me forward in my art practice and business, which is important if you want to have a sustainable creative life. Cobble together, then shift as you succeed. I go on creative retreats, take workshops, and collaborate with other artists. I have a mentor in Pia Sjölin, a Swedish fine artist who does museum-quality work, and she pushes me to create out of my comfort zone. I learn so much from her just in our daily conversations.

How do you know when to walk away versus overwork a piece of art or project?

I have been lucky to have this come to me intuitively. I have heard it is hard to know when you are done. For me, it just feels right in my being. It is like my soul steps back and has a look at the work and says this feels complete. Now, that doesn't mean that the next day I might add some touches. It is important to step back from your work or even walk away for a day.

Did you have formal education or apprentice to learn your craft or work?

I went to school for graphic design and textile design. As I mentioned earlier, I am graduate of the Colorado Institute of Art and the University of Hartford entrepreneurial business program. I studied textiles and fashion design at the Fashion Institute of Technology (FIT) in New York, where I received my millinery certification,

What do you want to tell to future generations of women?

To me, to be on a creative path or journey is to choose to make art, evolve and grow as an artist with knowledge through learning, build your body of work, create a style all your own. Your work is the essence of you, is it not? Be you, be true, be.

On your journey you might have to get off the bus or even change buses for a while due to family stuff or other commitments, or just to deal with what life throws at you. Just remember the creative path still awaits you; the road is still there to follow. You have made it to your first destination, though, and that is in choosing to be artist.

How do you know when to share something and when to keep it private?

If I feel fear or a discomfort in my gut, then I do not share it.

Don't let fear cripple you. Make him a friend; make him a welcomed guest at the table of your success. Don't let fear turn into regret; as I said earlier, "live life without regret." Thanks to my mom! Put yourself and your work out there. Take a chance; you might be pleasantly surprised. If you don't ask, you don't get. Everyone has or will have a customer, a client, a "their person" with whom their work connects with and speaks to. Make art every day; it can just be a doodle. I have an exercise I do in the morning—takes seconds. I take a sheet of paper and put the pen down once to make a continuous line of scribbles or doodles, never picking up the pen till the page is significantly covered with creative marks. Voilà! Your first masterpiece of the day! Don't let anyone tell you it is only a hobby! Or you don't really work because you make art! Or it's not a "real" job. Keep learning and share your knowledge to inspire others.

What keeps you going during tough times?

You mean creatively? I usually turn to the documentary *A Sense of Place*, about Virginia Lee Burton. It always makes me feel like I can do this. And listening to Nina Simone . . . takes me out of a funk and gets me painting.

What does self-care look like to you?

Coffee! I wish I were better at self-care, but I believe my art is my self-care; it brings me such joy.

What was a big goal or dream that you accomplished?
Writing a book was a wonderful life experience. I kept showing up and saying to myself, "Why not me?" I started my Instagram discipline in hopes of getting noticed and having more of a social media presence, and it helped me get work, and I did get noticed by Quarry Books.

What is the best advice on motherhood you received?
Follow your own path. Live with joy.

How do you handle people in your life who criticize or diminish your creative pursuits? Do you feel the need to defend it—how do you do this?
Make a decision that they are not my people, and I move on. It is so important for artists to have their tribe, so to speak. My community of fellow creatives is truly unbelievable at this point. I am so grateful to have friends to discuss new ideas, artwork, techniques, creative blocks, and clients.

What joy does being a mother bring to your life? What hardships?
That love, unconditional love, and when your boys say "Mom, you are beautiful," and you are running on two hours' sleep and have no makeup on and your hair has decided to go every way sideways—these are the best!

Hardship . . . Not having my mother around. My kids do not have grandparents, and that is something that makes my heart ache for them.

What's the hardest thing about being a mother? The easiest? The funniest?
To be honest, the juggling. For me, the mental gymnastics of the activities and the planning, but that goes with the territory, right? And the driving to and from school, ugh! With such busy schedules, it is a challenge to give the kids the quality of relaxed closeness, quiet time with you. Loving these sweet souls is the easiest and just the best part! The funniest is how the kids see what really matters, and how trivial things are in the big picture. Makes you stop and laugh for sure, because they see right through it! "Mom, why is there always a deadline; what about a lifeline?" . . . this kid, my eight-year-old!

What do you want to teach to your children?
To be true to who they are. I want them to have courage, love, and lots of laughter in their lives. I want them to become great citizens in this world and to know what it takes to be gracious and kind in the toughest circumstances. And to stand up for what is right and good in the world.

Tell us about a role model or supportive person in your journey.
My mother was very supportive, and she always said to "live life without regret" and "do everything." At some point after that, I was given an opportunity to work with a retail design team in New York—one of the best experiences of my life. I had the opportunity to work for two fabulous women who have affected my life in many, many positive ways. They were Nili Lotan and Jane Beard.

Did you experience a sense of loss or grief for the life you had before you became a mother?
Not the life so much, but the identity. I wanted both mother and artist, not one or the other.

How does being an artist influence you as a mother and vice versa?
Oh, we definitely have a creative life because of it. My little one thinks I can make anything out of

nothing. "But Mom, you are an artist—you can do anything." Ha! The two are intertwined. My children love all things in the creative culture. We love sitting around creating together. We make creativity part of our lives. On the business side, my children help with shows, packaging, organizing, and even setting up. Having a dedicated space to make art has been one of the best decisions I have made. I love my studio and my children love my studio, and it has become "our creative space." They are so blended into my creative life, and that lights me up.

What are you most proud of as a mother?

My kids; who they are and who they are becoming.

What has one of your biggest struggles been as an artist? As a mother?

Of course, giving the time to either one, the art or the family, without guilt.

Who is an artist mother you look up to? Why?

I have three: Lotta Jansdotter, Pia Sjölin, and Nili Lotan. I love how they balance their lives with their creative work and their family life.

Does seeing the world through your child's point of view inspire you in your work?

I am inspired by my children, and because of their

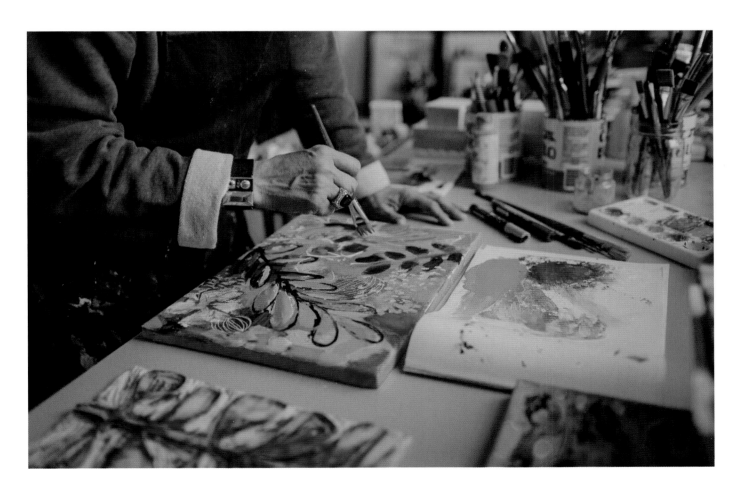

sense of wonder, I enjoy and see the beauty in every day. My youngest likes to mirror my drawing and sketches, and that just lights me up. Both my children love art and really enjoy creating. I love when they are in the studio and create with me. I created art side by side with my son as he grew and my body of work grew. That is how it all started.

How have you overcome struggles or times of feeling overwhelmed?

Step back, take a few breaths, and talk/think it through, because it isn't as bad as you think. And know that you can shift and break things down into small pieces and work a bit at a time. Reach out to other artist friends for conversation and guidance.

What helps you through creative slumps or times when life is full?

My art and garden books and magazines (piles of

them inspire me), and artist documentaries where you see their successes and triumphs. Two other favorites are the painter Rex Ray and the architect Charles Eames.

What is something in your life (or creative pursuits / art) that you never thought you'd accomplish but did?

Writing a book. And . . . Smithsonian has asked me to facilitate a workshop from exercises from my book. I have also been asked to speak to their Ambassadors program students at this event .

What do the easy times feel like?

Vacations at the beach; we love Martha's Vineyard— no schedules or cares, and creative times involves sketching, cut flowers, collecting rocks and shells. We stay creative but connect it with nature. My favs are the rock sculptures at the beach.

Describe what the feeling of flow is to you.

Oh, it like being in love; you get lost in it. Out of body. I call it "unbroken" time.

My creative joy is the movement of paint as I create and share my spirit and soul of that intuitive place.

What barrier or circumstance do you wish you could change? How would it affect your life or work?

Umm . . . I wish more women of color were represented at the creative table. Magazine features, trade shows, talks and summits featuring artists. I always wish there were more women that look like me. I would love to have more conversations about this. I do not want to be perceived as having a chip on my shoulder because I see things through a different lens. ■

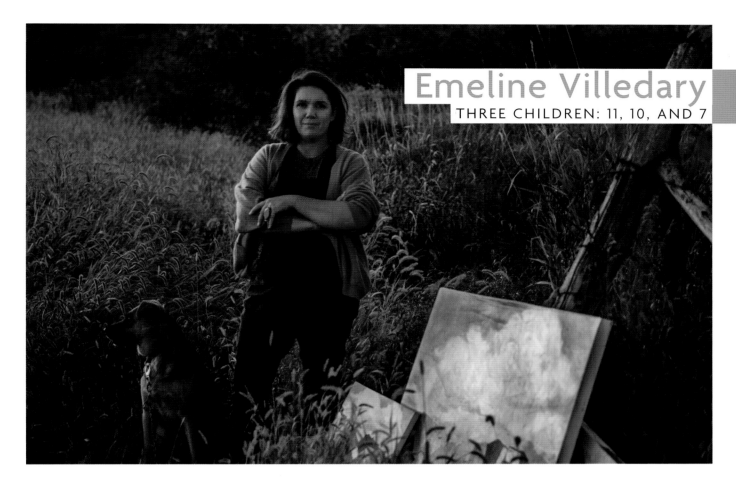

Emeline Villedary
THREE CHILDREN: 11, 10, AND 7

What does creative exploration mean to you? What does it look like to you?
Creative exploration is all about following that thread. For me, it looks like getting an idea and playing with it. Often it comes from a line in a book, or just a visual flash that comes into my head. And then I work it out; I play with it; I try it; I make stuff; some of it sucks; some of it doesn't . . . and then I keep following that thread to the next thing.

Did you think you would need to stop making work once you became a mother?
It was motherhood that actually made me realize the importance of creation. Somehow, creating life made me aware of how important it would be for me to continue creating and show them that you can craft a life of creativity.

Tell us about your work.
I think I've been able to narrow it down to painting—on canvas, on paper, on wood. Not to say that I won't continue to explore collage (I've got quite a bit of collage work) or explore 3-D work, maybe layering, painting, and 3-D. I definitely follow my interests . . . even if it's just for me. I loved sculpture in art school—and I've always loved working with wood. So who knows! I love the idea of keeping things open.

What ideas or themes do you explore in your work?
Landscape and botanicals pop up a lot, but I think when you dig a bit deeper, I work in the spaces of emotional and existential contrasts. Nature is a huge part of my work, and our human relationship to nature and our existence in space-time come

Photographs by
Annabelle Agnew

189

up in a lot of my writing. But if I'm being 1000 percent honest, I think color is the consistent theme. I get a physical rush from putting colors together.

Do you come from a creative family? Was there support in your endeavors?
I definitely come from a family of makers. My mom was an avid quilter, and my dad a great carpenter and photographer. But no one made a living from their art. My parents are definitely supportive, but I think they worry about the stability of it all. When I was a teenager, though, my mom really supported me in taking classes and nudging me along.

Was there a time when you thought you were not meant to make work?
You mean like how I feel after every time something doesn't quite go my way? (laugh) I think the more I do work, the more I realize it's the thing I'm meant to do . . . but nothing like a crap week

to get that hamster wheel of doubt going! All kidding aside, though—I truly believe that creative work is kind of like hitting a spiritual gym. It blocks everything else out, and for a few hours (if you're lucky) you're connected to this human presence. This act that is suspended from anything else; it's like a small moment in magical time.

What was the first thing you remember making after having your first child?
I made a series of orange silhouette art canvases as gifts for Christmas. It was 2006, and silhouette art was *super trendy*, and, well, I jumped on the bandwagon! They were actually pretty nice in retrospect!

What are you not working on that you wish you were?
I think I want to be working on getting my technical digital skills up to par. I feel like sometimes my lack of technical knowledge (like Illustrator or

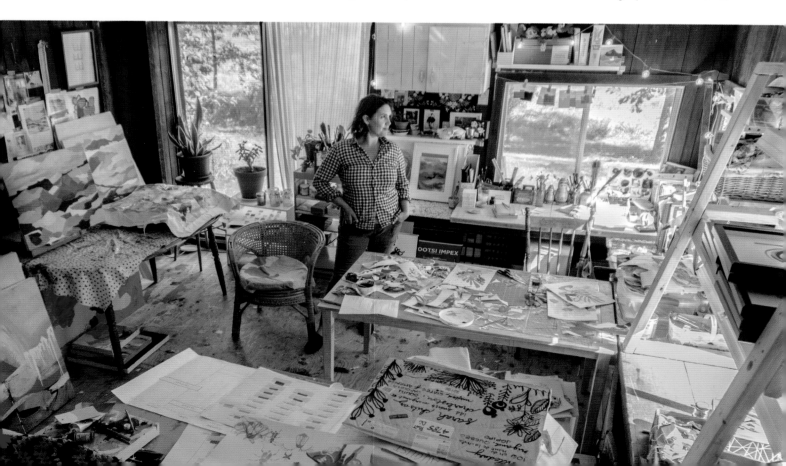

Photoshop) holds me back from participating in certain things. But I guess if I wanted it bad enough, I'd be making it a priority, right? I also have all these plywood ideas. I love plywood triangles, and I would be devastated if I never followed that thread!

What does your process look like?
I work in large generative spurts, so like nine canvases at once, but I also have a daily practice that warms me up and keeps the creative wheels going when I'm not in a spurt of large pieces.

What things do you do to continually learn, improve, and grow as an artist?
Take classes, say yes to things that are slightly out of my comfort zone, change up materials every once in a while, go out to museums, read books.

How do you know when to walk away versus overwork a piece of art or project?
I've learned to stop and take some time, and then it's really just about listening to that voice that tells you *enough*. Oh, and not washing your brushes; that stops you dead in your tracks sometimes!

How do you know when it's time to switch it up? Medium, body of work, parenting, anything.
When I don't feel excited about what I'm doing . . . or when I'm dragging my feet.

Did you have formal education or apprentice to learn your craft or work?
I have a bit of both . . . I was the art kid in school and then I studied interior design, which had two years of fine arts included in the program. But I've taken quite a few classes and workshops since.

Were you self-taught? What did that look like?
I didn't take any painting classes in school, and so I had to teach myself all about acrylics on my own. Which was expensive, since I had to try out all kinds of mediums and brushes before figuring out what worked for me. I definitely learned a ton from my online community of artists though.

How do you know when to share something and when to keep it private?
I try to keep things private until I know that I've gotten them somewhat figured out. I think sharing from a space of having traveled a hardship means that you can actually impart the process of getting through it, rather than focusing on getting stuck *in* it, if that makes sense.

What keeps you going during tough times?
Faith—and not the religious kind, but rather deep Trust or knowing that I'm part of something greater than myself and that this hunger for creating is

I think "self-care" is being hijacked right now, and sometimes self-care is less about the chocolate croissant and more about the dentist—you know?

part of that. I know, it was surprising for me, but in the last few years I've really seen my creativity intertwined with a faith. I have a pretty consistent meditation practice that keeps me focused on things outside my immediate surroundings . . . but that and a good cry on the phone with a friend!

What does self-care look like to you?
Bath time, meditation, journaling, going for blood work if you need it. Making sure I get good sleep and rose water. Yoga class, and once in a while I'll splurge on a fancy candle. Therapy. I think "self-care" is being hijacked right now, and sometimes self-care is less about the chocolate croissant and more about the dentist—you know?

Do you have moments of resentment or longing for freedom?
Daily? But I'm working on it.

Was there a moment or time when you could not see how you could make things work? How did you get through that?
I had a burnout in the summer of 2017, and it sent EVERYTHING into question for me. It was a tough month, but I reached for help—I found a great therapist who helped me identify some patterns, and she helped me set up some boundaries.

What do you wish you could tell yourself as a new mother?
Pretend like you have one arm and one leg. Limit what you think you *can* do, and trust your gut.

What is the best advice on motherhood you received?
Life sometimes makes it that we end up raising our families the way we can and not necessarily the way we want. Being nimble in navigating those two polarities can really save you from some dark times.

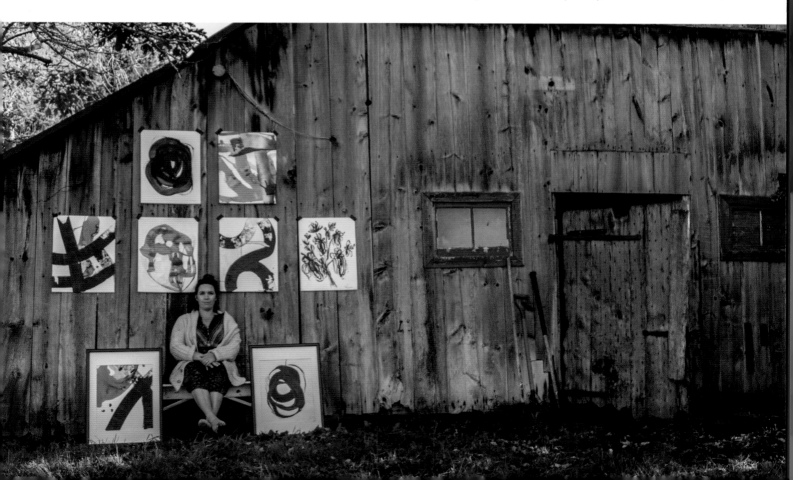

Why do you think so many mothers express that they're not good enough? How can we support each other and shift this?

I think as women we are socialized to believe we are not enough—mothers and nonmothers alike. I think it's pretty systemic, and we are starting to see movement in this area. Not enough makes sure you're buying into the stuff and busy trying to be enough, when in reality, we are born enough. Socialized to not see it, and then, if we're lucky, we start to find the clues that lead us back to enough. It's tough.

Do you experience guilt as a mother? What are your thoughts on this?

I mean, I think as your kids grow up, you experience less guilt? I mean, I always felt like I tried really hard, and so it wasn't guilt specifically, but somehow I felt not "enough" sometimes. So, for me it was more shame than guilt. That I felt like I should be better at (fill in the blanks). I don't think this is specific to moms, but I think because our kids are somehow seen as a reflection of us as parents, we can't help but feel responsible for the outcomes. As they are getting older, I'm seeing more and more that they are fully formed people already, and that my job is really just to steer them and be there when they fall off, get hurt, fail at something.

How do you handle people in your life who criticize or diminish your creative pursuits? Do you feel the need to defend it—how do you do this?

I like Brene Brown's quote about being in the arena! I rarely ask anybody's opinion anymore . . . I think we use other people as mirrors for our own insecurities. We look around for permission to take a break, take a class—whatever it is. And you will always be able to find people who think "why bother," and those people—well, they're not your

people! People get nervous when they see other people follow the thread and start taking up space. It's destabilizing for someone who isn't all that connected to themselves.

What joy does being a mother bring to your life? What hardships?

I mean, do you have an entire other book? I'm the flex parent at home, and so I never feel like I'm 100 percent present anywhere! But the joys are the little ones—like waking up my daughter and catching a snuggle, having my son confide in me, or being able to get us out of a tough moment by using love and compassion. Also, the humility and vulnerability it takes to apologize, to be honest about not being your best self. It's always beautiful and ugly at the same time. I think motherhood is the ultimate allegory for being human.

What has your role as a mother taught you about yourself?

My role as a mother has taught me about my capacity for expansion. Expansion of everything—physical expansion, emotional expansion (on both ends of the spectrum), mental expansion. Motherhood has shown me what a badass I can be when I am close to my edge. You know the story of the mother who lifts a car to save her child? Motherhood has taught me that incredible power and force live inside me.

Did you experience postpartum depression or "baby blues"?

I only now realize that I experienced postpartum and extreme exhaustion. I think at the time, it just felt like this was the reality—that it was hard. I had my first two sixteen months apart, and I can honestly say that I remember very little of those two years that followed. I did find INCREDIBLE support in the other moms in my community. They really saw that I was struggling, and offered help just in their friendship and camaraderie. I was very lucky that I connected to a group of women

Life sometimes makes it that we end up raising our families the way we can and not necessarily the way we want. Being nimble in navigating those two polarities can really save you from some dark times.

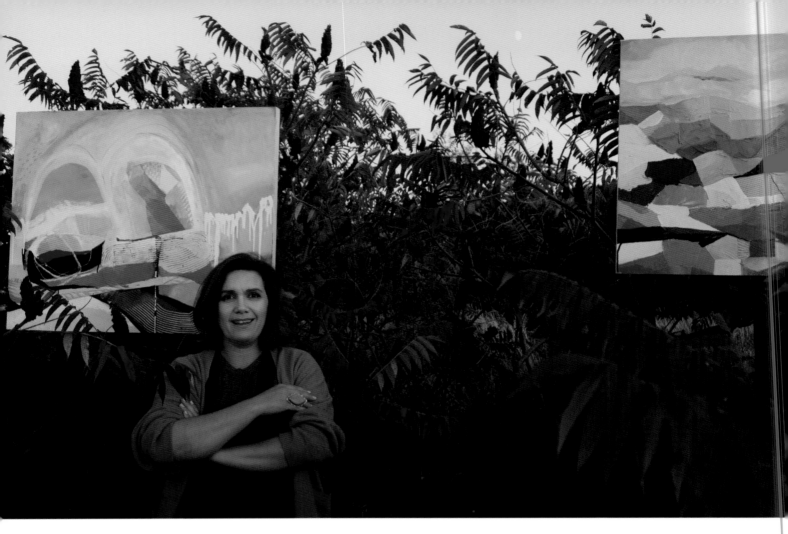

who had a similar experience to motherhood (i.e., *What the hell is happening to me!?*).

What do your kids teach you about life and yourself?

My kids are my deepest teachers. They are here to continuously mirror to me the things I need to work on in my own life. Patience, acceptance, freedom from judgment. They are the reminder that my job is to help them discover their own selves. I'm like a shepherd of children (but with nicer shoes).

What do you want to teach to your children?

To not dim themselves to fit in. That they can be as big as they want.

Did you experience a sense of loss or grief for the life you had before you became a mother?

Yes and no. I missed my party girl life of going out and causing ruckus in high heels and sassy coats, but honestly, I'm happy those days are behind me, and with each new phase of motherhood that awaits me, I become grateful for the one I just left.

What has one of your biggest struggles been as an artist? As a mother?

I think the thing I struggled with *most* was just calling myself an artist. I was in *agony* over this for at least a year. And then, all of a sudden, it wasn't a big deal anymore. I think self-doubt and being afraid of asserting the things I actually want—those are my biggest struggles as a person.

Share your tips on finding time to create when you have children.

Get up really fucking early. Like earlier than you would ever imagine. I make during that time and then put it away. The early morning is this beautiful ambrosial time when everything else is deeply asleep. It's my favorite time. In the evening I'm literally in bed at 8:30. Sad but true.

How do you deal with periods of no time to create or make things?

I find it hard. I really need the creative output to stay "sane," so I try to at least journal, and to me, that counts as creating. And the older I get, the more I realize the importance of keeping up the practice even in tough times.

Who is an artist mother you look up to?

Louise Bourgeois . . . Anne Truitt; they both exemplified the life of a working artist mother. I think it's not so much that they are mothers, but rather that they view motherhood through the artist's lens, and that is super interesting to me. I think I felt that early childhood swallowed my identity, and as I started creating, I rediscovered myself.

How have you overcome struggles or times of feeling overwhelmed?

Does locking myself in our bunk room and bingeing *This Is Us* count? In all honesty, I turn to my tools when I sense that I might get overwhelmed— therapy, Kundalini yoga, journaling, walking, meditating. Sometimes, though, it's just about sitting through the discomfort of the overwhelmingness and watching it go through you . . . as painful as that can be.

What helps you through creative slumps or times when life is full?

Cleaning my studio! Washing brushes! Taking inventory of what paint I have! I find housekeeping to be a good way to rekindle my love affair with my creativity. Sometimes I reorganize my home studio, or I do a big clean, or I cut up old work and play with collage. That always gives me a jolt!

Describe what the feeling of flow is to you. What does it mean to you?

The elusive flow! It feels like a complete disconnect from time-space reality. Literally. I think it's been documented so many times and across so many cultures . . . it's the thing that I think the cavemen felt when they painted the caves of Lascaux, or when Descartes was working on an equation . . . it makes me feel connected to the stars.

When was a time you felt like giving up? How did you get through this?

After doing a show and not selling a single piece. After not selling out of the product I was SURE was going to sell out . . . I think I want to give up at least twice a month! And now I've faced that feeling enough times to know that it's just a clue for me to change something. To start something new, to find a new yoga class . . . anytime I feel cornered, I know that it means I need to try one small new thing. like a new smoothie or a new coffee shop, and soon enough, I'll be excited again. ◼

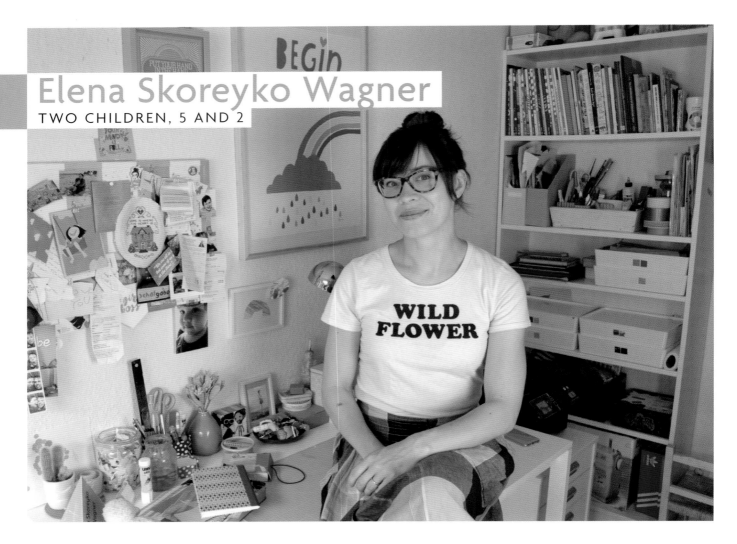

Photographs by
Zoë Suelen

Why is it essential for you to create? What happens if you can't have this time?
It is definitely essential for me to create; it's something pretty fundamental to how I move through the world. I overthink and analyze everything, but for me, creating and making is simple. I just sink into it, my anxieties or discomforts fade away, and it's like rest for me. Rest and, at the same time, fuel, as paradoxical as that sounds.

While I don't think the act of creating has to be making "art" for me, it is nice to have a medium I am fluent in, because it makes sitting down and just exhaling and losing myself in the flow of creating much more accessible. And it's also productive! If I don't get the chance to make, my

shoulders begin to inch up closer and closer to my ears, and my children seem louder and louder. The tears come quicker, and a little something deep in my chest starts to feel like it just might snap. Yes, it is essential for me to create!

Did you think you would need to stop making work once you became a mother?
Kind of the opposite. I got my BFA in visual art, graduated, flopped around a bit, and decided that art wasn't a feasible career choice. At least, I didn't know how, or have the confidence, to make it one. I didn't feel like I fit in; I thought my work was too pretty, not serious enough. It all felt very heavy, so I figured it wasn't for me, at least not then.

I was actually in the middle of a master's in occupational therapy when I got pregnant. I was very excited about a career in OT at the time, but then we moved to Germany. Suddenly I was a young mother living in a foreign country, not fluent in the language and at home with a one-year-old. Working in OT was not feasible, but spending my days doting on my little boy, as magical as that could be, gave me this insatiable drive to create something meaningful, outside of mothering. I started a blog, and slowly, making pictures began to find its way back into my life. I felt like I was coming alive! It was a palpable relief, like finding that one missing puzzle piece under the rug.

What was the first thing you remember making after having your first child?

The first thing I remember making was a blackout blind. Ha! Orchestrating that task felt like an enormously difficult yet lifesaving thing to do, so I remember it clearly. The first kind of crafty thing I remember making, though, was a little pair of leather shoes for my son, with printed fabric trim from a bundle of scraps I bought on Etsy. I was immeasurably proud.

Do you have moments of resentment or longing for freedom?

Yes, I do. Of course! That's human. Freedom is glorious! Ah, to be able to wake up on my own rhythm, drink a coffee uninterrupted in bed with my husband, linger over a quiet breakfast, lost in thought . . . meander out into the sun whenever it pleases me; find a flea market, a junk shop, a field of flowers; hop a bus to another city; lie on the beach with my eyes shut (and not worry about someone drowning); read in a coffee shop for hours; or just wander, wander, wander, no concern whatsoever for the time . . . ahhh. Delicious! Isn't that everyone's idea of heaven? But those times will come again, and there is an irreplaceable

heart-rendering magic to spending the days alongside small children too. Sure, there is always a trade-off, and that's okay.

Was there a moment or time when you could not see how you could make things work?

Honestly, I feel like this all the time. Every few months I will have a moment or twenty where it just doesn't seem possible, where I feel like I am failing on all fronts. Missed swimming-lesson enrollments for the third time. No vegetables in the house. Treading water but making no progress on creative projects. . . . But look, there was a time when I was a single student and just getting through my assignments, and feeding myself seemed gargantuan, unmanageable! And look at me now, ten times the responsibility and somehow managing, in some ways even thriving. Slowly maybe, imperfectly maybe, but accomplishing things.

Sometimes, it takes letting things just fall to shit for a moment, just eating pizza on the living room floor with my kids among mountains of laundry. Then, just getting back at it. Picking up the pieces, one at a time, and trying again. This, too, shall pass. It may sound trite, but it's true—it always does.

What do you wish you could tell yourself as a new mother?

As a new mom, I didn't feel like I fit in. I thought everyone else knew what they were doing, I was totally in love with my baby and thought I was ultimately doing okay, but I felt very self-conscious about how it all looked from the outside. My husband and I were still students, living in a teensy one-bedroom apartment; I was shit at cooking and cleaning; we had no nursery to speak of, let alone the Pinterest baby haven I was convinced all the other moms had. It wasn't a horrible time at all; actually, it was kind of beautiful, that sunlit winter basically spent chasing the sunlight around

6 square meters on my belly with my baby, but it was lonely too.

I let my vulnerability isolate me from other parents who were honestly going through most of the same stuff, Pinterest nursery or not. So I think there are two things I'd like to tell new-mom me:

1. Your choices, your life—it's all good and valid and in no way makes you a lesser mother. Own it. You are just fine.

2. No one else knows exactly what they are doing either. Let them in. You will laugh and cry and feel so much better.

What is something you needed to hear when you were in the early stages of motherhood?

I didn't know many mothers when I had my first child, so I hadn't seen my friends go through some of the less glamorous aspects of motherhood, as I now have. I was clueless about what our good bodies go through! But I had one friend who had a baby a couple of years before me, and quite young. I visited her in her student housing, and as she fiddled and fussed around to nurse her new son, I asked her if it was weird, breastfeeding. "Yeah," she said, shrugging matter of factly. "It's definitely weird. And awkward." And truthfully, that little exchange was really helpful for me. And I breastfed my kids for two years each! It's not about the breastfeeding; rather, it was just that inkling that

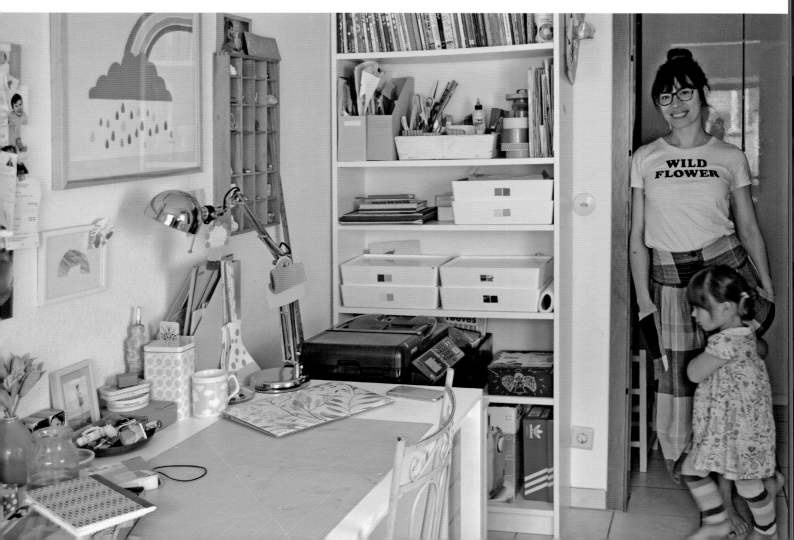

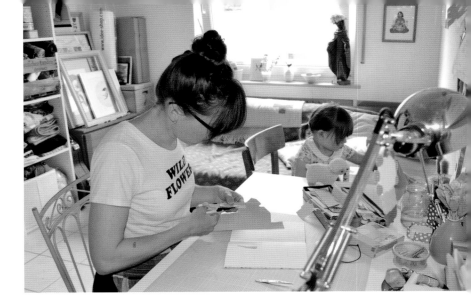

it's okay to feel weird in this new phase—it might not all feel rosy and beautiful and natural all the time. Especially at the beginning. That's normal. I always try to pass that idea on to other new moms, because it was relieving for me to recall that one little experience in those early days.

What were some physical limitations you experienced postpartum or during the first year?

I actually made a whole zine about this. I had some pelvic-floor problems after the birth of my son, basically mild pelvic organ prolapse. That's when the hammock of muscles that supports your abdominal organs are damaged through pregnancy and birth, and as a result the organs sort of push their way out of the vagina. It's quite common—surprise! Well, it was certainly a surprise to me. Everything seemed kinda different down there, so I didn't say anything and assumed my doctor would, if there was a problem. Nope. It took having a second child for me to realize on my own that something was up, and I followed up and found therapists myself. It's very treatable, usually, but you have to know something is up! I think we still suffer, as women, by the dainty little flower paradigm that makes talking about "icky" stuff like this taboo, and that's pretty uncool, because it means we end up actually suffering more.

Why do you think so many mothers express that they're not good enough? How can we support each other and shift this?

I am Canadian and had my first child in Canada, but we moved to Germany when he was eighteen months old. As a person from away, I was coming from one set of strong cultural parenting expectations to another, and it had the surprising effect of freeing me from the whole thing! I think it's like this: We're all new at this parenting thing, and it's one of the most crucially important tasks we

will undertake. We are therefore extremely invested in believing that we are doing the right thing. If someone else does it differently, that sort of implies that maybe we aren't. Which is scary! And I was as guilty of this as the next mama. But having that experience of two very different paradigms made it abundantly clear that it's not a right/wrong kinda deal! I think simply recognizing—and truly believing—that there are many, many ways to parent well goes a long way.

How do you handle people in your life who criticize or diminish your creative pursuits?

I know there are people in my life who see my career path as more of a playful hobby or a diversion, and when I have the chance to wave a magazine with my work in it in their faces, I do! It doesn't feel great in the end—values are personal, and I probably don't share theirs either.

I remember reading an interview a few years ago with Joanna Goddard, who has the enormously popular blog *Cup of Jo*, where she mentioned that benevolent uncle at the family event who comments on how nice it is that she can stay at home with her kids and still do her thing on the side! I have a lot of that kinda thing happen to me too. It hurts a little, but in the end, there are enough people in my life who do recognize

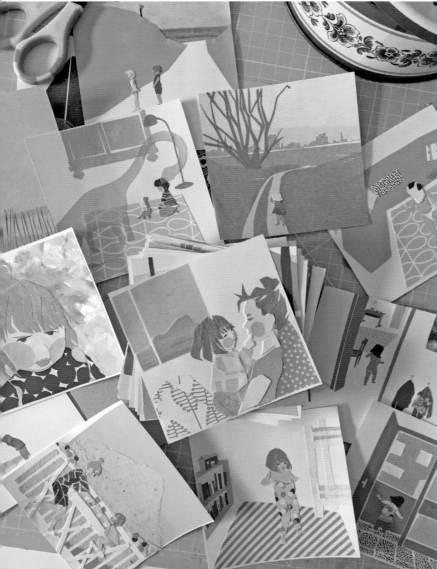

and value what I do. My suggestion for anyone struggling with feeling invalidated is to tap into an online community that gets it!

What do you want to teach to your children?

That fact that I am pushing this career as a maker has a lot to do with my children, especially my daughter. I used to have a lot of fear about putting my work into the world, loads of imposter syndrome; just felt like I had no business being there—like, maybe someday, but clearly not now because x, y and, obviously, z. But then I had this little rainbow girl and I wanted to show her that we can do hard things.

It didn't hit me as hard with my son, although I do think it's just as important for him to see his mom being who she wants to be. It's not about "working," like, goodness—mothering is definitely legitimate, honorable, hard work—it's that I wanted to do this, and I had a lot of fear. There are these invisible, sometimes overwhelming barriers, but I do not want to be a person who lets those things stop me. I want to have agency, and I want my kids to see that and have agency themselves too.

When I struggle, I often think about my kids. When they encounter obstacles and think or feel like they can't go on, what do I want them to do? How would I want them to approach it? And I try to be the example I hope they can learn from.

How does being an artist influence you as a mother and vice versa?

Motherhood is so encompassing, especially at first. Becoming a parent makes for a massive overhaul of priorities and big changes in the ways we use our time. My life has never had a lot of structure, but those new time and space constraints made the windows of possibility, however small, more apparent. Kind of like a tiny crack of sunlight in a dark room.

Motherhood really woke up a need to create

in me, and I started organizing my little bits of free time (during naps, after bedtime), or even just loose time (toddler somewhat entertained and within view), around creating. And because my life revolves quite literally around mothering, motherhood became a big theme in my work as well. I'm quite an autobiographical artist, and being a mother is just an integrated part of my perspective! Mothers, babies, and kids, my own and others, all show up often. And of course being a maker influences how I parent. In nebulous ways, like just having an exploratory, creative problem-solving mentality in the every day. And I think, like all parents, that the activities I provide tend to bend toward my own interests.

I am always collecting toilet paper rolls and little boxes and food containers, colorful beach garbage and driftwood, detergent jugs, etc. with crafty projects in mind. And my kids are also literally quite involved in my work. I am the primary caregiver and I work from home, so I am doing little things to run my business throughout the days. They see all my creative chaos, and I show them my work and ask their thoughts, and they celebrate with me when I get a new opportunity! And I actually just put an extra chair and low desk next to mine in my studio, because my kids really like to draw and collage alongside me, but I need their unpredictable fingers a bit farther from my work!

How have your studio practice and art changed over time? Especially before and after children.

I didn't really have a practice before I had kids! I went to art school, and in those days I painted and made videos, but that had all but dried up, and my creative life mainly consisted of scattered, random crafty projects and maybe the odd painting for a Christmas gift. I had the luxury of a lot of freedom, but that also meant I had my creative needs somewhat fulfilled without ever developing

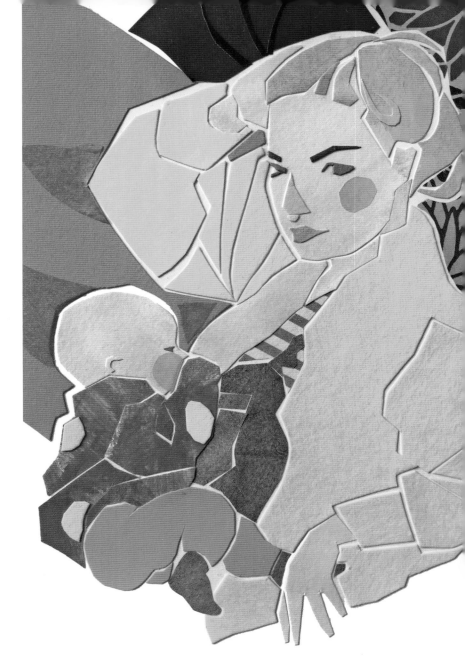

any kind of consistent practice or body of work.

Becoming a parent gave me the constraints I needed. Gone were the days of elaborate afternoon projects that took up tons of space; it was more manageable to work at a small scale, with simple, portable materials, and in short but consistent bites of time. And as a parent it's so easy to let that time get swallowed up; I found myself taking on even more structure through personal projects and challenges like the 100-Day

Project. Little by little, over the course of several years I developed a practice! A small business, even. I honestly wonder if I ever would have achieved that without becoming a parent. Parenting makes you efficient.

Share your tips on finding time to create when you have children.

Create in tiny bite-sized pieces. My friend Lena has seven kids; she is also very creative and an avid quilter. When she had her first three, who were all under three years old, she told me that she started timing herself to figure out how long things really took, so she could maximize her time. She realized she could make a surprising amount of progress on a quilt in just fifteen-minute blocks of time.

This was great intel for my tiny-babe days.

Sure, it's nicer to be able to really get that flow going, and I think taking the initiative to make arrangements with people in your life to have a couple house at least once a week is important. But when life is crazy, fifteen to twenty minutes will get you somewhere.

How do you deal with periods of no time to create or make things?

When things get really busy, first I try to revert back to my newborn-baby strategy of working in tiny bits, a half an hour after bedtime maybe, a little sketch while the kids play. Just keeping the pilot light on.

For my psychological need to create, I can make things with my kids, find creativity in the everyday; that helps for a little while. But

sometimes even that isn't manageable. This winter at one point, we were all sick and my husband was away, and I was just not getting any creative work done whatsoever, and it was making me increasingly anxious. Finally I just said, okay. I need to shift my priorities this week; it's not permanent. This week, I have to let it go.

My business is small, so most of the time its okay to write some emails, fill people in, and let it go. No one will die if something takes a few days longer to happen. As much as creating and making things is a form of self-care, it can also be a form of self-care to take a break from it when life demands it. And then, come back when you're ready.

How have you overcome struggles or times of feeling overwhelmed?

I consider myself a pretty happy person, but frankly, coming in and out of a state of being overwhelmed is my constant! I have gotten much better at managing it though. Usually it creeps up on me after I've been subconsciously coping poorly, through a diet of coffee and old holiday chocolate, staying up too late, working too hard and probably escaping into some Netflix series, letting the apartment fall apart, and spending too much time alone (as in, alone with my kids). So I forcibly reverse all that. Have a good cry and then get out a notebook and lay it all out. Write down all the things stressing me out, organize them, make a concrete plan for each thing, and then take care of myself. Plan simple, healthy meals, get some fresh air, tidy up the apartment, reconnect with good friends, talk honestly to my husband. Limit caffeine, sugar, work, and TV, and go to bed early. And last, be gentle with myself. Usually, I can get back on track again soon.

Describe what the feeling of flow is to you. What does it mean to you?

Flow is that delicious place where skill, challenge, and inspiration intersect in a field of time, and bloom! In the midst of diapers and nap refusals and playdates and supper and laundry explosions, it's not an easy thing to achieve. But when you find yourself there, having lost all track of time, immersed in a creation that engages your mind and your heart and feels meaningful and takes you to the edge of what you are capable of, so that you are excited to see what comes from your own hands, it's all the more precious!

Respond to the idea of social media envy.

A few years ago, when my firstborn was still a toddler, a friend of my sister's with small kids who had been following me on Instagram revealed to my sister, with a deep sigh, that my life just seemed so perfect, and how did I do it? My sister Johanna nearly choked. "What? Elena? No, no, no. She is NOT like that, trust me." She told me about it later, and I was part horrified, part amazed, and it really changed how I saw social media going forward.

I hadn't done it on purpose; I was just showing the beautiful bits because focusing on that felt good. But suddenly I recognized how possible it is to cultivate an image that doesn't represent reality, and all the "perfect lives" I followed looked different to me. It freed me a lot from envy and made me change my own approach. I still post lovely things, but I am careful to be honest about my experiences, to tell stories that represent the big ol', ugly ol', beautiful struggle that it all is.

I really think it's so important to realize what a tiny piece of the story we are seeing on social media! Some people are incredible curatorial artists, more able to evoke that fantasy, to pinpoint those beautiful moments when they appear in their lives. It's not a lie, but it is an art, and that is how we should see it and appreciate it. ■

Resources

POSTPARTUM DEPRESSION

Up to one in seven women experience postpartum depression. While all of these symptoms can occur in new moms, they usually go away after a few weeks. If you are experiencing these feelings for a longer period of time and more severely, please reach out to a healthcare provider.

Postpartum Symptoms

• Excessive worrying or feeling overly anxious

• Difficulty sleeping or sleeping too much

• Trouble with concentration and memory

• Difficulty making decisions

• Lack of interest in self-care, such as dressing and bathing

• Poor appetite or overeating

• Lack of energy to perform everyday tasks

• Crying frequently, even about minor things

• Showing too much (or not enough) concern for the baby

• Loss of pleasure or interest in things that used to be enjoyable

www.postpartum.net (Helpline 1-800-944-4773)

www.postpartumhealthalliance.org

National Suicide Prevention 1-800-273-8255

PODCASTS

Art & Cocktails, Ekaterina Popova

The Art History Babes with Allison, Ginny, Natalie, Jennifer

Artist/Mother, Kaylan Buteyn

Art Juice, Alice Sheridan and Louise Fletcher

Craft a Life You Love, Amy Tangerine

Creative Pep Talk, Andy J. Miller

Do It for the Process, Emily Jeffords

Happy Hacks, Kia Cannons

I Like Your Work, Erika B. Hess

The Jealous Curator, Danielle Krysa

Raw Milk, Beth Kirby

Savvy Painter, Antrese Wood

Side Hustle School, Chris Guillebeau

While She Naps, Abby Glassenberg

Women Up, Katie Deepwell

BOOKS

DRAW YOUR DAY by Samantha Dion Baker

IN THE COMPANY OF WOMEN by Grace Bonney

THE ARTIST'S WAY by Julia Cameron

ART INC./ BROAD STROKES, 15 WOMEN WHO MADE ART AND MADE HISTORY (IN THAT ORDER) / FIND YOUR ARTISTIC VOICE / A GLORIOUS FREEDOM: OLDER WOMEN LEADING EXTRAORDINARY LIVES / WHATEVER YOU ARE, BE A GOOD ONE by Lisa Congdon

BIG DREAMS, DAILY JOYS by Elisa Blaha Cripe

BIG MAGIC by Elizabeth Gilbert

ART BEFORE BREAKFAST by Danny Gregory

TRAVELS THROUGH THE FRENCH RIVIERA: AN ARTIST'S GUIDE TO THE STORIED COASTLINE, FROM MENTON TO SAINT-TROPEZ by Virginia Johnson

WATER PAPER PAINT: EXPLORING CREATIVITY WITH WATERCOLOR AND MIXED MEDIA by Heather Smith Jones

KEEP GOING / SHOW YOUR WORK / STEAL LIKE AN ARTIST by Austin Kleon

THE LIFE-CHANGING MAGIC OF TIDYING UP by Marie Kondo

A BIG IMPORTANT ART BOOK, NOW WITH WOMEN / COLLAGE / CREATIVE BLOCK / YOUR INNER CRITIC IS A BIG JERK AND OTHER TRUTHS ABOUT BEING CREATIVE by Danielle Krysa

LIVING AND SUSTAINING A CREATIVE LIFE: ESSAYS BY 40 WORKING ARTISTS by Sharon Louden

THE CROSSROADS OF SHOULD AND MUST by Elle Luna

ESSENTIALISM: THE DISCIPLINED PURSUIT OF LESS by Greg McKeown

MENDING MATTERS: STITCH, PATCH AND REPAIR YOUR FAVORITE DENIM & MORE / THE PAPER PLAYHOUSE by Katrina Rodabaugh

LADIES DRAWING NIGHT by Julia Rothman, Leah Goren, and Rachael Cole

BETTER THAN BEFORE / THE FOUR TENDENCIES by Gretchen Rubin

THESE THREE THINGS: A DAILY JOURNAL by Lisa Anderson Shaffer

MAKING YOUR LIFE AS AN ARTIST by Andrew Simonet

DRAW 500 EVERYDAY THINGS / A FIELD GUIDE TO COLOR: A WATERCOLOR WORKBOOK by Lisa Solomon

CRAFT A LIFE YOU LOVE by Amy Tan

DAY JOURNAL by Ann Truitt

DRAWING IN BLACK & WHITE: CREATIVE EXERCISES, ART TECHNIQUES, AND EXPLORATIONS IN POSITIVE AND NEGATIVE DESIGN by Deborah Velasquez

THE ART OF NOTICING by Rob Walker

Art and Craft Related

www.artistresidencyinmotherhood.com

www.artistsu.org

www.artparentindex.com

www.artsy.net

www.bothartistandmother.com

www.carveouttimeforart.com

www.collegeart.org

www.craftindustryalliance.org

www.creativebug.com

www.creative-capital.org

www.creativelive.com

www.culturalreproducers.org extensive parent friendly residencies

www.desperateartwives.com

www.diep.org.uk/

www.mommuseum.org

www.motherinarts.com

www.mothervoices.org

www.nmwa.org

www.patternobserver.com

www.procreateproject.com

www.risingtidesociety.com

www.skillshare.com

www.sustainableartsfoundation.org

www.the100dayproject.org

www.themotherload.org may not be updated but a great list of artists to connect with

www.thriveartstudio.com

www.wassaicproject.org/artists/family-residency

www.womenwhodraw.com

www.wsworkshop.org offers a parent artist residency

www.themotherload.org may not be updated but a great list of artists to connect with

Infant and Pregnancy Loss Support

www.nationalshare.org

www.babylosscomfort.com/grief-resources

Breastfeeding Support

https://kellymom.com/

https://www.llli.org/

Index

Marissa Huber is an artist and surface pattern designer who found motherhood to be a turning point in her art practice. Frustrated with being told she'd never have time to create after children, instead she found that her creative confidence flourished. Compelled by a desire to change this narrative and help others prioritize art, she cofounded the online community Carve Out Time for Art with Heather Kirtland. Marissa works primarily in water-based mediums and digital drawing and has recently been exploring linocut printing and silk dye. Her work is influenced by colors, patterns, and plants found in daily life. She attempts to capture fleeting moments and find joy in the every day. Her work has been featured at Brooklyn Art Library, in *HGTV Magazine*, and on Minted. She holds a BS in interior design from Indiana University, Bloomington, and works as an occupancy planner by day. She believes in taking her dreams quite seriously but not taking herself too seriously. She lives in South Florida with her artist husband, two kids, and mom.

Heather Kirtland, an artist, received a BFA in painting from the Maryland Institute College of Art. Heather currently teaches encaustic workshops and is focused on her own studio practice. She was awarded the Maryland State Arts Council Grant and was a resident artist at the Holt Center. Most recently she works with West Elm as one of their local artists. Her work has been exhibited throughout the Mid-Atlantic region and abroad in Italy and Wales and has appeared in *Modern Rustic* magazine and *Country Living UK*. The Make-A-Wish Foundation and Montessori school have commissioned her work, as have many private collectors. Heather recently moved from Baltimore to a more rural part of Maryland, where she lives with her husband and two children and their dog. When she is not painting, she loves to read, run, and encourage other mothers to find a creative outlet through the project she cofounded with Marissa Huber, Carve Out Time for Art.

Visit the authors and learn more about the book at

www.TheMotherhoodofArt.com

and social media accounts with that same tag.